Bombast

6-20-11

D0889437

Spinning Atoms

in the Desert

MICHON MACKEDON

Bombast

Spinning Atoms
in the Desert

MICHON MACKEDON

BLACK ROCK INSTITUTE PRESS / RENO

2010

Bombast Spinning Atoms in the Desert is the second published book for the Black Rock Institute Press. For more information about the Black Rock Institute please see page 236.

Black Rock Institute Press
Reno, Nevada

Library of Congress Control Number: 2010904860
ISBN: 978-0-9841014-3-6 Paperback
ISBN: 978-0-9841014-2-9 Hardcover

Printed in China
First Edition, 2010

The paper used in this publication meets the minimum requirements of ANSI/NISO Z39.48-1992 (R 1997) (*Permanence of Paper*).

NEVADA
HUMANITIES

Funding for this publication is provided in part by the Charles Redd Center for Western Studies at Brigham Young University, and by several private donors. The Nevada Visitation by Michon Mackedon is supported by a grant from Nevada Humanities, a state program of the National Endowment for the Humanities.

Cover photograph: De Baca, named for a county in New Mexico, was a 2.2 kiloton balloon burst detonated at the Nevada Test Site on 26 October 1958. Photograph courtesy of National Nuclear Security Administration/Nevada Site Office.

This book is dedicated to Leonard and Julia

Nevada

I love this state as I love a summer morn

And I've had this love since the day I was born

I have no quarrel with those who say

That this land is dry and parched like clay.

For I know of no finer thrills

Than the hours I have spent on these rugged hills

Oh, yes, I often have had the call

To travel far and see them all.

But I know too well my first love's best

And who would trade that for all the rest?

I love to wander this roughened land

And ponder where others have laid their hand

The sky is wide and bright and clear

And the mountains stretch beyond a year.

LEONARD O. MACKEDON

And the question remains,

What effect does nuclear testing have on us: on our culture, economy,

and environment, and finally, on the landscapes we create?

Peter Goin *Nuclear Landscapes*

Table of Contents

ILLUSTRATIONS

Maps

Black and White Photographs

Cartoons

Figures

Atomic Pop Color Plates

I n *Basin and Range*, John McPhee writes of driving the long, lonely lanes of Interstate 80 through vast reaches of the Nevada desert after nightfall, when all before him seemed endlessly black. Suddenly, from the horizon of this dark hole loomed the town of Winnemucca, Nevada, with its neon motel, casino, and restaurant signs of promise looking "like a Christmas tree alone in the night." To McPhee, "Neon looks good in Nevada. The tawdriness is refined out of it in so much wide black space" (1981, 48).

Apparently, atomic bombs and other assorted nuclear happenings must also look good in, or at least be suited to, the wide blue skies, mountain peaks, and desert floors of Nevada, for it is true that the eyes of nuclear barons have continually swept over the basins and ranges of the Silver State—they were seeking locations for splitting atoms (or hiding them), for blowing up nuclear bombs, and for the interment of nuclear waste.

A scant three years after the 1945 atomic bombings of Hiroshima and Nagasaki, Nevada figured prominently in plans for the further development and testing of the atomic bomb. After the extensive search to locate a national proving ground, the U.S. Army designated three sites, out of a total of five sites nominated, in the Great Basin. A Nevada site, as everyone knows, became the final choice.

In fact, if you take a map of Nevada and mark Xs over areas used for nuclear testing, and Os over areas examined as potential nuclear sites, you end up with a tic-tac-toe game played across the map of the state.

One X covers the Nevada Test Site (NTS), which served as the primary nuclear testing proving ground for the United States from 1951 until 1993 when nuclear testing was suspended. Other Xs mark Nellis Air Force Range, near Las Vegas, where nuclear rockets were tested; the Central Nevada Test Area, near Eureka, where the large, 900-kiloton underground Faultless test took place in 1968; and the Project Shoal site, near Fallon, Nevada, and some 300 miles north and to the

west of the NTS, where a small, 12-kiloton underground test was conducted in 1963.

Still other Nevada landscapes are marked with Os because they were studied, surveyed, probed, scratched, and "characterized," but ultimately dismissed as nuclear sites. These include an area of the exquisite Black Rock country, south and west of neon-festooned Winnemucca (and now the playground for Burning Man acolytes), where under the code name Project Gondola land was measured off for testing the hugely powerful Spartan warheads. Another site placed on the short list of areas considered suitable for testing atomic bombs was an area on the Utah border, near the town of Wendover, Nevada.

The Nevada landscape most recently achieving "O" status is Yucca Mountain, located 90 miles north of Las Vegas and adjacent to the NTS. For the last two decades, the Department of Energy (DOE) has studied the mountain to determine its qualifications for storing long-lived High Level Nuclear Wastes (HLNW).

And, if we include in our game sites examined between 1979 and 1981 for 4,500 possible underground silos for stationing MX missiles, the state map looks like a game board for playing "4,500 pick up," with the cards thrown against the Nevada–Utah border.

My interest in the relationship between Nevada desert places and nuclear events began with an unexpected phone call received in 1985 from the office of Nevada Governor Richard Bryan. Would I be willing to serve on a newly-created Nevada Commission on Nuclear Projects, a lay group charged with advising Nevada's governor and legislature on all issues related to the DOE's plan to store nuclear wastes in Yucca Mountain? After some initial reluctance, I answered yes, and served as vice chairman of the Commission for twenty years.

The Commission on Nuclear Projects meets several times a year, gathering evidence from DOE scientists and receiving often-contradictory briefings and data from consultants hired by the State of Nevada pertaining to the geology, seismology, and hydrology of the proposed Yucca Mountain site. I have viewed the changing DOE-proposed transportation routes for hauling the nuclear waste across the heartland of the nation, and listened to descriptions of complex and expensive plans to design and engineer transportation casks, storage canisters, and drip shields to be installed above storage canisters inside the repository to deflect water.

Despite the heavy reliance on engineering the mountain, the DOE has always maintained that the Yucca Mountain site is suitable, and that the engineering of casks,

canisters, and drip shields is scientifically sound—sound enough, in fact, to contain radionuclides over many millennia.

The repeated assurances of the DOE took on layers of irony when I began to study the history of atomic testing in Nevada. I consequently came to realize that the phrases "site suitability" and "sound science" had been deployed, almost robotically, since the nuclear narrative began. They became not only suspect phrases, but examples of what I have identified as rhetorical patterns or tropes used in the promotion of nuclear events. The central question of my study became: "How was official rhetoric used to pull the wool over our eyes?"

And so, this book is about words. Words have the power to shape culture, write the past to suit the present, create truth, and disguise falsehood. With George Orwell's essay on "Politics and the English Language" ever in mind, I identify many of the euphemisms woven into the history of siting and promoting nuclear projects in Nevada and elsewhere. Carefully selected and carefully implemented words have not only produced images of suitable sites, but have also created the notion of "suitable populations," leading the non-Nevadan to conclude that Nevada is a geographic, social, and cultural wasteland—a good habitat for rattlesnakes and radioactivity. Or, as printed in the book *Armed Forces Talk*, circa 1950, it's a "damn good place to dump used razor blades" (Gallagher 1993, xxiv). Words and phrases (such as "radiation is natural" and "no one was injured") have disguised truths about nuclear dangers and produced official histories that serve structures of power. Words have been used to make the unsafe appear safe, and the unthinkable, well, thinkable.

With Orwellian flourish, nuclear planners assigned euphemistic code names like Rose, Sunshine, Garden, Little Boy, and Apple to experiments with lethal nuclear forces. We have to ask ourselves, "What is going on when a deadly explosion is code named Danny Boy?" I may not be able to answer this question, but I will offer my thoughts, and some thoughts of others, about the code names of weapon tests, and what those names might suggest to us about the weapons culture itself. The chapters discussing the code names of the weapon tests are essays—my subjective attempt to squeeze meaning from enigmatic clues. To my knowledge, examining nuclear testing through code names, and the irony that naming invites, is unique to this book.

The narrative of locating and executing nuclear events in Nevada has left an unhappy legacy to the people of the state: a diminishing confidence in government and a discovery of their own invisibility. As atmospheric testing continued in Nevada, the

standard phrases used by the Atomic Energy Commission (AEC) to justify sites and promote testing became increasingly cynical and arrogant. The message was "We" know better than the invisible "You." The AEC claimed that scientific experts had been consulted, and safe limits established. To assure populations that safety measures were taken and to intimidate critics with mountains of data, they used what I call "a rhetoric of quantification" emphasizing details. The quantity and size of instruments and length of cables used in a given experiment, for example, was offered as a demonstration of safety, as if distributing 1000 air-samplers (or film badges) could prevent an accident.

The Yucca Mountain Project has stalled, as of February 2010, as the Obama administration seeks alternatives to what has proved to be a politically unpopular and scientifically questionable project. One of the reasons the DOE failed to successfully promote the project in Nevada was its continued use (robotically and uncritically) of the same well-worn and untrustworthy phrases that made up AEC's promotional campaigns in support of atomic testing.

What has occurred in Nevada—the disingenuous selling of nuclear projects desired by agents of power to a politically powerless region—has occurred in a much broader sense in almost every place on the globe chosen by "We" for a project to benefit "You," including places nominated for waste dumps, power plants, detention centers, and sewage treatment plants. Even projects like historical landmarks and parks, which on the surface may appear to be acceptable and attractive to all, have been promoted by marginalizing the local voices of dissent and silencing critics with claims of site virtue issued from the vantage point of outside authority.

When I examine my own history as a Nevada native, I find that the Nevada nuclear narrative has been part of my entire life. Dodge Construction Company—based in Fallon, Nevada, and managed by my father—paved roads into Mercury at the base of the NTS in 1951. On "shot" days, my father would wake me at dawn, in our Fallon home, to witness what he called "the marvelous southern sunrise." He stocked food in the basement in case of atomic attack, and taught his children that atomic testing ensured our freedom from the slavery of communism. Years later, in 1963, Fallon was chosen as a site for an underground atomic test, Project Shoal. And so, in many ways, I was raised with the bomb, bomb shelters, and bomb rhetoric that both advocated and resisted nuclear experiments.

Thus, I arrived at the point of writing this book from three directions: as native daughter, as a teacher of the English language, and as an appointed member of a commission whose daunting charge called for earnest research, thought, and action. The result is a book written for those who are not specialists in nuclear history or the science of atoms. The ideal reader might have a healthy interest in the history of atomic testing, especially as it has played out in Nevada, or might be engaged in contemporary issues surrounding the disposal of nuclear wastes. Or, the reader might share my deep concern that language has been used by the powerful to seduce the powerless in service of what is characterized as the greater good.

Although I use the term "rhetoric" throughout the book, I will be the first to confess that "rhetoric," and its step-sister "discourse," are ugly words overused by literary critics and mystifying to the non-specialist. I use rhetoric in a broad and flexible manner, as a body of images used to further an argument or to elicit an emotional response to a situation or idea. The term can be pejorative or not, and I stand guilty of using it both ways. When I use rhetoric to describe a body of images deployed systematically—as in rhetoric of suitability, rhetoric of sound science, rhetoric of quantification, and rhetoric of prediction—I intend the pejorative interpretation. However, toward the end of the book, when I describe works of literature and museum displays under the rubric of rhetoric, I am using the term less as a description of an argumentative technique and more as description of a body of images (visual as well as written) used to further an idea.

One of the greatest challenges I faced in writing the book was sorting through the many fascinating tales of nuclear testing in Nevada, and elsewhere. Readers who have read deeply into the Manhattan Project history, or who have followed fallout stories and fallout lawsuits in Nevada and Utah, may criticize the inclusion of previously published materials, or may take issue with my summary approach. The real subject here is not the history of atomic testing in Nevada, but the language used to promote it. My intent is to place the more widely known material within a fresh framework through the juxtaposition of promotional language used in the past and similar rhetoric implemented in the present. Spinning atoms in the desert continues.

Trinity's Children

O n Monday, 16 July 1945, an atomic fireball arose from the desert floor at Alamogordo, New Mexico, a sight never before witnessed by man. In an instant, Alamogordo became the first nuclear proving ground on the globe, and the nuclear age was born.

Following the successful Trinity test, the bomb was used twice in Japan, hastening the Japanese surrender and the end of World War II. It was subsequently tested again and again, as weapons designs became more efficient and the bombs more deadly. In all, including the Trinity test and the aptly named Divider—the last nuclear test conducted by the United States in September 1992—1054 fission and fusion weapons were tested by the United States on fifteen proving grounds, where bombs were dropped from planes, detonated atop metal towers, exploded from anchored balloons and barges, and fired underground and underwater.

Trinity was the only atomic test conducted at Alamogordo, but other United States proving grounds were used extensively.

They are silent now, those lands that once played host to nuclear bombs. During summer days at the Nevada Test Site (NTS), the heat rises in weightless waves from the desert floor, forming ghostly auras about the towers and concrete bunkers, which stand as silent reminders of one of the strangest chapters in recent American history. A visitor to the site might as well be on the moon or on an underwater exploration of the *Titanic*, as the landscape seems unconnected to the rest of the earth as we know it. Like the surface of the moon, it is a vast, lonely place, dimpled and pockmarked here and there with craters of all sizes. In some areas, abandoned relics look like undersea wrecks frozen in time, cobwebs and dust their arid barnacles. Like sunken ships, they hold tales of their halcyon days, when the NTS bustled with over 10,000 workers and sea urchin shapes rose as flames into the sky.

The Trinity test site near Alamogordo is equally silent and surreal. Gates are unchained twice yearly to allow visits by atomic tourists. One of the few remaining clues

U.S. Testing Grounds: Alamogordo (1 test); Bikini and Enewetak in the Marshall Islands (66 tests); Christmas Island (24 tests); Johnston Island (12 tests); an "area of the Pacific" (4 tests); an "area in the south Atlantic" (3 tests); nine sites within the United States other than Alamogordo or the Nevada Test Site (16 tests); and, of course, the Nevada Test Site, the king of the U.S. nuclear proving grounds, where 928 nuclear tests took place, 100 above ground, 828 underground.

to the site's atomic history is an overlay of glassy green radioactive pebbles, named trinitite and dubbed "atomic eggs." They formed in a microsecond when the desert sand was fused by the heat of the blast. Little else of historical interest can be seen, but those who have read the history of Trinity can readily conjure up apparitions to fill the void: the 100-foot tower up which the bomb was hoisted, mattresses spread around the base to cushion an accidental drop of the bomb referred to as "Jumbo," and the Manhattan Project scientists gathered at the site betting on the yield of the bomb—Dr. Robert J. Oppenheimer wagering on a puny 300-ton yield, I. I. Rabi on a close to accurate yield of 8 kilotons, and Edward Teller on an optimistic 45 kilotons. (A kiloton is an explosive force equal to that of 1,000 tons of TNT.) And, visitors might imagine the strains of Tchaikovsky's *Nutcracker Suite*, playing on amplified radio and wafting above the countdown decrescendo "nine, eight, seven, six...."

Scuba divers are virtually the only visitors to the Marshall Islands proving grounds, where the largest U.S. nuclear tests were detonated. Throughout the year, divers gather off the shore of Bikini Atoll to explore the undersea resting place of a once sea-worthy fleet of American and captured Japanese ships, sunk as practice targets for A-bomb exercises during the 1946 Operation Crossroads atomic test series. Fading letters identify the *Saratoga*, *Nagato*, *Independence*, and *New York*.

Underground testing was undertaken at eight so-called "off-site" proving grounds in the United States. The locations are called off-site because they lie outside the boundaries of the NTS: two in New Mexico, two in Colorado, two in Nevada, and one each in Mississippi and Alaska. On the surface, above underground zero, a concrete marker stands like a tombstone, each engraved with a minimalist epitaph commemorating the nuclear event. Date of the test. Yield of the bomb. Name of the test. Today, grasses ripple or sagebrush moves stiffly as the wind sweeps these enigmatic nuclear sites, deserted like Shakespeare's "boughs that shake against the cold / Bare ruin'd choirs where late the sweet birds sang" (The Riverside Shakespeare 1974, 1762).

These diverse places were chosen as nuclear proving grounds through the imple-mentation of official site selection processes, which claimed the legitimacy of sound science to locate the most suitable site. Yet, an examination of the records leads me to believe that what took place was more de-selection of competing sites than active selection based on scientific data. Political, aesthetic, and sociological judgments, as well as a desire for expediency, almost always wore the label "sound science" in the

The battleship USS *Nevada*, after surviving Pearl Harbor and Iwo Jima, was sent to Bikini and painted bright orange to serve as Ground Zero for the first test of Operation Crossroads. The bomb veered off target and the *Nevada* remained afloat. However, she was so contaminated by radioactivity that she was towed to Honolulu, where it took a combination of shells from the battle-ship USS *Iowa*, radar guided bat bombs, and Tiny Tim rockets to sink the ship (Henley 1988). Given the role the state of Nevada would later play in nuclear testing, it's hard to avoid attaching irony and symbolism to this event.

final decision-making moments. Words used to characterize a site as suitable or sci-entifically sound for nuclear testing or nuclear experimentation fly from a "Pandora's box" stuffed with preconceptions about place, landscape, and populations—beginning with the dubious assumption that nuclear testing can be done safely at all.

The facts will show that the rhetoric of site selection conflates the terms "suitable" and "sound" with concepts and terms like uninhabitable wasteland, barren, marginal, scarcely populated, politically insignificant, economically depressed, and logistically feasible. Furthermore, experience teaches that these same phrases have crept back into Pandora's box, for future release by the Department of Energy (DOE) in its quest to locate and build nuclear waste disposal sites.

Nuclear Colonialism

The words in Pandora's nuclear age box illustrate a type of "colonial" rheto-ric. The term colonial is used because in seventeenth- and eighteenth-century colonialism—England and India, Belgium and the Congo, Spain and Paraguay—foreign peoples and places (the *others* and their land) were described in language that suited the needs of the colonizing nation. Plans for land use in foreign colonies were most often conceived and stamped official in the relative security of the homeland, without the potentially tiresome participation of the locals.

As part of their governing procedures, colonizing nations commissioned official reports of their colonies. Resulting descriptions of people and landscapes were deliv-ered as census data that served to reinforce whatever stereotype justified coloniza-tion. As described by the scholar Nicholas Thomas, "The subject nation was encom-passed in a book, in a document that enumerates, classifies, hierarchizes and locates … according to an array of data that are objectified … in the vision of the state" (Thomas 1994, 38).

As an example of what Thomas means by classifying and "hierarchizing," in the discourse of nineteenth-century colonialism, the native of, say, India or the Congo was described in document after government document (and in more than a few novels, as well) in terms of the other—as backward, poor, uneducated, untamed, heathen, and lazy. He was further described, for reasons helpful to the colonial outlook, with the adjectives licentious or lusty, or in the case of she, promiscuous. The discourse itself, therefore, created an image of the natives that justified their being modernized,

educated, tamed, sanitized, clothed, unsexed, and Christianized by the host country. It provided a rationale for turning their country's natural resources into a colonial export, the resulting wealth of which would surely "trickle down," to use a modern colonial phrase. The subjects' lands, as well as the subjects themselves, were turned into objects of study and described as "suited to, or suitable for" the intended use. So was a colonized territory robbed of any particular charms and described in terms of negative qualities, as a "wasteland" or a "blank canvas" on which to locate mining claims or plantation agriculture or industry. The land, in other words, was (re)created as empty space awaiting the colonizers' plans. Geographic, racial, and cultural stereotypes were then manufactured or produced to serve colonial ends.

Marlow's Map

Almost one hundred years ago, in his novel *Heart of Darkness*, Joseph Conrad explored the allure of maps depicting the land of the other through a flashback to the childhood of his fictional sea captain, Marlow, who as a boy was enchanted by a map of Africa with its large and still uncharted interior Congo. Marlow tells us, "Now when I was a little chap I had a passion for maps. I would . . . lose myself in all the glories of exploration. At that time there were many blank spaces on the earth, and when I saw one that looked particularly inviting on a map (but they all look that) I would put my finger on it and say, 'When I grow up I will go there....' But there was one yet—the biggest, the most blank, so to speak—that I had a hankering after" (Conrad 1989, 22).

For Marlow the blank space was a "delightful mystery—a white patch for a boy to dream gloriously over" (22). The map is an image of mystery and opportunity, a *tabula rasa* awaiting inked-in symbols to lend it character and purpose and ownership. Conrad does not let us escape the irony that the tabula rasa was, in fact, not blank, but already overwritten with names for villages, rivers, and mountains—in the minds, if not on the maps, of the indigenous people.

Our atomic age "Marlows" found their vacant spaces in the deserts of New Mexico, the oceans of the Pacific, and the vast expanses of the Great Basin. Like earlier colonizers, they described, characterized, mapped, and produced spaces they found suitable for their experiments.

The late scholar of colonialism, Edward Said, analyzed an excerpt from a 1990–91

"The earth is in effect one world in which empty, uninhabited spaces virtually do not exist. Just as none of us is outside or beyond geography, none of us is completely free from the struggle over geography. That struggle is complex and interesting because it is not only about soldiers and cannons but also about ideas, about forms, about images and imaginings" (Said 1993, 7).

Foreign Affairs article titled "The Summer of Arab Discontent" to illustrate the produc-
tion of a suitable image of a given landscape for political or military aims. The author,
Fouad Ajami, describes Saddam Hussein's ascendancy to power in Iraq. As Said points
out, the author's choice of language produces serviceable political images of both
Hussein and the nation of Iraq. "[Saddam Hussein] came from a brittle land, a frontier
country between Persia and Arabia, with little claim to culture and books and grand
ideas," (Said 1993, 297). Said chides, "Yet even schoolchildren know that Iraq was seat
of Abbasid civilization, the highest flowering of Arab culture between the ninth and
twelfth centuries, which produced works of literature still read today as Shakespeare,
Dante, and Dickens are still read…. Even though Saddam was a Takrili, to imply that
Iraq and its citizens had no relation to books and ideas is to be amnesiac about Sumer,
Babylon, Nineveh, Hammurabi, Assyria, and all the great monuments of ancient Meso-
potamian (and world) civilization…." And "What happened," Said asks, "to the verdant
valleys of the Tigris and the Euphrates?" (298) (The ancestral land, I might add, of Gil-
gamesh, the Hanging Gardens of Babylon, the Code of Nebuchadnezzar, and the gates
of Ishtar.)

Said answers that author Fouad Ajami created an image of a brittle frontier, of
emptiness, both geographic and cultural, that helps to justify a takeover. Ajami tells
the public what he wants it to hear, "that it could go ahead and kill, bomb and destroy,
since what would be being attacked was really negligible, brittle, with no relationship to
books, ideas, cultures, and no relation either, it gently suggests, to real people" (289).

Important distinctions should be drawn between Said's examples of the kind of
language used to justify cultural colonialism and the language used to site nuclear
proving grounds. Valerie Kuletz, in *The Tainted Desert*, contrasts the old colonialism
and nuclear or internal colonialism: "Unlike colonialism, where 'core' countries in the
'first world' exploit 'peripheral' countries for their natural resources, internal colonial-
ism is characterized by one region—usually a metropolis that is closely associated with
state power—exploiting a colony-like peripheral region. In the case of nuclear colonial-
ism, what is usable, sparsely populated, arid geographic space is used as a dumping
ground or a testing field to allow more powerful regions to continue their present form
of energy production or to continue to exert military power globally" (Kuletz 1998, 8).

Kuletz's definition of internal colonialism fits with the nation's history of nuclear
site selection, in that sites were selected for nuclear testing (or are presently being
studied for nuclear dumping grounds) by those living in more populated regions who

served the most powerful cultures on earth: the weapons production industry, the nuclear energy industry, and the military.

Scholar Maria E. Montoya agrees: "Americans historically have deemed certain places as 'empty' or 'wasted' space. Consequently, despite the fact that 'empty' and 'wasted' space is almost always teeming with life, human, animal, botanical, Cold War engineers have come here to look for places to put waste and to place testing sites.... The federal government labeled some land uninhabitable and turned both [Nevada and Alamogordo] to what the government perceived as its highest utilitarian use. The desert land, its flora, its fauna, and its human inhabitants have been sacrificed so that the federal government could test its weapons" (Montoya 1998, 24).

And, as recently as 2004, the British author Gerard J. DeGroot summarized Nevada's suitability for hosting nuclear events: "The bleak, hostile seemingly endless desert seems suitable for no other purpose than dumping loathsome waste or blowing up bombs" (DeGroot 2004, 26). Both DeGroot's use of the word hostile and Said's example of land termed brittle are aesthetic judgments that have produced and endorsed the idea of suitability.

To add support to the idea that suitability does not exist a priori, but is, in fact, produced, I turn to a DOE map of the NTS which shows 1,375 square miles divided into 30 more or less rectangular areas, or grids. (Figure 1.1)

The DOE map is by itself rhetorical, arguing for the suitability of the land for testing weapons. It draws a conclusion about the history and usage of a singular piece of ground, one that is, after all, not unlike the rest of the land around it. The map suggests that the site is not only suitable for testing bombs, but that the nuclear action that has taken place there was (and still is) contained, managed and controlled. Points are labeled "Central Support Facilities," "Test Cell A," "Control Point," and "Area Two Support." The place names are military, organizational, and institutional. The grids are squared off neatly at the corners and labeled with numbers one through thirty. Conversely, roads through the site (which were carved around topographical features, not laid out on graph paper) look like a ball of string unwound by an excited cat. All in all, the map communicates that order has been superimposed on the chaos of nature—order essential to managing and justifying the land use. In simple terms, the map creates a landscape suitable for nuclear testing.

Interestingly enough, if we compare the DOE map of the NTS to maps of the same area drawn up before it was designated a nuclear proving ground we can see

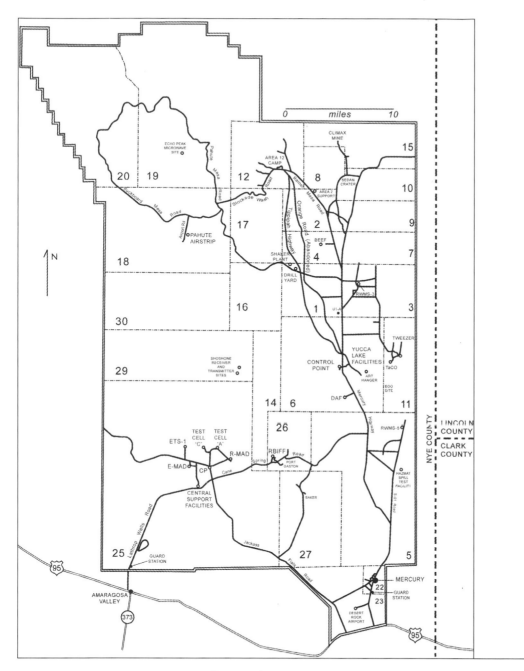

Figure 1.1 **An intensive grid overlay, dividing the Nevada Test Site into sections, is evident on this map dating from years past. Redrafted by Irene Seelye, from a copy held in archives of the U. S. Department of Energy.**

how maps produce the territory and interpret its history. Maps are cultural; maps are political; maps reveal a piece of the mind of the mapmaker.

Road maps produced of this same area, in the 1940s, depict quite a different place. The mountains are named (Skull, Massachusetts, Banded, Shoshone), as are the hills (Calico), the canyons (Cat, Fortymile), and the natural springs (White Rock, Cane, Topopah, Oak). These place names impart character (Banded, White Rock, Calico), natural beauty (Oak), even mystery (Skull, Cat), and honor both the Native American (Topopah, Shoshone) and the pioneer (Fortymile) heritage of the region. On these early road maps the area looks similar to most of southern Nevada—not yet segregated and dismembered and even inviting to those who like to explore desert expanses, alkali flats, mountains, canyons, and springs.

In the early 1960s, a map of the newly designated atomic proving grounds was drawn by Frederick C. Worman, a biologist and anthropologist working for the Los Alamos Scientific Laboratory. He was asked by the Atomic Energy Commission (AEC) to conduct a base biological and archaeological survey of the area, and to map its flora, fauna, and artifacts. The resulting hand-drawn map shows natural features found on the 1940s road maps and natural springs used by Native Americans. Most charming is the rich descriptive text he wrote to accompany the map. "Nevada," he writes, "is a land of violent beauty; a land of thrusts and folds and block-faulted mountains; a land of heat and cold; and of deserts and snow-capped mountains" (Worman 1965).

Of the desert flowers blooming on the site, he wrote: "To view the blooming desert during a wet period is to see it at its most magnificent moment. One looks out upon a myriad of flowers designed to move the amateur taxonomist to complete ecstasy which may be followed by complete despair when an attempt is made to classify them all." Of the multifarious desert creatures, he wrote: "Unfortunately, too many people think of the desert as an immense wasteland of drifting sands, populated by centipedes, scorpions, awesome spiders and reptiles—all dangerous and deadly. The few venomous forms are actually shy and retiring...." Worman maps his territory as benign and beautiful, a land with history and heart.

Science writer Scott L. Montgomery uses maps of the moon produced over many centuries to explore the cultural and political biases of mapmakers. One map was designed by William Gilbert in the 1590s, as England was subduing the lands that would form her colonial empire. On it, Gilbert labeled the light areas of the moon "water" and the dark areas "land." One of the island portions of the moon is named

"The Map is Not the Territory, and the Name is Not the Thing Named.... This principle, made famous by Alfred Korzybski, strikes at many levels.... Above all, the relation between the report and that mysterious thing reported tends to have the nature of a classification, as assignment of the thing to a class. Naming is always classifying, and mapping is essentially the same as naming" (Bateson 1979, 30).

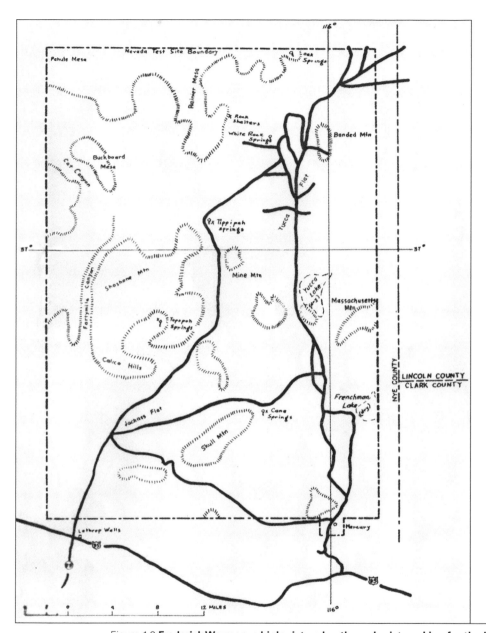

Figure 1.2 **Frederick Worman, a biologist and anthropologist working for the Los Alamos Scientific Laboratory, Los Alamos, New Mexico, was commissioned by the Atomic Energy Commission to map natural features on the Nevada Test Site. This drawing, although of an earlier unknown date, was published in 1965. Courtesy of Los Alamos National Laboratory Archives. Prepared for publication by Megan Berner.**

Brittania. The name "Brittania," observes Montgomery, "planted a claim on the Moon and implied, historically, that England, the new naval power of Europe, might one day send ships of a different kind to these distant seas and lands." The moon becomes a domesticated (ripe for colonizing) land that might one day be England's, replete with lunar land forms that Gilbert named "Cape Bicke" and "Cape Longum" (Montgomery 1996, 212).

The DOE map of the NTS, like Gilbert's map of the moon, creates a colonized territory by transforming blank canvas into symbols and names that fix solidly, on paper, a history, ownership, and purpose. The land itself is a palimpsest, bearing inscriptions of successive cultures—Native American, explorer, naturalist, and, presently, nuclear.

Another Map

In 1995 a friend of mine living in Nevada attended a meeting of Yucca Mountain stakeholders, held in Washington, D.C. After the meeting ended, she toured the DOE office complex on C Street, a nine-story building composed of warren-like rooms connected by narrow hallways. "On the wall of every office I peered into," she observed, "was a large wall map of Nevada, with prominent markings identifying the N[evada] T[est] S[ite] and Yucca Mountain and not much else. The walls contained not one map of Washington, where I stood, but maps of Nevada, my home, almost the width of a continent away. And, those were the only maps I saw." The DOE maps are versions of Marlow's map, hanging on the walls of the powerful, with suitable land use indicated by labels and markings inked inside the outline of the state.

Alamogordo ·

The entire history of locating U.S. atomic proving grounds is replete with the rationale and rhetoric of nuclear colonialism as I have described it. Although accomplished early in the nation's atomic history, the selection of Alamogordo, New Mexico, as the site for the first atomic test, fashioned a template that exposed the hypocrisy of claiming that only sound science ruled the decision-making. Site suitability criteria based on the science of meteorology were in fact clearly developed, but, in application, the safety criteria were gradually modified, or even ignored, due to pressures from competing political, logistical, economic, or aesthetic concerns.

The testing of the Trinity atomic device was the culmination of several years of concentrated effort by Manhattan Project scientists and engineers living in Los Alamos, New Mexico. The Manhattan Project, established to develop an atomic weapon, was blessed with brilliant leadership, even genius, in its two directors—General Leslie Groves, the military director, and Dr. Robert Oppenheimer, the scientific director. The team worked, step by careful step, to develop an atomic weapon, moving from equation to model to explosion.

In the late spring of 1945, the time was ripe for turning model into test. The design was logical, but it employed new theories and complex mathematics that had not been borne out in a full-blown experiment. Working on a schedule squeezed by the loss of American lives in the European and Asian theaters of World War II, and quickened by the threat of the certain tyranny of a victorious Nazi regime, Manhattan Project administrators launched a search for a suitable site for testing the theoretical new weapon. Groves was at first opposed to testing the bomb, calling it a waste of plutonium and a "shameful exhibition should it fail" (PB Hales 1997, 301). Once convinced that testing the bomb had merit, he laid out his view of a scientifically sound site in advance of visiting any potential testing location. Such a site, Groves dictated, should be far from population centers, flat, close enough to Los Alamos to facilitate

the transport of men and materials from the lab to test site, and, most importantly, it should meet the meteorological standards established for limiting dispersal of radioactive debris. Groves and his research teams poured over maps and scouted much of the western United States from the windows of a Beechcraft C-45 airplane, to identify sites that might comply.

Isolated does not necessarily mean inhospitable or barren, but we are told by Peter Bacon Hales that Groves and his staff scanned the West for "vast hostile zones, places already inhospitable, already lit by a harsh and unrelenting light, already written out of the mythology of redemption" (302). It's as if the word "suitable" was already associated in Groves' mind with western wastelands, as he judged them.

General Groves is described in Richard Rhodes' monumental work *The Making of the Atomic Bomb* as "one inch short of six feet tall, jowly, with curly chestnut hair, blue eyes, a sparse mustache and sufficient girth to balloon over his webbing belt above and below its brass military buckle" (Rhodes 1986, 425). His personality was summed up by one acquaintance as "[a] tremendous lone wolf," and by another as "the biggest sonovabitch I've ever met in my life, but also one of the most capable individuals.... He had absolute confidence in his decisions and he was absolutely ruthless in how he approached a problem to get it done" (426).

Eight sites were nominated for Groves' review. Let's turn back the pages of history to view General Groves as he reacts to one of the nominated sites—a desert training area near Rice, California, that appeared to possess the desired characteristics: flat, accessible to Los Alamos, and isolated enough to provide security for the project at hand. Groves was told that General George Patton had been using the Rice area as a training ground for his Africa Corps troops. Like a peevish lover outwitted by a rival, he refused to even examine the suitability data gathered to support the California site. "Patton," fumed Groves, is "the most disagreeable man I ever met" (Szasz 1984, 28). That ended the nomination.

One site after another was de-listed rather than selected by applying the established safety and security criteria. Elimination trumped election. Hales tells us that sites next to Indian reservations were ruled out when Harold Ickes, Roosevelt's Secretary of the Interior, decreed that no Indians should be displaced because of the test. Sites next to Mormon settlements and ranches were ruled out because Mormons "were too politically savvy, too resistant, too powerful" (PB Hales 1997, 302).

Finally, one nominated site remained. Lying within the boundaries of the White

Sands Air Base near Alamogordo, New Mexico, it was large, barren, and dispossessed of conventional beauty. Prophetically, the site bore the name Jornada del Muerto (Journey of Death or Road of the Dead Man).

The fact that Jornada del Muerto was already under government control further raised its value in this peculiar treasure hunt. According to Ferenc M. Szasz: "One reason General Groves approved the Jornada for the test was that most of the land was already in the hands of the federal government in a leasing arrangement" (Szasz 1984, 28). But which part of the valley would most safely serve to test the unknown power of what the project team had nicknamed the "gadget" or, more affectionately, Jumbo? Meteorological criteria had been clearly established by Groves' group. Trinity test director, Kenneth Bainbridge, wanted to use the southwest corner of the Jornada, an area which he thought the safest because of the prevailing wind patterns. However, politics and expediency entered into the decision-making process. The base commander, Colonel Roscoe Wriston, did not want to hand over the southwest corner, so Bainbridge eventually agreed to use a block of land on the northwest corner, where wind patterns were thought not to be as favorable for the test. Indeed, weather data for the northwest region was almost nonexistent. However, to balance the dearth of information, there was no political opposition to the use of the northwest region (Szasz 1984, 31). The site selection for the Trinity test was finally finished.

The Marshall Islands

The next nuclear test site selection for the United States took place in 1946, after the gadget had been tested at Alamogordo and used in Japan. As the world adjusted to new hegemons, the U.S. military called for further testing of the weapon that had won the war.

Both Congress and President Harry Truman knew that atomic research and testing called for extraordinary planning. But no one could say with certainty what those plans should be.

In the halls of the U.S. Congress, atomic issues affecting the fate of the planet were debated. Should the U.S. share atomic secrets with other nations? Should an international governing body be established to manage the new weapon? If control and management of the bomb remained in American hands, should those hands be civilian or military?

The Atomic Energy Act of 1946 settled these matters, with Congress opting for national rather than international control, and civilian rather than military management. The Atomic Energy Commission (AEC) was created and charged with the immense task of developing, testing, and safeguarding atomic weapons. Then, the debate shifted to staffing the new commission. Who should serve as members? Who could effectively chair a body charged with so many vital tasks?

Following lengthy congressional hearings, David Lilienthal, former head of the Tennessee Valley Authority, was confirmed as the first chairman of the AEC. During initial AEC meetings, high on the list of pressing questions was whether or not the bomb could be safely tested within the borders of the United States. The members of the AEC concluded that the prospects of doing so did not look promising. Horrifying images of the atomic destruction at Hiroshima and Nagasaki—bodies vaporized into shadow and homes and offices charred to ashes—had become haunting motifs of many an American nightmare. Americans were traumatized, shell-shocked, and far from ready to accept testing an atomic bomb on their own soil. Despite this gloomy assessment, Lilienthal assigned the Army Special Weapons Project the task of searching for a suitable place for testing the atomic bomb within the U.S., should the need arise. The search was given the code name Project Nutmeg.

The military, even before the Atomic Energy Act had been signed, proceeded with its own plans to test the atomic bomb in the South Pacific. During the same month that the act was passed in Congress, July 1946, Operation Crossroads began a series of two atomic tests named Able and Baker, in the Marshall Islands. This location was chosen for a number of reasons. As with the Alamogordo site, de-selection was step number one: sites within the continental United States were cast from the selection pool.

On the whole, the Marshall Islands were politically and logistically appealing. They were under U.S. control, solving potential legal problems of land ownership and land withdrawal. And, situated as they are, in the middle of the Pacific Ocean, far from American homes, their selection was unlikely to stir anxiety in most Americans. Furthermore, Bikini, an atoll in the Marshall Islands, possessed a sweeping wide lagoon suitable for anchoring U.S. ships and barges. And Bikini was close to Kwajalein, an atoll already in use as a military base.

Because I'm arguing that a nuclear site selection template had already been fashioned, it's important to concede that the nation's first two proving grounds were odd atomic bedfellows, exhibiting almost no common environmental or demographic

characteristics. The Marshall Islands are rainy and tropical, while Alamogordo is an arid desert. The Marshalls are inhabited by Micronesian natives, while the Trinity site in New Mexico, at the time of the test, was inhabited by American ranchers and sheepherders. The Marshall Islands were (and still are) held as a United Nations trust territory administered by the United States, unlike the state of New Mexico. Nevertheless, the two sites did share other social and political characteristics that ultimately figured into the site selection. Both were inhabited by people vulnerable to authority because of their physical isolation and poor economic status. Neither area was politically well organized or governed by influential leaders who might create public relations difficulties for the testing program. They were chosen in part because these sites did not possess vast private landholdings, urban centers, sophisticated political leadership, and well-developed economies.

More Like Us Than Mice

Colonial stereotypes (or the view of the other) enhanced the practical suitability of the Marshall Islands. The Micronesians, at the time of site selection, subsisted on what nature provided: coconuts, taro, and the harvests of the ocean. With their Marshallese language and their native dress, they matched a traditional colonial view of the exotic. In a government public relations film, the Marshallese were introduced to American audiences by a member of the military as "a nomadic group" who are "well pleased that the yanks are going to add a little variety to their lives" (Rafferty, Loader, and Rafferty 1982). One American official characterized the islanders this way: "While it is true that these people do not live, I would say, the way Westerners do, like civilized people, it is nevertheless true that they are more like us than mice" (IPPNW and IEER 1991, 82).

Even so, meteorological safety criteria were outlined by the military in promising ways, as in the Trinity site search. A 1946 radiological safety report detailed three meteorological conditions necessary to safely test atomic weapons at the islands. One, there should be a reasonable frequency of cloud or weather conditions that should meet the operational requirements for the experiment; two, the wind conditions from the surface to stratospheric levels should be such that there can be no possibility of subjecting personnel to radiological hazards, or surrounding land or water area to unintentional radioactive contamination; and three, the mechanism of meteorological

processes for the site should be adequately understood and the weather predictions for the site demonstrated to be of a high and reliable accuracy (72).

Yet even before testing had begun, the U.S. Army Chief of Staff gave an opinion of how well the site met the stated conditions for suitability: "The Marshall Islands in the main do not meet these meteorological requirements" (72).

A report issued in 1991, called *Radioactive Heaven and Earth*, adds weight to the claim that stated suitability criteria may have been placed on paper but were largely ignored when other Island attributes became more attractive. "The Marshall Islands were selected because of the fear with which the U.S. public regarded nuclear weapons and ... because of U.S. government control of the territory.... In the selection of the Marshall Islands, as with the choice of a continental test site, public health considerations were disregarded in favor of other advantages" (72).

If expediency and colonial perceptions helped justify the selection of the Marshall Islands, an appeal to patriotism and God helped implant it. Establishing a link between supporting nuclear testing and patriotism is a rhetorical strategy that continues in nuclear politics to this day.

Preceding test Able at Bikini Atoll, the American military governor of the Islands told Chief Juda Kessibuki that it would help the U.S. if the chief would agree to allow the island to be used for nuclear testing. It was "God's wish," he claimed. The governor referred to Old Testament teachings, implanting the splendid simile that the Marshallese were like the children of Israel whom God had led into the Promised Land. The new weapon tested on their island would bring heaven's blessings upon them. Chief Juda responded with a gallantry formed of equal parts of faith and subjugation, "If the United States government and the scientists of the world want to use our island and atoll for furthering development, which with God's blessing will result in kindness and benefit to all mankind, my people will be pleased to go elsewhere" (Rafferty, Loader, and Rafferty, 1982).

And so they went. In advance of tests Able and Baker, they were evacuated by the military to the neighboring island Rongelap. In 1948 Operation Sandstone was conducted on nearby Enewetak Atoll. Chief Juda and his people were told that once the test series had been completed, they could return to Bikini. But their island and others close by were used for nuclear testing—66 tests in all—up until 1958. Although these tests were declared a success in terms of helping the military evaluate new weapons designs, a radiological safety officer observed, "From a Radiological Safety

On 12 January 2002, John Sununu, former governor of New Hampshire, serving as a lobbyist for the U.S. Chamber of Commerce, said in an interview with the *Las Vegas Review-Journal* that "If Nevada is not willing to do its part in what is part of a national plan for homeland security, maybe Americans ought to vacation somewhere else" (Berns 2002, B2).

standpoint, Enewetak Atoll has proven to be a far from satisfactory site for atomic tests" (IPPNW and IEER 1991, 72).

The effects of atomic testing in the Marshall Islands have been heartrending and ongoing for the displaced Bikinians. Without their large lagoon, customary methods of fishing yielded less than they needed to sustain an independent life, and without their indigenous palms and roots they were forced to depend on the canned and tinned rations provided by the Americans. In the 1952 Ivy testing series, another atoll within the archipelago, Elugelab, just disappeared. Left behind was a vast crater in the reef 1.6-kilometers long and 300-meters deep (O'Neill 1994, 136).

In 1954, eight years after Chief Juda evacuated his islanders, 15-megaton thermo-nuclear Bravo was detonated on the depopulated Bikini Atoll. The blast pulverized mil-lions of tons of coral, sucked up into the bomb's fireball, creating numberless particles of radioactive debris. The debris fell out over populated islands, exposing many Mar-shallese to enough fallout to produce radiation sickness. A Japanese tuna boat, the *Lucky Dragon*, was in the path of the fallout, and by the time the boat reached harbor in Tokyo, nearly every one of the 23 crewmen showed signs of radiation sickness. Images of Japanese dock workers unloading the radioactive tuna were broadcast around the world and international protests ensued. The bottom dropped out of the tuna market. Six months after the detonation, a crewmember of the *Lucky Dragon* died of radiation poisoning.

About 50 hours after the detonation of Bravo, the people on Rongelap, many of them already displaced Bikinians, were evacuated by the U.S. Navy to another atoll. About 24 hours after that, the people of Utirik were evacuated. Within two weeks of the test evacuees began losing hair, and medical teams found that they exhibited ab-normal blood counts, de-pigmented skin spots, and skin lesions.

The official response to reports of fallout effects incorporated another long-lived nuclear promotional phrase. Throughout the nuclear testing years, and into the pres-ent, the phrase "no one was injured" has appeared in public relations statements in multiple incarnations, like a shape-shifter. A common variation of the phrase is "only one person was injured," followed by some scenario where the injured person was silly, or careless, and supposedly not injured as a result of unplanned fallout or an unexpected testing accident. AEC Chairman Lewis Strauss gave the trope a distinct shape following the Bravo debacle. "None of the 28 weather personnel have burns. The 236 natives also appear to me to be well and happy. The exceptions were two

On 1 July 1946, as fashion designer Louis Reard was putting the finishing touches on a new and daringly bare swimsuit design, radio announcers around the world proclaimed that Operation Crossroads had commenced at the Bikini Atoll. With a flash of marketing inspiration, Reard seized the moment and christened his new swimsuit the "Bikini."

sick cases among them, one an aged man in advanced states of diabetes, the other a very old woman with crippling arthritis. Neither of these cases have any connection with the tests" (36).

In 1972, when Bikini was finally returned to its people, it was a waste dump. On the once clean beaches of the small atoll were strewn boxes, mattresses, life belts, tires, boots, bottles, broken-up landing craft, rusting machinery, oil drums, broken concrete, cranes, and steel towers. Or, as David Bradley suggested in *No Place to Hide*, "all the crud and corruption of civilization spread out on the sands, and smeared over with inches of tar and oil" (1948, 44). One Bikini native, tears in his eyes, turned to a government civilian and asked, "What have you done to us?" (Taylor 1995, 157). The soil remained so contaminated that in 1978, when internal doses of radiation were measured in the islanders, they were once again asked to evacuate. Presently, no vegetation grown on the island can be consumed because of omnipresent cesium-137, a radioactive byproduct of atomic testing.

A solution to the island's radioactive contamination has proven elusive. Conflicts remain in place between natives' points of view and those of American administrators. The exiled Bikini community prefers a complete removal of the topsoil to rid the island of the cesium-137. However, such a radical cleanup procedure would at the same time transform Bikini into another kind of wasteland, one of wind-swept sand. Many American scientists who have visited the island favor a plan to spread potassium fertilizer over the entire island, because potassium, similar to cesium in atomic structure, will theoretically block food crops from uptake of the radioactive cesium. A compromise position is to scrape the lagoon side of Bikini and use potassium fertilizer on the remaining land areas. Even with the implementation of these measures, the radiation releases would not meet the Environmental Protection Agency's Superfund radiology cleanup regulations. In any case, suspicion, fear, and anger fed by the memories of disingenuous promotional rhetoric and un-kept promises lie deeper than the topsoil.

To date, the people of Bikini live in exile, carrying with them the memories of their white-salt sea beaches and the old ways before the bomb. They make periodic ceremonial returns to their homeland, performing rituals of sympathetic magic that grant hope, a pattern and despair, some relief. But memory will soon give way to legend, legend to myth. What form will it take? Fire in the sky? Death in the rain? Eden forever lost? Poet Lore Kessibuki, one of the tribal leaders during the Bikini exodus, said in a 1987 interview, "Bikini is like a relative to us: like a father or a mother or a sister or a

Hugh Gusterson reports in the *Bulletin of the Atomic Scientists:* "The National Cancer Institute has predicted a 9% increase in cancers; yet the Marshallese, for all the promises of United States aid, still lack the necessary medical infrastructure—oncologists, screening programs, chemotherapy treatment centers—to deal with the disaster" (Gusterson 2007).

brother, perhaps most like a child conceived from our own flesh and blood. And then, to us, that child was gone.... Buried and dead" (Interviews with Bikinian Elders). Kessibuki's words poignantly echo those of E. B. White, in his *New Yorker* essay written on the eve of Operation Crossroads in 1946: "Bikini lagoon, although we have never seen it, begins to seem like the one place in all the world we cannot spare; it grows increasingly valuable in our eyes—the lagoon, the low-lying atoll, the steady wind from the east, the palms in the wind, the quiet natives who live without violence. It all seems unspeakably precious, like a lovely child stricken with a fatal disease" (Boyer 1985, 82).

E. B. White's word map of Bikini is strikingly different from the descriptions employed by the military organizers of a place suitable for testing atomic weapons.

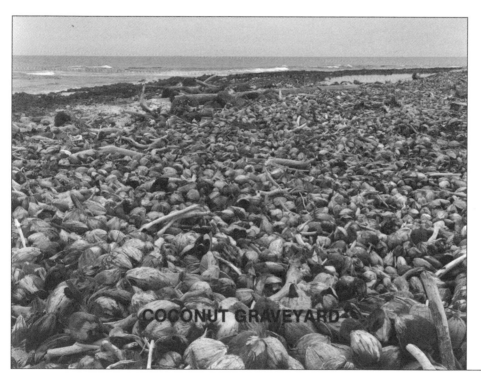

Figure 2.1 **"Coconut Graveyard." Contaminated radioactive coconuts on Bikini Island. Photograph courtesy of Peter Goin.**

PROJECT NUTMEG
Three

Backyard Testing

Following the 1946 Operation Crossroads and the 1948 Operation Sandstone tests, a series of political and logistical crises arose that, when added to the weather pattern setbacks, strengthened arguments for locating atomic proving grounds within the continental borders of the United States. The nuclear site-selection template was applied once more.

The first of the crises arrived in 1946, when the Soviets made several aggressive moves, closing off rail, water, and highway access to East Berlin and seizing power in Czechoslovakia. Then, in September 1949, came the biggest blow of all: a discovery that AEC Chairman David Lilienthal referred to in his diary as "what we'd feared since January 1946" (Halberstam 1993, 26). Fission particles appeared in a routine analysis of filters carried by American reconnaissance planes, most certainly fallout from the detonation of a Soviet atom bomb. President Truman reluctantly announced the unwelcome news to the public.

U.S. military strategists pounced on the Soviet test, claiming it to be evidence of American laxity. General Curtis LeMay lamented the fact that gone forever was the era "when we might have destroyed Russia completely and not even skinned our elbows in doing it" (26).

As the shock of the Russian test was slowly absorbed into the American psyche, more upsetting news followed, this time from Korea, where the North Korean People's Army, trained and supported by the Soviet Union, crashed through the 38th parallel in June, 1950. The People's Army pushed south across the demarcation zone, forcing back General Douglas MacArthur's American troops and a ragtag South Korean army, across icy ground and solidified night soil (human feces spread across the fields as fertilizer). The retreat was an ignominious one, played out on the movie screens of the world in grainy black and white newsreel film. Truman reassured his nation that we would save face by taking any necessary steps to reverse the retreat. On November 30, at a White House press conference, a reporter asked Truman if he was including

in those steps the use of the atom bomb. "That includes every weapon we have," replied Truman. Then the reporter asked, "Does that mean that there has been active consideration of the use of the atomic bomb?" To which the President replied, "There has always been active consideration of its use" (109).

There followed an outbreak of atomic fever. MacArthur requested 34 atomic bombs to use against the Chinese Communists, who were streaming into Korea to attack the American lines. He considered "sowing a belt of radioactive cobalt to interdict further Chinese advances" (Kennedy 2000, 16). Senator Henry Jackson, a member of the Joint Committee on Atomic Energy, took to the floor of the Senate calling for an "all out" atomic effort to produce weapons "by the thousands and tens of thousands." He challenged his fellow legislators: "I cannot … imagine any member of this House going before his constituents and saying that he is not in favor of making every single atomic weapon it is within our power to produce" (Lapp 1968, 52).

Speaking in the same congressional session, Senator Brien McMahon, who once voiced the opinion that the bombing of Hiroshima was the greatest event in world history since the birth of Jesus Christ, urged his fellows to fund "an atomic army and an atomic navy and an atomic air force." He called up images of "a sweeping variety of atomic weapons—one model that takes the place of a thousand bazookas, another that makes unnecessary a hundred depth charges, yet another that would substitute for TNT stacked as high as Pike's Peak" (Lapp 1968, 83–84). Bolstered by oration and appropriations, the military began to order atomic weapons "like mess kits and rifles" (Pringle and Spigelman 1981, 93).

Following all the ebullience, the atomic fever was dampened by cool and unwelcome actuality. The strategic atomic weapons McMahon and MacArthur so ardently visualized had yet to be developed, let alone tested for battlefield use. In Operation Crossroads and Operation Sandstone a total of only 5 bombs were detonated, each a cumbersome Fat Man design like the weapon used at Nagasaki. If the army's goal was to implement battlefield atomic weapons, more development, manufacture, and testing was clearly needed, lending urgency to the search for a continental test site.

Adding to this realistic assessment of weapons development were the vexing logistical problems presented by testing bombs at the Marshall Islands. Each test required the transportation, lodging, feeding, doctoring, barbering, and general maintenance of troops, technicians, politicians, scientists, cooks, doctors, barbers, and maintenance crews across thousands of miles of oceans for weeks on end. During

Operation Crossroads alone, 42,000 personnel were carried across the Pacific by 242 ships and 156 airplanes. Equipment needs included four television transmitters, 750 cameras, 5,000 pressure gauges, and 25,000 radiation recorders. Personnel consumed 70,000 candy bars, 40,000 pounds of meat, 89,000 pounds of vegetables, 4,000 pounds of coffee, and 38,000 pounds of fruit" (Hilgartner, Bell, and O'Connor 1983, 72). Key scientists at Los Alamos, reluctant to absent themselves from home for the lengthy periods of time necessary to test their weapons at the Marshall Islands, had long lobbied, privately, for a proving ground close to Los Alamos for testing relatively small devices.

In early 1950, these factors led to a revitalization of interest in the "Project Nutmeg Report," which had been submitted to Lilienthal's Atomic Energy Commission by the Army Special Weapons Project three years earlier. Within the AEC, reconsidering domestic testing was furthered along by a sense that the American preoccupation with atomic destruction could be lightened up by "educating the public that the bomb was not such a horrible thing that it required proof-testing 5,000 miles from the United States" (Fehner and Gosling 2000, 40).

"Project Nutmeg" lays out scientific site suitability and safety criteria against which we can measure the later unfolding of the site selection itself. As the below excerpt indicates, the report clearly identifies safety factors important to selecting a continental test site and specifically downplays the importance of political, security, and logistical aspects.

> This study will attempt to determine the physical feasibility of using test sites for nuclear explosions of atomic bombs within the continental United States. The solution of the problem of this study will be answers as to how, when, and where these tests can be conducted within the continental United States without physical or economic detriment to the population. The political, security, and logistical aspects of such tests will be dealt with only incidentally, if at all. (Project Nutmeg Report 1949, 2)

Much of "Project Nutmeg" is devoted to an analysis of fallout data collected at Alamogordo and the Marshall Islands. The authors acknowledged that following the Trinity test there was a heavy dumping of radioactive material at a distance of some "tens of miles northeast" of the site (9). Further to the east, in Rochester, New York, Eastman

Kodak reported that camera film had become exposed in storage. The paper used to pack the film was manufactured from straw grown in Indiana, and the report conceded the link between the radioactivity produced by Trinity and the contaminated straw and exposed film (3). Fallout patterns from the troposphere over the Marshall Islands, Hiroshima, and Nagasaki were analyzed, with the conclusion that "this fall-out has negligible concentration at the surface outside a radius of 600 miles from the test site" (42).

Two subsequent conclusions are somewhat surprising, as they seem unconnected to the rest of the report. The first is that the safety of any site chosen could be enhanced with surface preparation/engineering:

> Cleaning up the site of a nuclear explosion, i.e. preparing the surface and increasing the height of the tower will prevent the formation of a crater or the indraft of sand and soil and water into the rising column of hot gases. This will prevent in large measure the dumping action of large fragments near the site and will decrease the fall-out of intermediate size fragments within 600 miles of the site. (Project Nutmeg Report 1949, 46)

Despite the common sense nature of the recommendation, it was never seriously considered. Later, at the NTS, a few patches of desert near ground zero were paved with concrete. However, generally, for reasons of economics and tight testing schedules, the test site floor remained "un-engineered," and fireballs sucked up dirt and sand that eventually "fell out" as radioactive debris.

Equally remarkable and even more instrumental to the practical (as opposed to the theoretical) dynamics of the eventual site selection is a second conclusion: "The decision to hold future tests within the continent will devolve, not upon the physical feasibility of conducting the tests without harm, but upon the elements of public relations, public opinion, logistics and security" (46). With that pronouncement, the report had come full circle from disclaiming the role of politics or logistics to embracing both as necessary to successful nuclear site selection.

Oasis Dwellers

Two regions are mentioned in the report as potential safe areas for nuclear testing: "the marginal strands and islands of North Carolina, between Cape Hatteras and Cape Fear, which have summer colonies but are relatively uninhabited except in that season" (45), and a region of the areas of the West and Southwest having "no permanent population" (46).

Images of the American West and its people produced stereotypes of emptiness and wasteland. Nuclear colonialism is at its discursive best, clothed as a feasibility study: "In the West, population distribution is of the oasis type, dependent upon a water supply" (44). There are "areas covering thousands of square miles having no permanent population" (45). In particular, there is an extended area in the Great Basin "having a density of less than two people per square mile, only broken by islands of [population] density clustered around mining and irrigated areas" (44).

Islands of density? An oasis-type population distribution? Mirages shimmer in the mind's eye: cowboy sheiks clustered around watering holes, famished miners struggling across desert sands, nomads. And, the report concludes, "It has now been determined that sites can be chosen in the arid west … in perfect safety" (50).

As the Korean state of affairs worsened, David Lilienthal's commission, with "Project Nutmeg" to guide them, stepped up the search for a continental test site. By the early months of 1950, five potential test sites had been nominated, three located in arid Western deserts in or bordering Nevada (The Problem 1950).

During a 13 December 1950 meeting, the AEC made its choice from the slate of five. On 18 December 1950, President Truman signed a top secret memorandum designating the Las Vegas–Tonopah Gunnery Range as the nation's continental atomic test site. By the end of January 1951, atomic bombs were bursting over the Nevada desert.

How and why the Las Vegas site eclipsed the Alamogordo–White Sands site remains cloudy. Outdated census data certainly played some role. A document that I call "The Problem," for lack of a clearer way to identify it, details populations within a 125-mile radius of each proposed site, using 1940 census data. According to the census, 4,100 people lived within the 125-mile radius of Las Vegas–Tonopah (The Problem 1950). By 1950, the year in which the decision to use the region for testing was made, the population of the city of Las Vegas had reached almost 25,000.

In the order of their initial listing, the nominated sites were: 1) Alamogordo–White Sands Guided Missile Range, New Mexico (Trinity Site); 2) Dugway Proving Ground–Wendover Bombing Range, Utah; 3) Las Vegas–Tonopah Gunnery Range, Nevada; 4) Area in west–central Nevada, about 50 miles wide and extending from Fallon to Eureka (including the area used later to detonate Project Shoal); 5) Pamlico–Sound/Camp Lejune area, North Carolina

It is clear that politics entered into the eventual de-selection of the Alamogordo site from the list. The Los Alamos Scientific Laboratory staff had at first endorsed the use of the Alamogordo site, voicing their need for that "backyard" site. The "Project Nutmeg" report specifically characterized New Mexico as a state "conditioned to nuclear work; and with easy logistics from the center of atomic bomb storage at Sandia" (51). As late in the site selection process as October 1950, minutes of an AEC meeting reveal that the committee was leaning toward the selection of the Alamogordo site: "A geographical location as close as possible to the Los Alamos [Scientific] Laboratory, to enable accelerating the pace of the weapons development program is obviously a characteristic of such desirability that it could outweigh partial deficiencies in other respects" (The Problem 1950).

The military, as well as the scientists, appear to have favored the Alamogordo site over the Nevada site. A memorandum submitted for the record on 17 July 1950, by Colonel Schlatter, United States Air Force, Division of Military Applications, states that "Lt. Colonel Harris favors White Sands" and that "all sites appear to have both

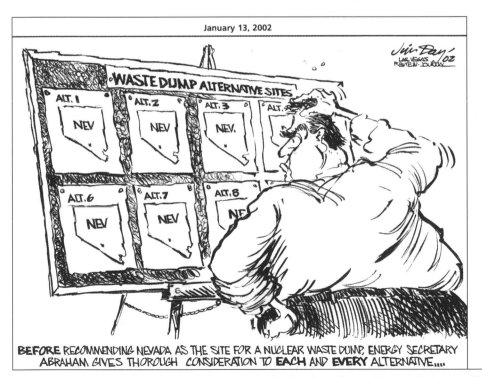

Figure 3.1 **By Jim Day from *Screw Nevada!: A Cartoon Chronicle of the Yucca Mountain Nuke Dump Controversy*, 2002, © Stephens Press, LLC.**

advantages and disadvantages which, when balanced out, indicate that perhaps the best basis for selection would be the standard, business approach of logistics and utilities. White Sands certainly enjoys an edge over other sites on the basis of proximity to Los Alamos" (Schlatter 1950, v-2).

Then, an eleventh-hour memorandum submitted from scientists at Los Alamos suggested that proximity to the lab may have become a personal and political issue, tipping the scales in favor of the Las Vegas site over Alamogordo. A document entitled "Desirability of an Area in the Las Vegas Bombing Range to be Used as a Continental Proving Ground for Atomic Weapons" was issued by the Los Alamos J–Division Laboratory on 22 November 1950, and a copy was attached to the minutes of the 13 December 1950 meeting. The minutes summarize the attachment as referring to radiological problems in New Mexico following the Trinity test (AEC 1950).

Shifting Desert Sands and Rada-calves

Without a doubt, the Los Alamos community gradually gained access to classified Trinity fallout information. Following the Trinity test, the chief of radiological safety for the Manhattan Project, Stafford Warren, advised General Groves that "significant" fallout had been discovered 200 miles from the explosion. Further information on fallout became available to Los Alamos scientists when Louis Hempelmann of the Los Alamos Health Division made several trips to Alamogordo to inspect livestock affected by radiation. In particular, cattle grazing close to ground zero had lost large clumps of hair. The "rada-calves," as the press called them, were eventually brought to Los Alamos for an up-close and highly classified study.

Los Alamos scientists were privy to a top-secret ecological study of the Trinity site conducted by the University of California, Los Angeles (UCLA) in 1948, 1949, and 1950. Following the test, blowing sands, a phenomenon common in the area, failed to respect fences and boundaries. Plutonium was discovered to have migrated to soil and plants as far as 85 miles outside the fenced-in Trinity area. Historian Ferenc M. Szasz states that after a series of heavy storms descended on the Trinity site, in 1950, UCLA laboratory chief Albert W. Bellamy exclaimed, "The entire valley—some 3,000,000 acres—is on the move" (Szasz 1984, 138).

Logistics figured into the Nevada site decision in several ways. The fact that

immediately to the south of the bombing and gunnery range was the government-owned Indian Springs airfield, with 6,600 feet of runway and housing for 300 to 500 people, helped sway the decision makers.

And, as in the case of Alamogordo, there was disagreement over which part of the Nevada site should be used for testing the bombs. The so-called North Site was situated in a basin known as Cactus Flat, which left Las Vegas outside the 125-mile radius that had been defined as a radiologically safe region for 25-kiloton tests. (The "Project Nutmeg Report," remember, acknowledged fallout within a 600–mile radius of the Marshall Islands test site and revealed that significant fallout had been measured 200 miles from the Trinity test site). The South Site consisted of Yucca Flat and Frenchman Flat, and was much closer to the facilities at Indian Springs. However, Las Vegas fell well within the 125-mile radius; Frenchman Flat is only 65 miles from Las Vegas city hall.

The eventual selection of the South Site came with conditions attached—almost an admission of its imperfections. Meteorologists were asked to pick the "safe" shot days, when wind direction was favorable. However, even on the best of days there would be measurable offsite fallout. The euphemism "emergency tolerance dose" was crafted for discussing exposures that exceeded the official limits. The public would be warned to stay indoors and take showers when optimal meteorological conditions did not materialize as predicted. Openly discussed was the "probability that people will receive perhaps a little more radiation than medical authorities say is absolutely safe" (Fehner and Gosling 2000, 46).

A few years after the selection of the Nevada site, the musical L'il Abner, based loosely on Al Capp's comic strip of the same name, was produced in New York. The curtain rose to Senator Jack S. Phogbound singing lyrics to the effect that the atomic bomb tests near Las Vegas would ruin his gambling empire there. As the plot developed, the government began searching for a truly worthless place to relocate the tests. They picked, oh no, Dogpatch, calling it the "most unnecessary place in the whole U.S.A." Of course, L'il Abner, Daisy Mae, and the rest successfully headed off the government at the pass. The bomb tests, much to everyone's relief, remained exactly where they belonged, in the deserts of Nevada.

My interpretation of the choice of the Nevada site as the nation's atomic proving grounds is not meant to suggest that either Alamogordo or North Carolina (or Dogpatch, for that matter) should have been chosen instead. Any site selected would

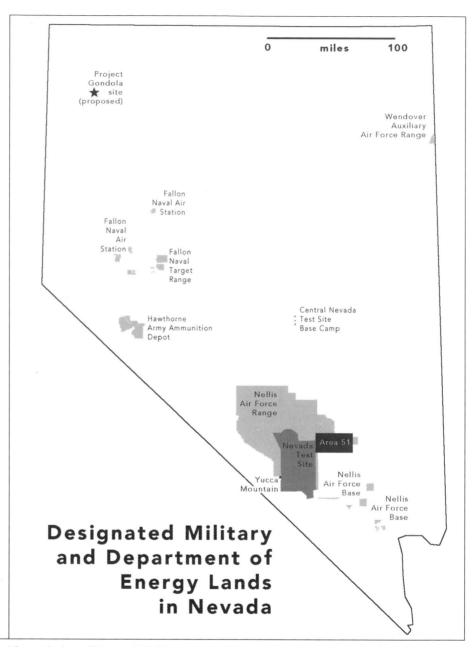

Designated Military and Department of Energy Lands in Nevada

Figure 3.2 **Lands reserved for exclusive military or U.S. Department of Energy use appear across much of the state of Nevada. Far larger areas are overflown or utilized in military maneuvers, or were fingered in the 1990s and 2000s as sites where nuclear waste-carrying trains or trucks would cross the landscape. The Nevada Test Site, the Central Nevada Test Site, and Yucca Mountain are identified. Courtesy of the Department of Geography, University of Nevada, Reno.**

have placed adjacent populations in jeopardy, as Los Alamos scientists and the AEC were learning. The real point is that the "Project Nutmeg Report" claimed the legitimacy of sound science and specifically excluded the role of politics, logistics, and all factors other than safety. In the end, however, the site nomination relied on unproven hypotheses about engineering sites and "safe" fallout zones, and revealed geopolitical and aesthetic biases. Ultimately, Nevada was selected by agency representatives who did not live in the state and who held the secret knowledge that people living there would receive a little more radiation than medical authorities said was absolutely safe.

Global Sites

Little is known about North Korea's nuclear test site, but other foreign nuclear nations, including Great Britain, France, China, India, Pakistan, and the Soviet Union have all selected proving grounds whose locations suggest that the same external factors are at work there as in the United States. These sites are hearts of darkness on a global map with politically insignificant populations and, in conventional eyes, un-lovely landscape features. The 1991 report on the health and environmental effects of nuclear weapons testing has this to say about the demographics of the world's nuclear test sites: "The nuclear weapons powers have tended to visit the worst health and environmental ravages of testing upon rural, minority, and colonized populations by their choice of test sites" (IPPNW and IEER 1991, 170).

For former empires, like Great Britain and France, their colonies—in the most literal, traditional sense of the term—were deemed suitable locations. Great Britain, which tested nuclear weapons in Australia, characterized both Emu and Maralinga—the atomic proving grounds in the Australian interior—as "unused wastelands." Historian Gerard J. DeGroot extends this point by saying that "since the tests were conducted hundreds of miles from population centers, little consideration was given to the appropriate weather conditions in which to conduct them, and because fallout was expected to dissipate over land populated by Aborigines, concern was low. Warning signs were printed in English, which many Aborigines could not read" (DeGroot 2005, 243).

In 1957, when Los Alamos weapons designers visited the Maralinga site as advisers to the British counterpart of the American Atomic Energy Commission, they bought boomerangs and Woomera spears from the Aborigines, who had lived in the so-called unpopulated wastelands and unused landscape for hundreds of years.

Apparently, the designers were not aware of any irony in purchasing souvenirs from people who were invisible. One member of the Los Alamos team, John Shelton, in his *Memoirs of a Nuclear Weaponeer*, tells about congratulating British engineers on leaving a nuclear device half in and half out of the earth during the British Buffalo test at Maralinga. "I am glad you have the device half in and half out.... [That will] provide better conditions for cratering" (Shelton 1996, 7/57). Shelton did not mention that the desired conditions for cratering increased the potential for radioactive fallout over Aboriginal land and people, as opposed to burying the weapon more deeply in the ground.

France tested atomic bombs in the deserts of Algeria, during the time it remained their colony, and later on the French-owned Pacific islands of Polynesia. In China at least 45 nuclear devices have been tested on the isolated Takla Maken desert near Lop Nor, Xinjiang Province, populated by the impoverished minority Uigher people. The Soviets used Semipalatinsk, Kazakhstan, as their primary test site, a poor region compared to the rest of the (then) nation. A total of 456 tests were conducted there. Two islands off the north coast of Siberia were used for many of the megaton Russian tests, including the largest test ever conducted anywhere—a thermonuclear explosion yielding 60 megatons. Russia conducted non-military, nuclear earth moving experiments at over 100 sites, most of them in or close to Siberia or Kazakhstan.

The 1998 Indian tests were conducted in Rajasthan, a desert region near the (downwind) Pakistani border. Predictably, the landscape is arid and the people economically deprived and politically irrelevant. "There is a sense of isolation in Rajasthan," writes Mary Anne Weaver, "which stems perhaps from its desert fastness" (Weaver 2000, 50). In Rajasthan, only 28 percent of the population has finished the eighth grade, and the per capita Gross National Product is less than half that of the rest of India. Photographs, released shortly after the detonations, show deserted villages adjacent to the site. Whether they were abandoned by consent or evacuated by government order is not clear.

Pakistan tests their nuclear bombs in Baluchistan, very near the downwind Afghanistan border. Radioactive particles released by nuclear testing in India and Pakistan follow a political trajectory: from India over less powerful Pakistan, and from Pakistan over an even less powerful Afghanistan.

Remote areas of the Pacific Ocean were used by both Britain and the United States for atmospheric testing, including Christmas Island and Malden Island. Malden Island is uninhabited, but Christmas Island was home to 300 Micronesians, who were

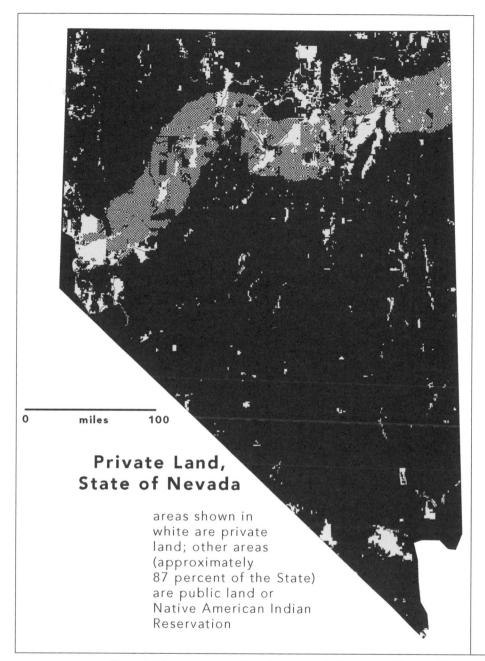

Figure 3.3 **A map showing the private lands in the state of Nevada. The areas in white are private while the rest of the lands (more than 87 per cent of the state) are public lands or Native American Indian Reservations. Notable is the Union Pacific Railroad checkerboard across Nevada. Courtesy of the Department of Geography, University of Nevada, Reno.**

taken offshore in British and U.S. military vessels to look homeward at the atomic fire-ball boiling up from their native soil.

The Malden and Christmas islands were chosen for testing in 1956, after Australia's enthusiasm for British nuclear testing in their homeland had cooled. At the time, the British launched a global search for a replacement test site. In a BBC documentary, Squadron Leader Roland Duck described the selection of the new site: "When we were first given the task of finding a site, we decided the nicest way and the easiest way was to find a vast expanse of water. The largest amount of water with the least land is the Pacific. So we took a large map of the Pacific and we really settled our finger and put it down rather like picking a winner and we got Christmas Island and Malden" (IPPNW and IEER 1991, 234). Duck was, I presume, using Marlow's map.

A-Bomb Test Able

Acontinental test site having been selected in December 1950, Nevada's atomic age rapidly advanced beyond the theoretical and into the practical. The same agencies that had produced images of the southern Nevada landscape as suitable for atomic testing now produced images of Nevada's populations as suitable for living next to atomic detonations. The depictions of Nevadans did not instantly materialize with the detonation of the first nuclear weapon. Rather, they were honed over time as journalists and AEC public relations officers experimented with effective ways to convince the rest of the nation that the choice of the Nevada proving ground was a sound one and that Nevadans made up perhaps the most suitable population in the nation for living next to the chthonic force of the atomic bomb.

In the wee hours of 27 January 1951, the first in a chain of events commenced, leading to Nevada's inaugural atomic weapons test, code named Able. Under the cloak of night, a nuclear capsule was transported from the Los Alamos Scientific Laboratory (now Los Alamos National Laboratory, or LANL) to a highly secure area of Kirtland Air Force Base, outside Albuquerque, New Mexico. At Kirtland a B-50D bomber idled while the Los Alamos capsule was coupled, on board, with an assembled nuclear device; the two units, when locked together, comprised an operational atomic bomb. The B-50D took off from the Kirtland airstrip, droned northwest over the Nevada border to the Las Vegas–Tonopah Gunnery Range (soon to be called the Nevada Test Site). After two practice runs over Frenchman Flat, at 5:36 a.m. the bomber released an operational weapon, which detonated in a fiery burst at 1,060 feet above ground. After a few seconds, there arose a pinkish mushroom cloud that drifted eastward. A series of echoes from the blast concussion seemed to drum the cloud out of Nevada and into Utah.

Even as the shock waves receded and the mushroom cloud blew east, secrecy gave way under a flare of light bright enough to wake up people in Los Angeles. The

public was, in an instant, sucked into a vortex of amazement, enchantment, fear, and pride—emotions that would be rekindled later that same year by the detonations of Baker, Easy, Baker-2, Fox, Sugar, and Uncle.

In the hushed aftermath of Able, members of the press took a collective deep breath and exhaled the unfiltered sensations of the moment. The resulting prose was delivered in a tone of wonder, well suited to the new vision, at once so diabolically dreadful and so exquisite and mystical. Reporters scribbled as the countdown began. They watched silently as the so-called Teller light (named after Los Alamos scientist Edward Teller) flickered, indicating in a microsecond that supercriticality had been achieved. Then, the bomb exploded, and the mushroom cloud ascended in livid hues of red, purple, pink, and orange. In their attempts to convey to their readers the frightening miracle they had just witnessed, reporters sought new metaphors to describe the union of the terrible and the sublime.

The resulting prose was often heightened with cosmic and theological imagery: creation/destruction, salvation/damnation, infinite purity or corruption incarnate. Gladwin Hill, reporting for the *New York Times*, described Easy, detonated in February 1951, as apocalyptic:

> Then suddenly the surrounding mountains and sky were brilliantly illuminated for a fraction of a second by a strange light that seemed almost mystical.
>
> It was strange because, unlike light from the sun, it did not appear to have any source but to come from everywhere. It flashed almost too quickly to see. Yet the image that persisted for a fraction of a second afterward in the eye was unforgettable.
>
> It was a gray-green light of infinite coldness, apparently completely devoid of any red tones. In its momentary glare, the mountains looked in the silence like the weird and lifeless peaks of a dead planet. (Hill 1951)

Clint Mosher, an International News Service correspondent, described Baker-2 in Biblical syntax: "An intense white light, pure in color and frightening to behold, rose up from the desert high enough to silhouette the 6,000-foot saw-toothed peaks of the Sheep Mountains, 40 miles from the fringe of Las Vegas" (Miller 1986, 98).

With the humility of one experiencing a religious or poetic epiphany, each reporter

sought words to match his vision. A description of Fox, created by a *Los Angeles Times* reporter, is pure poetry:

> The predawn darkness eased in a glow of incandescent lividity, turning
> within seconds to a bright orange and then a fiery crimson which suf-
> fused the mottled patches of snow with a brief rosy glow before it faded
> abruptly, plunging the night into a deeper blackness than it had known
> before. The silent violence of the flare hushed the noises of the night
> creatures momentarily and for minutes afterward there was nothing to
> be heard but the faint dry whispering of the pine branches stretching
> majestically toward a star-dappled sky. (Eyewitness Atop Peak 1951)

Edging away from the tone of awe to express the sight in a more Hemingwayes-que prose style, Leonard Slater wrote for *Newsweek*: "The time was 5:58 a.m. We held our breaths. The cops put on harlequin-shaped sun glasses. Then the world blew up" (Miller 1986, 104).

The bomb was at once romanticized and naturalized, painted fantastic, funky, and even friendly. It was art deco in the desert. Jackrabbit chiaroscuro. It was proof of the success of the enlightenment project, the truth of evolution, and the superiority of America's technology.

As testing became more routine, cavalier reporters described the weapon as if it were a new toy, showing off a kind of atomic connoisseurship. Atomic clouds that varied from the mushroom norm were assigned metaphorical shapes. The atomic cloud from Easy fluffed into a gigantic bow, another cloud assumed the shape of a dumbbell, and Fox's mushroom became a great fist with four knuckles showing clearly (105). One atomic cloud was described as displaying the head of Donald Duck, soon dissolving into Dame Democracy, and then becoming the head of an angry man (like a slideshow parody of various public reactions to the bomb itself). Following a 1952 test, a broadcaster "barking like a coxswain into his microphone fastened on to the word mushroom and couldn't seem to let go.... 'That's no mushroom,' yelled a spectator; 'that's a Portuguese man-of-war.... Look at those ice tentacles coming down from the cloud.'" The broadcaster conceded that the cloud was no ordinary mushroom and had become a "cataract of white waves" (Lang 1959, 264).

The reporters' fascination with atomic cloud formations continued throughout the

atmospheric testing years. In 1957 the Priscilla test formed a double cloud, prompting reporters to gush that Priscilla wore "skirts." The flamboyant reportage and the more commonplace tests drew curious and adventurous vacationers to Nevada, where watching the atomic tests shortly became a form of tourism, bordering on cultural voyeurism. Those in the know learned that cancellation of airline flights from Las Vegas to Reno signaled an imminent atomic test, and in that way news of an impending blast leaked out. Bomb watchers drove up from Los Angeles to take part in "bomb parties," drinking and gambling in packed casinos until the much anticipated dawn show. Clad in a swimsuit, the winner of a Miss Atom Bomb pageant, or rather a large cutout representing her, greeted visitors at airports and casinos.

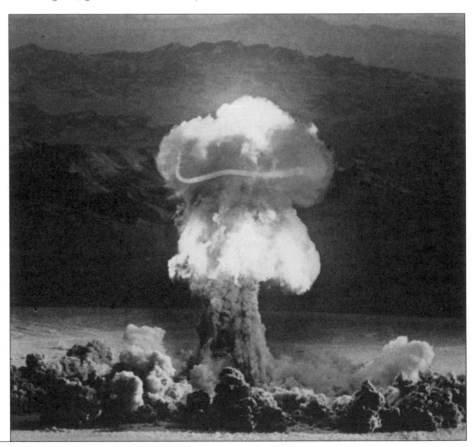

Figure 4.1 **Test Priscilla was undertaken on 24 June 1957 at the Nevada Test Site as part of Operation Plumbbob. The unusual cloud formation prompted reporters to comment on Priscilla's "skirts." Photograph courtesy of the National Nuclear Security Administration/Nevada Site Office.**

At some level, whether conscious or subconscious, journalists at the Nevada site may have attempted to outdo the splendid imagery that materialized in the spoken and written accounts of the first ever explosion of an atomic bomb on earth. At Trinity, the fleeting euphoria felt by the successful Manhattan Project scientists joined their poetic and philosophical leanings to create majestic prose.

On that remarkable New Mexico morning, of 16 July 1945, the countdown finished at exactly 05:30 Mountain War Time.

Oppenheimer—the physicist, the linguist, the poet, the Manhattan Project leader, Dr. Atomic, and Prometheus—looked out over the sublunary plain, and, as dark dissolved into blinding light, found words in the literature of the sacred: "If the radiance of a thousand suns were to burst into the sky, that would be like the splendor of the Mighty One.... I am become death, Shatterer of Worlds" (Titus 1986, 17). Like Oppenheimer, scientist George Kistiakowsky found eschatological meaning in the Trinity light. "In the last millisecond of the earth's existence—the last men will see what we saw" (Pringle and Spigelman 1981, 116).

Others expressed hope in the false dawn. William L. Laurence, science writer for the New York Times and the only professional journalist present at the secret test, described the birth of a new age: "Just at that instant there rose from the bowels of the earth a light not of this world, the light of many suns in one. It was a sunrise such as the world had never seen, a great green super-sun climbing in a fraction of a second to a height of more than 8,000 feet, rising even higher until it touched the clouds, lighting up earth and sky all around with a dazzling luminosity.... One felt as though he had been privileged to witness the Birth of the World—to be present at the moment of Creation when the Lord said: 'Let There Be Light'" (Titus 1986, 17).

More profane, but no less memorable, were the words of Kenneth Bainbridge, director of the Trinity test: "Now, we are all sons of bitches" (Rhodes 1986, 675). Bainbridge's words, placed between those of Laurence and Oppenheimer, trace a Christian mythic cycle of birth, the expulsion from Eden, and death.

And, while journalists at the NTS may have borrowed from prose fashioned by Trinity observers, they could not have known yet of the even more poignant images that had been imprinted on the anguished souls of Japanese bomb survivors. "I could see a great bare eyeball," dreamed Michihiko Hachiya after the destruction of Hiroshima, "bigger than life, hovering over my head, staring point-blank at me" (480). An office clerk in Hiroshima, Doi Sadako, saw "The demon light from the sky" (Treat

War time was the local time adopted by the United States from 9 February 1942 to 30 September 1945. It was mandated in order to conserve resources, the same as today's daylight saving time.

Figure 4.2 **"Miss Atom Bomb." Photograph courtesy of the Las Vegas News Bureau.**

1995, 155). Masuji Ibuse wrote, in *Black Rain*, "In my mind's eye, like a waking dream, I could still see the tongues of fire at work on the bodies of men" (Rhodes 1986, 712). For eight-year-old Maeda Masahiro the explosion was "white jade," and for playwright Sato Makoto it was a "falling star" (Treat 1995, 32).

Wastelanders

As testing became more commonplace in Nevada, the images created and disseminated by the press shifted away from the spectacle itself to suggest something about those who lived next to the NTS. Descriptions of suitable populations were incorporated into AEC press releases and speeches, where the effect was to marginalize, manipulate, and intimidate Nevadans for reasons that justified and promoted atomic testing.

Marginalization was easy to accomplish, for at the dawn of the atomic age the American West was widely viewed, by easterners at least, as populated by wild and bewildering natives, creatures of low sensibility.

In 1934 *Harpers Monthly* magazine ran an article, penned by Bernard DeVoto, entitled "The West: A Plundered Province." The article exposed this eastern view of western man and established a trenchant and iconoclastic frame through which we can examine how the idea of the atomic American West has been developed through the use of images of unredeemed landscape and irredeemable people.

Argued Utah-born DeVoto, "The Westerner remains a bewildering creature to the rest of the nation. Socially he has never blended with the energetic barbarian that for many decades symbolized the Middle-westerner to the appalled East.... In our metropolitan press, the Westerner is a national wild man, the thunder-bringer, disciple of madness ... deluded by maniac vision" (DeVoto 1934, 357).

And the land? Well, the western landscape is as alien as its people. And, to paraphrase DeVoto, such views of the westerner helped justify the plundering of the West by the East. He uses the word plundering to characterize the building of financial empires in the East on the backs of western laborers and resources. However, his analysis of the westerner and the western landscape might be just as aptly applied to the nuclear plundering of the West, Nevada in particular. The imagery of "Project Nutmeg" became the imagery employed to describe Nevadans living with the bomb, people depicted in more than one sense as natives.

They were the oasis dwellers of Nutmeg joined by prostitutes, cowboys, the divorced, or the "should-be" married. They were folks whose lives left them few options but to dwell in hostile deserts or cavort in garish casinos. They were indifferent to the bomb; their impoverished culture unaffected by it in any negative sense, perhaps even enriched by an infusion of excitement and new blood. They were DeVoto's bewildering creatures: disengaged, politically ignorant, fanatic in habit, sometimes downright goofy.

A syndicated newspaper piece written following Baker-2 provides an early example of the marginalizing discourse. The article is staged around a meeting of a journalist and a waitress. The scene is a small unnamed café close to the test site. The piece begins, rhapsodically, like other examples of the wondrous reaction to atomic testing.

> Somewhere, on the still air, came a cock's crow, followed by several more in nearby barnyards. In the east a ribbon of light lay along the mountaintops. The moon was a still crescent in the sky. A single plane flew overhead, its green wing light visible. Maybe nothing would happen....
> I thought about Korea and Russia and death and the world twenty years from now. (Miller 1986, 98)

Then the tone flattens, moving from soliloquy to irony.

> I asked the waitress, 'Did you see it?'
> 'Yes,' she said, 'what do you want: black or cream and sugar?'
> And that's the way it was. (Miller 1986, 98)

The sensitivity of the poet, the worry over the fate of the planet have passed by this poor Nevada waitress, scrambling as she is to make her roadhouse living, oblivious to all the rest.

Time magazine published another version of the bewildering Nevadan, quoting a Pioche resident viewing the bomb:

> There was a kinda flash lit up the window—a real big flash it was. With it comes a bang—, just like that. I thought two cars must have hit into one another on the road outside. The white flash started on the ground and sort of swooshed up into the air.... I reckoned there wasn't much I could

do about it, so I just sat down and ate my breakfast. What did you want me to do? (Miller 1986, 24)

Condescending depictions of childish or ridiculous Nevadans soon cropped up everywhere in articles about atomic testing in Nevada. On 1 February 1951, Las Vegas Chief of Police A.B. "Jack" Maxwell was quoted in the *San Francisco Examiner* as saying that the only ones who were frightened [by the bomb tests] were "women who don't like lightning" (Mosher 1951a, 18).

The Green Felt Test Site

That Las Vegas was associated with fast bucks, fast women, and low culture helped embed in the public mind the caricature of indifferent (and culturally different) Nevadans. Many reporters focused on the bomb's non-impact on the driving greed of the casino culture. One example of this green felt/A-bomb journalism, published before the dust settled from Baker-2, claimed that Nevadans were becoming so accustomed to the blasts that "dealers continued to flick cards to '21' players … without doffing a green eyeshade" (Ball 1986, 63).

Bob Considine added yet another anecdote to the growing stock of bomb/casino lore:

> The first one that went off … created a fierce white light that illuminated the red, white, and blue eyes of the predawn players. There they stood, momentarily transfixed in the sinister and silent flash that betokens mankind's most silent change, and for a bare split second the stick man at one of the tables—I like to think it was at the Last Frontier—paused his little rake…. "Must have been an A-bomb," he commented. Then he pulled in the chips or silver dollars and added, "Place your bets, gentlemen. New shooter coming out." (63)

In many instances, the description of the test-site town complemented the portraits of the players. Paul Coates, a columnist for the *Los Angeles Mirror*, wrote that he had traveled up from Los Angeles figuring "to find a grim and apprehensive public. Instead, there was the usual unreal carnival atmosphere" (Coates 1951).

Journalist Gladwin Hill, in a bylined article for *New York Times* on 1 February 1951, described the test-site town and its residents in terms befitting a carnival. Las Vegas is "an assembly of glittering chrome and flaming color by day, a flowing jungle of flowing neon and flashing lights by night.... All in all Las Vegans can be described as pleased with its new acquisition—the town's publicity man has had the local hairdressers create an 'atomic' coiffure and has rushed out to the nation's press a collection of pictures of bathing beauties equipped with Geiger counters." Daniel Lang, a widely read contributor to *The New Yorker* on atomic issues, titled one of his reports "Blackjack and Flashes." Calling Las Vegas a "shrill, restless resort town," Lang opined that the "dawn parties" were really a misnomer in that most of the shots of the second series went off between 7:00 and 8:00 a.m. instead of at dawn, but "that was no bar to dawn parties." One of the parties was held even though the scheduled shot had been cancelled. The pianist at the casino bar is quoted by Lang as saying, "That was quite a night. Standing room only. They were drinking like fish. Some of them had cameras for photographing the flash—a thing they couldn't have done even if they'd been sober" (Lang 1959, 279).

In a subsequent *New Yorker* piece, Lang stated that some casino managers were worried "the bombs might shake the tables so hard that the dice would be tipped or the roulette balls would bounce out of one number into another. We thought we might have to post signs warning players that in such an event the house man's ruling ... would be final." Lang described what happened during a test in November of 1951, when a window near a crap game in the El Cortez Hotel was shattered by a shock wave and the players turned away from the table to look at the broken glass. When they turned back to the table, twenty dollars was missing from the pot (273).

Gladwin Hill, writing in 1957 for the travel section of the *New York Times*, described the allure of the test site as a place to take an atomic vacation. "This is the best time in history for the non-ancient but none the less honorable pastime of atom bomb watching. For the first time, the Atomic Energy Commission's Nevada test program will extend through the summer tourist season, into September" (1957, 353). Rather than caution tourists about the risks of testing, Hill warned visitors about crazy Nevada drivers under the spell of the bomb: "In the excitement of the moment, people get careless in their driving."

There is something beyond the journalism of adventure in Hill's description of the test site as a vacation destination, something detached and arrogant. Like traveling to

New Guinea to watch tribal puberty rites, tourists could travel to Nevada to view the strange rituals of atomic testing and perhaps glimpse a native atomic beauty queen. Afterward, like returning from New Guinea, they could go safely back home, to more conventional living.

Atomic Energy Commission Anecdotes

I do not believe that the AEC planned in any way to marginalize Nevadans as part of a promotional atomic testing campaign, but who could fail to believe that the AEC public relations officers sensed the advantages of spinning what the press was emphasizing? As testing continued, anecdotes playing on Nevada stereotypes entered official news releases and public outreach speeches made by AEC officials.

AEC Chairman Gordon Dean told radio newsman Morgan Beatty that the AEC had heard no direct criticism of atomic testing from Nevadans, but that he had "heard of one fellow who's planning to sue the government for damages sustained when one of our blasts shook a pair of dice on a Las Vegas gaming table from a 'sure seven' to 'snake eyes.' He claims it busted him" (Ball 1986, 23).

A speech delivered by an AEC spokesman to the Phoenix Kiwanis Club contained a bewildering anecdote, and with it the following shape-shifter phrase later adopted by Lewis Strauss after test Bravo: "[N]o one has ever been injured in an atomic test." Regaling his audience, the speaker said: "I can say honestly that to the best of my knowledge none of our nuclear detonations has caused direct harm to the public off the Test Site in Nevada, except for one case where the air shock wave startled a man while he was shaving, and he turned his head so rapidly that he sprained his neck" (Reeves 1961, 4).

As late as 1998, a story circulating among Department of Energy (the DOE replaced the AEC in 1977) librarians in Las Vegas might be viewed as a variation on the same tale type motif, that of the dull-witted Nevadan reacting to the A-bomb. This one is about a Tonopah man and his film badge.

A film badge is a strip of camera film calibrated to measure the amount of exposure to gamma rays from a nuclear test. Following the first few atomic tests, film badges became standard issue for test site workers, soldiers, newsmen, and people living in the projected paths of radioactive fallout. Gilbert Fraga, interviewed by Carole Gallagher in *American Ground Zero*, tells the story of a Nye County prostitute named Lucky who wore her badge day and night. "Lucky's business shot sky-high:

Sheepherders, ranchers, and miners came from miles around to do business with the girl that had the film badge. She never took it off, that was the gag" (Gallagher 1993, 109). Lucky and other residents of Tonopah were issued film badges before the commencement of the 1955 Teapot series of atomic tests.

The protagonist of the tale circulating among DOE librarians was told to wear his badge until the series had ended. Instead, he hung the badge in his window, convinced that it would capture the fallout particles it was designed to measure. For him, the badge became a totem, trapping or warding away invisible evil. When test site safety teams arrived to collect the badge, he wouldn't let it go. Like a post-modern St. Christopher medal, it hung over the windowpanes, protecting him from whatever the bomb sent his way.

Stories like these were told to soothe atomic paranoia, a paranoia viewed by the AEC and DOE as foolish and provincial. Each tale produced a chuckle at the expense of the local fool who became the focus of the joke, rather than the test, the radiation, the fallout, or the governmental organizations themselves. The bomb, the tales suggest, is benign. The blast and radiation do not create problems, but the IQs or EQs of those living nearby might. Stereotyping Nevadans as living either in an impoverished wilderness or a fantastic bazaar played a necessary role in the campaign to sell atomic testing to citizens in the rest of the country, who were encouraged by the AEC to celebrate the "big bangs in the desert" (Titus 1986, 71).

The clearest example of the argument is an article written by Samuel Matthews for the June 1953 *National Geographic Magazine*. The title of the piece is "Nevada Learns to Live With the Atom." The subtitle proclaims: "While Blasts Teach Civilians and Soldiers Survival in Atomic War, the Sagebrush State Takes the Spectacular Tests in Stride" (Matthews 1953, 839).

Las Vegas is described in the article as "successively a watering stop for thankful forty-niners, [a] Mormon outpost, Civil War fort, and railroad construction camp." Matthews further states, "The Nevada Proving Grounds lies in one of the loneliest and most inhospitable regions of the country" (847).

Matthews described residents and animals as indifferent to the tests: "Las Vegas has taken atomic tests in its stride. Cab driver and casino owner alike profess complete indifference … and even the animals take blasts in stride. A biologist reported that he had studied the area carefully, finding no sign of animal injury. A 'mountain lion' reportedly driven into Las Vegas by the explosions turned out to be a Great Dane dog on a morning

walk" (849). This last detail is especially interesting in that it is actually an animal kingdom version of the "no one has been injured" motif, which almost always surfaced, in one shape or another, in the human interest side of the test site reporting of the 1950s.

In the article, Matthews related interviews of supposedly representative Nevadans living near the NTS. After examining who is interviewed and the comments he quoted, there is little doubt that the article produces the kind of images of Nevada natives that served to assuage and absolve the national conscience.

Nye County Deputy Sheriff Gilbert Landis is described by Matthews as having a "coppery face belonging to a full-blooded Paiute Indian." Landis is quoted speaking in folksy terms about his hometown, Beatty, Nevada: "We have a population of about 400, counting kids and dogs—and the dogs outnumber the kids." More quotes follow, with sentence fragments and down-home diction: "After the first explosion, those radiation fellows came down the main street, stopping with their counters every 10 feet or so. Scared us to death. But we didn't have to be evacuated after all. We weren't 'hot'" (830).

Matthews introduces Lewis Murphy as the caretaker of the Bottle House Museum, built out of 51,000 beer bottles. He lives in the "weathered ruins" of Rhyolite with four other people, ignorant of the importance or threat of the bomb, even bored by it. "Sure, I've seen the flash of that atom Thing. But who wants to get up at 5 a.m. just for that" (830). An eccentric prospector, well known in Nevada, Death Valley Scotty, adds a particular demotic diction: "What do I know about the Bomb? Doggone it, young fellow, asking my opinion is like pulling a hair out of a horse's tail and asking him how fast he can run! I don't know any more about it than a jackass braying" (839).

We aren't provided the full texts of the interviews, but the material selected for publication reveals the desired spin: that the site is suitable and the bomb is innocuous in the eyes of these Nevadans. Like Shakespeare's Caliban in cowboy boots, each struggles to make sense of the people and events that have entered his life from a more sophisticated realm, a brave new world.

I think it is important to consider that the journalists I have quoted were free to interview and include in their articles any subjects they thought would produce a good story. Yet, left out were the thoughts of urbane housewives, blue-collar workers, lawyers, bankers, priests, teachers, and writers (there were many living in Nevada at the time) in favor of the thoughts of gamblers and desert denizens. Those characters became the cultural symbols of the state, and remain so today, still serving to promote the goals of the planners of nuclear projects in Nevada.

THE LITTLE
GREEN BOOK
Five

Nancy and Harry

Throughout 1951 and 1952, the AEC continued to encourage all in the land to celebrate the big bangs in the desert. However, following Operation Tumbler-Snapper (eight tests conducted in 1952), the AEC found itself in the middle of a public relations crisis. The casino anecdotes and jokes about Nevadans were brushed aside by a public insisting on answers to questions about the safety of atomic testing. Evidence was accumulating that radioactive fallout posed a serious threat to the health of citizens living in Nevada, Utah, and elsewhere beneath the atomic clouds. Historian Barton C. Hacker claims "disillusionment came slowly for many—a mushroom cloud's inlaid image still graced the sidewalk in front of Las Vegas City Hall in 1981—but some learned more quickly. Operation Upshot-Knothole in 1953 taught the first major lessons" (Hacker 1998, 157).

The AEC's public relations techniques were adjusted in response to the swelling discontent. Although images of Nevada as wasteland populated by "wastelanders," and the words patriotism, freedom, sacrifice, plus the phrase "no one has ever been injured" remained in the publicity handbook, AEC public relations officials began to mix in new rhetorical elements and to fine-tune the old ones. The AEC's aim was to concoct a balm for fallout fear. Added to their lexicon was the word "experts." The public was told before and after each atomic test that experts had been consulted to establish safe radiation limits, that experts had determined safe testing schedules, and that experts were employed to monitor each test. As the word "experts" crept in, the words fallout and radiation fell out. Continuing to expand this rhetoric of omission, in 1953, the AEC decided to withhold entirely the projected yields (or sizes) of the Operation Upshot-Knothole tests—known by them to most likely constitute the largest tests to date, as Los Alamos scientists were then designing and testing new atomic weapons with higher yields, to serve as detonators for the yet untested hydrogen bomb.

Operation Upshot-Knothole brought something else new to Nevada: atomic tests sporting individual code names. For the first 6 atomic testing operations in the

Marshall Islands and Nevada, names of tests were drawn from the military alphabet: Able, Baker, Charlie, Dog, Easy, Fox, and so on. When one operation ended, the tests in the succeeding operation were named, beginning again with Able. By the end of 1952, duplications of test names had created a communications morass. The fourth Able test had just been completed as had four Bakers, one Baker-2, three Charlies, four Easys and two tests named George. So the nomenclature policy was revised, and tests in the Operation Upshot-Knothole series were variously named Annie, Nancy, Ruth, Dixie, Ray, Badger, Simon, Encore, Harry, Grable, and Climax.

Where did these names come from? Why names of men and women? Were they classmates of the test director? Friends? Rivals? Personnel at today's Los Alamos National Laboratory (formerly Los Alamos Scientific Laboratory) answered these questions and provided the following information: assigning nuclear testing nomenclature was initially done in a whimsical and spontaneous manner. Names were chosen imaginatively, rather than to provide mnemonic clues to classified matters of bomb design, yield, or purpose. Names were to be, to use a modern phrase, politically correct, and no puns or double entendres were accepted. The test director was granted the privilege of naming tests, a job he took seriously and jealously guarded.

On 17 March 1953, the first test in Operation Upshot-Knothole, the 16-kiloton Annie, dubbed the "St. Pat Blast," was successfully detonated, much to the delight and amazement of politicians and members of the press, who had packed the grandstands to watch the Operation Doom Town Civil Defense experiments, conducted in conjunction with the Annie test.

A week later, 24-kiloton Nancy, the second test of the series, was detonated and sent radioactive debris over the Cedar City, Utah, area, where herding sheep on the open range was common practice. When the lambing season arrived in Cedar City, ewes began giving birth to lambs with missing legs and extended bellies. The newborns would stand, then collapse: dead. Ranchers stacked the dead lambs, over 4,000 of them, into piles rivaling the heights of their haystacks. Hacker states that dosimeter readings taken from living animals and from the tissue of dead animals were "high enough to implicate fallout in at least some of the puzzling symptoms observed. Implicate—but not convict" (Hacker 1998, 161).

As more than one government insider remarked, finding something other than fallout to blame for the sheep deformities was crucial to the survival of the testing program in Nevada. That "something other" became malnutrition, and AEC veterinarians

The June 1953 issue of *Nevada Highways and Parks* magazine covered Annie and Operation Doom Town, claiming that 600 observers were on the spot to view the detonation and 15,000,000 others watched the test on their television screens. The author of the article explained, "Simulating conditions typical of American family homes, two frame houses of modern design and size were erected on Yucca Flat" (Operation "Doom Town" 1953, 1).

stuck together in this diagnosis. However, many non-AEC veterinarians remained less certain, maintaining that radioactivity was at least a factor in the deaths of the sheep. Meanwhile, the owners of the sheep sued the AEC for their losses. In 1956 the federal court ruled in favor of the government.

Hacker further claimed that the handling of the Utah sheep investigations betrayed a defining feature of AEC public relations, which was becoming more and more prominent: "arrogance of officials who knew secrets and their underlying disdain for ill-informed outsiders" (163).

The AEC held up the authority of classified data, and the agency contracted with hundreds of tame scientists who were ready to testify in court or write responses to criticism. The result was not only disdain on the part of AEC (We) for ill-informed outsiders, but fear on the part of the questioning public (You), a situation I later refer to as the We/You polarity.

The tests Ruth, Dixie, Ray, Badger, Simon and Encore followed Nancy with less fanfare, although Simon's far-flung fallout eventually reached Albany, New York. Then, on 19 May 1953, Harry was detonated atop a 300-foot steel tower, and all hell broke loose. Likely, test Harry was named for the bandleader Harry James, plausible in that the tenth test of the Operation Upshot-Knothole series was named Grable, most certainly for famed pinup girl Betty Grable, who was also Harry James' wife. Test Grable was unique in that it was a cannon shot, an offspring of the army's effort to develop strategic battlefield atomic weapons for use in Korea. Even though Grable was termed successful—the test yielded 15 kilotons and provided atomic battlefield conditions for military maneuvers—atomic cannons have never been used in battle because the soldiers firing them could not avoid exposure to radiation, a safety problem never solved. Grable earned the distinction of being a bomb test named for a real human bombshell, although not the first. In 1946, when testing commenced at Bikini Atoll, a soldier cut a photograph of Rita Hayworth from a magazine and glued it onto the Able bomb, while his company cheered "Rita" on to her fiery fate. In 1967 an underground nuclear test was named Za Za for the blonde bombshell Zsa Zsa Gabor.

Harry looked ominous from the moment of its catastrophic birth, when it formed an atomic fireball visible for seventeen seconds, an uncommonly long duration. The striking brilliance of the fireball was due to vaporized soil, rock, tower, and bomb casing. "Everything that could go wrong with Shot Harry went wrong," wrote Philip L. Fradkin, in the prologue to *Fallout: An American Nuclear Tragedy* (1989, 3). "The roiling,

blinding white-orange-red stem of the fireball had a nascent cap at its top and a bur-geoning gray dust surge at its base … raw and uneven," claimed Fradkin, "like an ado-lescent" (3). As the mushroom cloud, tinged with pink, ascended it collided with the troposphere and spread out at 42,000 feet, while the bottom of the cloud fixed itself at 27,000 feet. A U.S. Congressman, one of thirty-seven viewing the test from bleach-ers, gasped, "Today's atomic blast made the sunrise a candle by comparison…. We were not prepared for what seemed to us an eighth wonder of the world" (Nevada Atom Test 1953).

To residents of St. George, Utah, Harry evoked not wonder, but terror. Winds at the test site blew from the northwest. Gusts recorded at ninety-one miles per hour whipped the cloud into the St. George area. Never in the past had the residents seen such "an ugly, thick darkness overhead" (Fuller 1984, 72). Resident Loran Bruhn re-called that it seemed as if "a giant reddish-black hand had obliterated the sun." Her husband, the president of Dixie College, telephoned her and used words straight from a horror film: "Don't go out, and keep the children in. The cloud is coming our way" (72). In fact, the AEC did urge people to stay indoors for two hours, after which they issued an "all clear." Even so, many residents of St. George failed to get the warn-ing. Agatha Mannering was weeding her garden when the cloud from Harry passed over. As Richard Miller recorded, "Toward sundown, she began to feel sick; her throat and lungs began to burn and her scalp began to itch. By morning, she felt as though her skin were on fire, like being stung by red ants. Upon visiting the doctor, she was told that it was only fallout, that there was nothing to worry about, and that 'it will go away'" (Miller 1986, 176).

Estimates now place fallout doses of iodine-131 in the St. George area at 500 times higher than the limits endorsed by the AEC. And, despite the test directors' desire to avoid punning and double entendre when code naming nuclear tests, Harry serves as an example of the kind of irony that naming can generate retrospectively: Utahans now resolutely refer to the test as Dirty Harry.

New Promotional Strategies

In late 1953 the AEC released the *Semi-annual Report to Congress*, summarizing the success of Nancy, Harry, and the other tests in the Operation Upshot-Knothole series as "undoubtedly the most important event in this period in the weapons field" (AEC 1953, 1). The press release accompanying the report was a version of the standard model; it claimed that the tests had brought some complaints from people living near the test site, but "no injuries have resulted." And, it reassured the public that experts had been consulted:

> Several persons reported various symptoms, such as nausea, headache, rash, and the like, which they feared were caused by radiation. The cases were given careful investigation by representatives of both the AEC and the U.S. Public Health Service.... None of the examinations substantiated the claims that radiation was involved.... An example was the case of a child who suffered a rash which was found to be German measles. (AEC 1953, 8)

Associations between nuclear testing and patriotism, reinforced during Operation Crossroads in the Marshall Islands, were more regularly made in press releases as the AEC struggled to appease or subjugate the public.

Historian Paul Boyer notes that as early as 1947, AEC Chairman David Lilienthal had begun lashing out at critics of atomic testing, impugning their patriotism and loyalty, and accusing them of "scaring the daylights out of everyone so no one can think, inducing hysteria and unreasoning fear" (Boyer 1985, 74). Lilienthal attacked any scientist who censured further nuclear weapons development and anti-nuclear activists for their "extravagant and sensational picturing of the horrors of atomic warfare" (307).

On 7 March 1955, a 43-kiloton test (code named Turk, but nicknamed by the public as Big Shot) was conducted in Nevada as part of Operation Teapot. Immediately following the detonation, two University of Colorado Medical Center scientists, Dr. Ray R. Lanier and Dr. Theodore Puck, measured an upsurge in radioactivity, which they labeled "appreciable." As a result, they joined other activists in calling for an end to atmospheric testing in Nevada. An AEC spokesman replied to Lanier and Puck, "[O]n the basis of the readings on which their statements are based, the commission is of

the opinion there is no concern for the public and that the radioactivity is inconsequential" (Miller 1986, 176). Colorado Governor Edwin C. Johnson added that Lanier and Puck had indulged in "scare tactics," and questioned their loyalty and motives. "The two scientists should be arrested," said Governor Johnson. "This is a phony report.... The statements are part of an organized fright campaign" (176).

Rising to boilerplate status within AEC press releases about this time was the phrase "radiation is natural." The AEC, on 25 March 1955, helped produce a "friendly" article about fallout, which was published in *U.S. News and World Report*. Among the statements submitted by the AEC are: "From the 'Big Shot' tests a radioactive 'cloud' crossed the U.S. but hurt no one," and "Effect of its 'fallout' on anyone in the U.S. equaled that of a luminous-dial watch." AEC Commissioner Willard Libby further explained, "The world is radioactive. It always has been and always will be" (Miller 1986, 199). Libby's statement, or a variation upon it, was inserted into AEC press releases, letters to concerned citizens, and pamphlets, and it remains ubiquitous today in the promotion of nuclear projects.

A Nevada Death

In Nevada, questions about the dangers of fallout increased in numbers and intensity following the death of a Central Nevada child, Butch Bordoli, in 1956. On a Nevada topographical map, the Bordoli Ranch is nestled in a hollow where the Quinn Canyon Range meets the Grant Range to the east of Railroad Valley, in Nye County. The ranch home is situated about 80 miles from Yucca Flat, where a majority (eighty-six of the one hundred total) of Nevada's atmospheric tests were conducted. Martha and Alfred Bordoli were in many ways typical of people living near the test site: not misfits or bewildering desert dwellers as featured in the stories of the press, but rather they were productive ranchers engaged in raising hay, grazing livestock, and enjoying their wide open spaces and growing families. During the 1950s, they were almost always hard at work before daybreak, aware that the predawn sky to the south periodically turned brilliant colors, and then darkened as black clouds blew toward them.

Martha Bordoli felt uneasy about atomic testing from the beginning. "Our cows got white spots on them and cancer eyes. At school, children broke out with rashes from the radiation" (Gallagher 1993, 107). In 1955 seven-year-old Martin "Butch"

The 23 June 2002 issue of the *Reno Gazette-Journal*, in a regular Sunday feature called "Earthweek: Diary of the Planet," delivered this update on nuclear testing in India: "Indian farmers who live adjacent to the Pokharan military test range report an increased occurrence of mutated and blind cattle during the four years that have followed India's nuclear testing at the facility. Several have also complained of human health problems during the same period. The cattle are believed to have been affected by grazing near the fence that surrounds the test site in the scrub desert. Farmer Ranjeeta Ramji said his herd alone has produced four blind calves with tumors since the underground nuclear blasts, none of which survived for more than a year. Other villagers have reported various birth defects in their animals. Health difficulties that some villagers have experienced since the test include bloody noses, itchy skin and vomiting. Indian health officials explained that those symptoms were the result of excessive heat in the desert region."

Bordoli came home from school one day with a fever, and feeling unusually fatigued. He was diagnosed with stem cell leukemia, almost certainly, believed his parents and neighbors, a result of exposure to radiation from atomic fallout. He died shortly afterward. In 1957 his mother circulated a petition, signed by 75 neighboring ranchers and business people, asking the AEC to halt atmospheric atomic testing in Nevada. The petition was forwarded to Washington, D.C., to the Joint Committee on Atomic Energy. While the Committee debated its response to the Bordoli petition, an AEC promotional text, *Atomic Tests in Nevada*, commonly called "The Little Green Book," rolled off the press. Copies of the small pale-green booklet, about the size of a pocket Bible, were shipped to every public school in Nevada and Utah.

The authors of The Little Green Book faced a rhetorical quandary. Their goal was to explain atomic testing, radiation, and fallout without raising public alarm more than Harry and Nancy already had. At the same time, the AEC wanted to preserve the public's perception that the bomb was sufficiently lethal to successfully annihilate the enemy. It appears they wished to address specific questions raised by angry Nevadans about the safety of testing in Nevada, but they needed to do so without shaking the confidence of the rest of the nation in the wisdom of the NTS selection.

The result was a collection of stumpy sentences delivering all the rhetorical techniques formerly developed by the AEC to characterize atomic sites, downplay danger, mollify affected populations, and underscore the need for atomic testing in a Cold War world.

The booklet begins with another version of the shape-shifting "injury" motif, similar to the story of the man who sprained his neck when shaving, in that the injury was not a result of what the public feared most:

> All findings have confirmed that Nevada test fallout has not caused illness or injured the health of anyone living near the test site. To our knowledge no one outside the test site has been hurt in six years of testing. One person, a test participant, has been injured seriously as a result of the 45 detonations. His was an eye injury from the flash of light received at a point relatively near ground zero inside the test site. (AEC 1957, 2)

As might be expected, in the booklet peace and freedom enjoy a symbiotic

relationship with atomic testing: "You people who live near the Nevada Test Site ... have been close observers of tests which have contributed greatly to building the defenses of our country and of the free world. Nevada tests have helped us make great progress in a few years, and have been a vital factor in maintaining the peace of the world" (2).

The greater part of the booklet emphasizes sound science and scientific expertise, the new direction being taken by AEC public relations. First, the AEC contended that a scientific selection process had been followed to locate the safest atomic proving ground in the nation: "Public protection began with selection of the site. Nevada Test Site was selected only after extensive studies of other possible locations.... The controlled areas are surrounded by wide expanses of sparsely populated land, providing optimum conditions for maintenance of safety" (3).

Second, the AEC assured the public that scientists and other experts were in charge of safety precautions—a subject delivered in the booklet with a tone of authority, if not domination. Scientific jargon and a didactic, chalk and blackboard tone characterized the lists of scientists, credential rosters, and designated responsibilities for safe testing, which implied at every turn the innate superiority of the experts [We] over a naive audience [You]. The booklet claims: "An advisory panel of experts in biology and medicine, blast, fallout, and meteorology is an integral part of the Nevada Test Organization.... This panel carefully weighs the question of firing with respect to assurances of your safety under the conditions then existing" (4).

In the booklet, fallout is explained in two ways. One explanation depends on technical and scientific jargon: "The instrument readings are translated in to roentgens of whole body gamma exposure in terms of 'effective biological dose'" (15). The other explanation relies on the concept of naturally occurring radiation:

> Radiation is nothing new. Since the beginning of time, mankind has been bombarded by radiation from outer space and from the ground beneath him.... Each of us also has radioactive materials within his body.... It has been calculated that people packed in a dense crowd would receive about 2 MR. a year dosage from the radioactive potassium in their neighbors' bodies.... The earth's surface everywhere is radioactive. Granite rock, for instance, contains radioactive radium, thorium, and potassium. (48–49)

"Small" is used eight times to modify "fallout particles," and "low" or "minimal" modify "exposure" in at least five sentences. Interestingly, the AEC reintroduced a discussion of "yield" into the document, a phrase omitted in previous public communications. In doing so, they walked another fine line. References to yield invited negative responses to the growing sizes of the bomb tests, but the AEC felt it necessary to use the word to publicize forthcoming tests, because of rampant rumors that thermonuclear bombs were scheduled for testing in Nevada. The booklet explained, "Please understand that in the [discussion] of radioactive fallout, we are not talking about high-yield A-bombs or H-bombs tested elsewhere. We are not talking about radiation from enemy bombs designed to do the most damage possible. We are talking only about low-yield tests, conducted under controlled conditions at Nevada Test Site" (11).

The booklet's stated intention was to inform the public about atomic testing in Nevada. And yet, the rhetoric swiftly moves from clarity to mystification, obfuscation, and jargon. For instance, what does low-yield really mean? And what is a roentgen? The authors express superiority when using the words "control" and "controlled" (for a total of seven times in the text), and they intimidate when using the phrases "you people," "[p]lease understand," and "panel of experts." The commanding univocality, the selective use of pronouns, and the repetitive and monosyllabic syntax all add power to the argument that We know a whole lot more than You.

Cartoon drawings of those living near the bomb reveal The Little Green Book authors' view of a rural Nevadan. One drawing has a cowboy astride a horse looking off into the distance at a mushroom cloud. The horse casually nibbles tufts of grass, the reins are loose: An A-bomb can't scare a cowboy, much less his steady mount. Another drawing depicts a cowboy and his girl, both bowlegged caricatures in Levis and kerchiefs. Standing atop a mountain, they are looking away from the mushroom cloud. Both wear sunglasses to protect their eyes from the blast. Grinning and waving, like two happy country kids tickled at the sight of the A-bomb, they vaguely resemble the actors Mickey Rooney and Judy Garland.

Use of scientific jargon and the emphasis on the We/You polarity is discussed by Scott L. Montgomery under a chapter subheading he calls: "The Creation of Insiders and Outsiders." He describes the "jargonization" of scientific discourse as "the weedy growth of local, specialized lexicons of expertise" whose status depends on exclusion. He further asserts that "technical language sets up a barrier between those who can speak and understand and those who cannot," and, quoting French

philosopher Roland Barthes, he claims that such a discourse "exalts, reassures all the subjects inside, rejects and offends those outside." The discourse alone, Montgomery summarizes, "has power to intimidate" (Montgomery 1996, 7).

Martha Bordoli received a number of official responses to her petition. A letter from Lewis Strauss, who succeeded Gordon Dean as AEC chairman in 1956, dismissed any connection between leukemia and fallout, referring to experts. And, with chiding words, Strauss made the link between accepting nuclear testing and keeping our nation safe and free. "The Government decisions regarding nuclear testing have not been made lightly," he told Mrs. Bordoli. "The possible risks from continued weapons testing have been carefully evaluated by competent scientists.... The risks of atomic testing are small, exceedingly small in fact when compared to other risks that we routinely and willingly accept every day." Quoting President Truman, Strauss continued, "Of course, we want to keep the fallout from our tests to an absolute minimum, and we are learning to do just that, but the dangers that might occur from fallout in our tests involve a small sacrifice when compared to the infinite great evil of the use of nuclear bombs in war" (Gallagher 1993, 107).

Figure 5.1 **From *Atomic Tests in Nevada*. Nevadans were stereotyped as provincial and accepting of atomic tests. Courtesy of the U. S. Department of Energy.**

Senator George Malone of Nevada wrote to Martha Bordoli, expressing anger over the petition and questioning whether there was a subversive connection between the act of petitioning and the fact that early in 1957 several famous scientists, including Linus Pauling, had begun to question the government's nuclear testing program in Nevada: "The President has questioned these reports coming from a minority group of scientists, some admittedly unqualified to comment on nuclear testing, and as he has said it is not impossible to suppose that some of the 'scare' stories are Communist inspired. If they could get us to agree not to use the only weapon with which we could win a war, the conquest of Europe and Asia would be easy" (109).

Both Strauss and Malone sent Martha Bordoli a copy of The Little Green Book.

Rainout in Reno

In 1957, two years following Operation Teapot and the same year Martha Bordoli's petition made its way to Washington, another large series of atomic tests commenced in the late Nevada spring under the banner Operation Plumbbob. It was the last of the large-scale atmospheric testing operations conducted at the NTS. One year later, the big bomb tests were moved back to the Marshall Islands. Eventually, the tests were moved underground at the NTS and elsewhere in the United States. The largest atmospheric test conducted at the NTS after Operation Plumbbob was a modest 6 kilotons.

The Plumbbob series can be viewed as another turning point in promotional rhetoric. The tests extended the dialogue about fallout (between the AEC and the public) beyond the immediate test site peripheries, and the downwind states of Utah and Colorado, into the Reno area some 300 miles north of the NTS, a region where the AEC version of testing safety had remained largely unchallenged. The AEC's responses to questions and criticisms from Northern Nevadans was a stepped up We/You rhetorical strategy, one that became more dismissive as it became more technical.

Boltzmann was the first test of the Plumbbob series, an ambitious undertaking of 29 tests, most of them named for scientists (Boltzmann, Franklin, Columb, Kepler Owens, Pascal, Doppler, Galileo, Newton, Fizeau) or for mountains (Lassen, Wilson, Hood, Diablo, Shasta, Smoky, Wheeler, Whitney, Charleston).

Atomic operations undertaken after 1955 almost always included tests with names belonging to at least two distinct lexical categories, as in Plumbbob's scientists

Bruce Fein wrote an article entitled "Nuclear Waste Parochialism," for *The Washington Times*, in which he echoed former Governor John Sununu's opinion that Nevadans should do their patriotic duty and accept nuclear waste at Yucca Mountain. Fein used even stronger language, remarkably similar to that used in the official letters received by Martha Bordoli. Citing freedom fighting in Afghanistan, Fein lectured Nevadans: "The risks of a Yucca Mountain repository to citizens of Nevada seem trivial in comparison. Shouldn't we all ungrudgingly accept sacrifices on behalf of major national enterprises as welcome opportunities for our finest hours?" (Fein 2002, A21).

and mountains. The two groups of names can be explained by the fact that the United States had commissioned a second national laboratory, which began contributing nuclear weapons designs to the atomic testing program.

The central figures in the early years of atomic testing were the scientists at Los Alamos Scientific Laboratory, the birthplace of Trinity and workplace for many of the most renowned scientists and mathematicians of the century: Robert J. Oppenheimer, Hans Bethe, Niels Bohr, Richard Feynman, Stanislaw Ulam, I.I. Rabi, and Edward Teller. The Los Alamos team designed the bombs, supervised the bomb tests, and analyzed the test data in order to develop improved designs for ever more efficient bombs.

In the early 1950s, a rift opened in the team. Oppenheimer and a number of his Los Alamos colleagues were actively opposed to the development of the hydrogen bomb. Oppenheimer believed that the U.S. nuclear arsenal had already reached "unholy" numbers. Edward Teller had by then taken ownership of the H-bomb design and development, and he publicly criticized his fellow Los Alamos scientists for not whole-heartedly supporting him in what was a passionate, some might claim monomaniacal quest. Teller began to lobby Congress to authorize a second national laboratory, winning support from the powerful nuclear weapons proponent Senator Brien McMahon. Teller's position prevailed after Ernest O. Lawrence, professor of physics at the University of California in Berkeley, agreed to head up the new lab, lending both his well-respected name and trusted leadership to the project. In 1952 Congress created and funded the Lawrence Radiation Laboratory, situated in Livermore, California, later renamed the Lawrence Livermore National Laboratory.

The Los Alamos and Lawrence laboratories entered into a spirited rivalry. One Livermore scientist claimed, "If ever there was an arms race, it was between the competing nuclear bomb design teams at Los Alamos and Livermore" (Gusterson 1996, 14). The rivalry eventually expanded from designing weapons to naming weapons tests. Tests designed by the scientists at Los Alamos, who lived in a land of arid desert high plateau, were named for reptiles: Platypus, Armadillo, Hognose, and for rodents: Ermine, Packrat, Raccoon, Chinchilla, Dormouse, Stout, Ferret, Aardvark, and Boomer. The tests designed by the scientists at the ocean-oriented Lawrence Radiation Laboratory were named for birds: Parrot, Auk, Cormorant, Bitterling, and for fish: Barracuda, Sardine, Anchovy, Grunion, Mackerel, Bonefish, Pike, Minnow, Sturgeon, and Pipefish.

Landlocked Los Alamos designed tests named after golfing terms: Par, Club, Tee, Hook, Backswing, Driver, Fore, Eagle, and Bogey; while the East Bay Livermore team designed tests assigned nautical nomenclature: Oarlock, Spar, Snubber, Keel, Topmast, and Rudder.

Then, there were the wines and the cheeses. Livermore scientists named tests for a wide array of cheeses: Roquefort, Salut, Leyden, Jarlsberg, Romano, Havarti, Fontina, Muenster, Stilton, Edam, Chevre, Asiago, Camembert, Gouda, Kasseri, and Gruyere. And the Los Alamos scientists supplied liquors, mixed drinks, and French wines by naming tests Bourbon, Scotch, Absinthe, Cognac, Daiquiri, Pommard, Stinger, Ricky, Fizz, Sazerac, Barsac, Bordeaux, and Chateugay. Together, the names of the tests formed quite the cocktail menu.

Boltzmann, a Los Alamos test named for Austrian physicist Ludwig Boltzmann, was detonated at dawn on 28 May 1957. The fireball rose to an unusual height: 29,000 feet, high enough to be seen for many miles in all directions. Observers as far away as Sacramento reported that the cloud looked like a giant dumbbell (Miller 1986, 254). AEC meteorologists had predicted that the cloud would move easterly, as was customary, toward the Utah border. Instead, a whirlwind of debris punched its way toward the California border, to the west of the test site, and then headed straight north toward Reno. A Las Vegas merchant looking skyward remarked that the cloud had "goofed and taken a walk" (254). It walked, among other places, over Quincy, California, where an amateur prospector watched in amazement as his Geiger counter, resting on the kitchen table, began clicking away (254).

In Reno, rain began to fall on the morning of the shot producing "rainout" conditions. Radioactive rainout, as opposed to fallout, is a meteorologist's nightmare. Rain, passing through an atomic cloud, brings radionuclides to earth in a shower of concentrated particles. Although the AEC must have been aware of the situation developing in Reno, it was a private citizen, or several of them, who discovered the rainout and brought it to the public's attention. The *Reno Evening Gazette* of 29 May 1957 gives the credit to an unnamed electronics engineer. However, a radiologist at Washoe Medical Center, named L. J. Sandars, began to note anomalies in his routine radiation surveys. He made a connection to the announced Boltzmann test and raised the alarm in the *Gazette*, remarking that radiation readings were "anywhere from three to six times above the acceptable tolerance level … for the first 48 hour period." The AEC quickly denied the local measures and provided a scientific overview of fallout to the public, albeit sim-

There was a brief craze in America for an atomic cocktail, first served at the Washington Press Club, in Washington, D.C., within hours after the announcement of the Hiroshima detonation. It consisted of one part gin, one part Pernod. When atomic testing began in Nevada, bartenders in Las Vegas concocted their own version of an atomic cocktail with equal parts champagne, vodka, and brandy, and a splash of sherry.

plified and laden with the kind of phrases included in The Little Green Book: tests were controlled, fallout was light, and experts were in charge of monitoring all tests.

In a letter addressed to Nevada Senator Alan Bible, Sandars objected to the AEC version of the test: "The newspaper quoted reassuring phrases from the AEC to the effect that the … intensity of fallout was negligible and without danger and that the half-life of the radiation sources was calculated to be 12 hours. This last statement is erroneous" (Sandars 1957).

Sandars's letter was followed by another letter to Senator Bible from Dr. James S. Roberts, a University of Nevada political science professor, who like Sandars had peered through the veneer of official explanations and fashioned a series of tough questions of his own:

> [W]hat constitutes a 'light' fallout? Who bears the responsibility of track-
> ing and measuring radioactive fallout? Did the AEC continually measure
> this fallout?…. If the movement of the radioactive dust was not moni-
> tored over the Reno area, it would seem that negligence on the part of
> the AEC is involved. If this movement was monitored, it would seem
> the responsibility of the AEC, not a private electronics engineer, to make
> this fallout known. (Roberts 1957)

As word of the fallout spread among academics at the university, the Reno City Council received a letter from Dr. Paul F. Secord, a University of Nevada psychology professor, asking for action to halt atomic testing.

K. E. Fields, general manager of the AEC, wrote the official response to questions posed by Senator Bible. He did not provide the requested information about Boltzmann fallout; instead he gave explanations about naturally occurring radiation: "It is not pos-sible to predict precise radiation exposures at a locality on the spur of the moment.… The amount of fallout there was far below hazardous levels.… Each year, the persons living in Reno receive more exposure from naturally occurring radioactive substances in the environment than from fallout from all nuclear tests to date" (Fields 1957).

Fields offered to "assist in correct interpretation of the data," restating the AEC radi-ation dose limits: "The maximum permissible exposure is ½ roentgen a year for general population, which would allow Reno 3 roentgens during the six years of testing to date. The exposure to persons in this locality has been about 1/25 this amount" (Fields 1957).

The term "permissible exposure" is, in reality, absurd. Fallout does not ask for permission. Nor does it stop falling when it reaches "permissible limits." And, despite Fields' confident and official assessment of permissible limits, the series in actuality released 58,300 kilocuries of iodine-131 into the atmosphere, more than double what had been produced from all previous tests. Reno residents received 2 to 4 rads of radiation. (A rad is a unit used to measure absorbed radiation doses.) A report written in 1959, entitled "Fallout From Nuclear Tests at the Nevada Test Site," was not released until 1979. It documents higher than previously published fallout from the Plumbbob series in Ely, Butler Ranch, Dodge Construction Camp, Galt, Lincoln Mine, and Reed, Nevada.

How much damage to public health was inflicted by tests like Harry, Big Shot, and Boltzmann? How much was the public trust damaged by the promotional rhetoric employed by the government, the military, and the test directors? We don't have the answers. What we do know is that the American West now holds many stories linking illness and atomic fallout, whether fact, fiction, or lore. Throughout the 1950s, cattlemen and sheepherders across Nevada and Utah reported birth defects and beta burns in livestock. Ninety-one members of the 220-member cast and crew of the movie *The Conqueror*, filmed near St. George, Utah, during the summer of 1955 (Operation Teapot), developed cancer, including John Wayne, Susan Hayward, Agnes Moorehead, and director Dick Powell. To replicate Mongolian desert storms, huge fans were set up to produce blinding whirlwinds of Utah desert dust. Later, the crew remembered how after a day's shooting the faces of the cast were caked with sand, which clung to their sticky makeup, forming a mask. Even the experts now concede that the cancer rates in the cast and crew of this film are extraordinarily high. Thirty cancers might normally be expected in a pool of 220 (Miller 1986, 187).

Utah author Terry Tempest Williams, in her book *Refuge*, recounts the moment when she made her own connection between a series of family cancers and Operation Plumbbob. The epiphany arrives as she tells her father about her recurring dream of seeing a strange flash of light in the night in the desert:

"You did see it," he said.
"Saw what?"
"The bomb. The cloud."
"We were driving home from Riverside, California ... north past Las

Vegas. We pulled over and suddenly, rising from the desert floor, we saw it, clearly, the golden-stemmed cloud, the mushroom."

Williams, at that moment, "realized the deceit." She knew that her family history of mastectomies and chemotherapy, her "Clan of One-Breasted Women," was linked to the atomic tests whose safety she had not questioned before (Williams 1991, 283).

Carole Gallagher's gallery of photographs in *American Ground Zero* puts faces—dozens of them—on wrenching stories of leukemia, breast cancer, bone cancer, cancer of the larynx, sterility, and mental retardation. She tells us that "Cancer was such a rarity that when a cluster of leukemia deaths struck the small towns of southern Utah and Nevada, a few years after testing began in 1951, even the doctors had no idea what this illness could be. One nine-year-old boy who was brought to the hospital in St. George was diagnosed a diabetic by a physician who had never seen leukemia before. The child died after one shot of insulin.... Enormous concern and fear were voiced by families of the dead, yet every vehicle for denial was firmly in place that would keep those most directly downwind of the Test Site from, as Don Cartwright put it, 'making a fuss'" (Gallagher 1993, xxix).

The primary point, though, is not that nuclear fallout and radiation are dangerous. Enough has been written on that subject. My argument is that dissembling official rhetoric and casuistry have tainted the public trust, with long-lived and far-reaching consequences. Wedding atomic testing to patriotism intimidated and silenced all but the most confidant critics. Implementing insider jargon distanced those seeking straightforward answers by suggesting that the ordinary citizen could not possibly understand the business of the more scientifically-minded insiders. Withholding or delaying data on fallout fed the already high levels of skepticism and created a situation where every illness could be blamed on atomic fallout.

On 5 October 1990, Congress passed the Radiation Exposure Compensation Act, providing payments "to individuals who contracted certain cancers and other serious diseases as a result of their exposure to radiation released during above-ground nuclear weapons tests or as a result of their exposure to radiation during employment in underground uranium mines" (Radiation Exposure Compensation Act). The act outlines the types of cancers that qualify for compensation, and carefully defines what constitutes a qualifying time and place of exposure. Amendments have expanded

claimant categories to uranium mill workers, and have extended the list of downwind counties where exposure may have occurred.

The AEC maintained that Operation Plumbbob had been highly successful, almost without mishap. The future of atmospheric atomic testing in Nevada, though, was ultimately shaped not only by distrusted official data and promotional rhetoric, but by an international rhetoric of resistance, manifested in worldwide campaigns waged to ban atmospheric testing, and by a mounting willingness among nuclear nations to ban atmospheric testing.

In March 1958, the Soviet Union announced a unilateral halt to all-nuclear testing. Closely following the Soviet announcement, the so-called Geneva Convention of Experts convened to discuss technical problems of monitoring a test ban. American and British governments announced readiness to suspend atmospheric testing for one year if the Soviet Union would join in an agreement. The moratorium took effect on 1 November 1958. There was a brief resumption of atmospheric testing by the United States and the Soviet Union in 1961 and 1962, but shortly thereafter the era of atomic fireballs and mushroom clouds came to an end for Americans, Englishmen, and Russians alike. The Limited Nuclear Test Ban Treaty (LNTBT) was signed by representatives of the United States, Great Britain, and the Soviet Union in Moscow, in August 1963, and ratified by the U.S. Senate in September 1963.

At the time of the treaty signing, Great Britain had detonated 21 weapons above ground, the United States 216, and the Soviet Union 217, including the record-setting 60-megaton test detonated over Novaya Zemlya archipelago in October 1961. Tsar Bomba, as the mammoth test was nicknamed, was proof that there would be no limit to yields of the nuclear devices tested in the atmosphere or to the numbers of fallout particles produced unless mutually agreed-upon rules were adopted.

Raising Limits

Because my interest is not confined only to nuclear historical moments, but is also engaged in current nuclear events, I want to shine a light on one other promotional phrase that surfaced during Teapot and Plumbbob, and is still actively implemented in defending nuclear projects, whether power plant operations, clean-up projects, or nuclear waste disposal plans. The phrase is "safe limits have been established." During the atmospheric testing years, Dr.

Shields Warren, of AEC's Office of Biological Studies, was a steady voice of caution and reason, pleading with management to limit testing in Nevada to low-yield (under 20 kilotons) atomic weapons. Public relations statements made throughout the 1950s included the phrase, "The AEC conducts only 'low-yield tests' in Nevada," a phrase that made it into The Little Green Book. The story goes that although agreements between the military and the AEC banned fusion (thermonuclear) tests on American soil, weapons designers at Lawrence Radiation Laboratory met with President Dwight D. Eisenhower before the detonation of Climax, in 1953, to convince him that small fusion tests could be undertaken in Nevada with minimum fallout, and that the public would not be able to tell the difference. It was at that moment that President Eisenhower is reported to have coined the famous remark, "Let's keep them confused as to the difference between fission and fusion" (Miller 1986, 180).

In advance of 1957 Operation Plumbbob, the low-yield assertion was frequently repeated in the press. The *Albuquerque Journal* printed an AEC press release on 25 January 1957, which stated that "The new series will involve low-yield nuclear tests ... not much more than 30 KT.... [T]ests of high yield devices—or H-bombs—are not conducted in Nevada."

Nevertheless, and once more contrary to the official information, test Hood, conducted in Nevada in 1957 (part of Operation Plumbbob), yielded over 80 kilotons, and is now acknowledged to have been a test of a fission fusion design and a fine example of what has been labeled "kiloton creep."

The AEC's Dr. Warren pleaded with management and the military to restrict a soldier's distance from ground zero to no less than six miles. But because Nevada tests were designed, in part, to simulate the atomic battlefield, the army kept pressure on Warren and the AEC to relax the restrictions, first to three miles, then during some of the Plumbbob tests to much less than three miles. Atomic veteran Thomas Saffer waited in a foxhole two miles from ground zero as 37-kiloton Priscilla was detonated. He later reported:

> I was shocked when, with my eyes tight closed, I could see the bones
> in my forearm as though I were examining a red X-ray. Within seconds,
> a thunderous rumble like the sound of thousands of stampeding cattle
> passed directly overhead, pounding the trench line.... The sound and
> the pressure were both frightening and deafening. The earth began to

gyrate violently, and I could not control my body. I was thrown repeatedly from side to side and bounced helplessly off one trench wall and then off the other.... A light many times brighter than the sun penetrated the thick dust, and I imagined that some evil force was attempting to swallow my body and soul. (Miller 1986, 262–263)

Saffer and his fellow soldiers were transported to within 300 yards of ground zero, where the heat from the sand burned through their combat boots. A few weeks later, Saffer was again positioned two miles from ground zero, as the giant Hood was detonated. He later recalled, "Some of the soldiers began to shake and vomit," (Miller 1986, 266).

The history of nuclear projects in Nevada is filled with raised limits: exposure limits, yield limits, distance from ground zero limits, and more recently, raised repository storage limits should nuclear waste be placed in Yucca Mountain.

Judged within the frame of "wastelanders," raising limits is another way of saying that some populations qualify as special cases, and therefore should sacrifice and be sacrificed for the public good.

At a meeting of the Nevada Commission on Nuclear Projects, held in April 1999, DOE's Yucca Mountain Project director admitted that the existing cap on storing fuel at Yucca Mountain, should the repository be built, would eventually have to be raised or lifted. The cap had been established to allow for safe spacing of the storage casks and to limit the accumulation of heat produced by the fuel rods (both important measures for keeping the waste packages from reaching criticality). The capacity has been established at 77,000 metric tons, but Director Russell Dyer estimated that well over 100,000 metric tons would eventually be emplaced in the mountain.

W hile atomic testing series were well underway in Nevada, larger nuclear weapons were detonated within the Marshall Islands. Following the first thermonuclear explosion, in 1951, on Enewetak Atoll, scientists returning to Los Alamos were overheard using the expression, "George was a very good boy." The "very good" referred to a 225-kiloton test, named George, that pleased AEC Chairman Gordon Dean, who had flown to Enewetak to witness it. Dean later wrote about the "amazing destructiveness" of good boy George, evidenced by the complete disintegration and disappearance of a concrete blockhouse and the vaporization of a 200-foot-high steel tower and almost 300 tons of equipment. "Part of the island," wrote the astonished Dean, "vanished" (Hacker 1987, 56).

The story is interesting in and of itself for what we learn about the power of a thermonuclear explosion. But, the curious personification of the bomb as "a very good boy" delivers up another way to examine the rhetoric of atomic testing. The examination begins with the idea that naming of an object, including a bomb or bomb test, is never arbitrary or objective. It requires making a choice. It is an act of control and signifies power. According to *Genesis*, God formed the beasts of the field and fowl of the air and brought them to Adam "to see what he would call them: and whatsoever Adam called every living creature, that was the name thereof." We can imagine Adam calling (in an early tongue) a goat a "goat" and a serpent a "serpent." Adam's names separated goats from serpents and bestowed on each a verbal identity, distinct and unique. And, beyond separating goats from snakes, Adam's act of naming initiated a linguistic chain which over time has enriched—or rendered banal—the "goatness" of goats and the "serpentness" of serpents, a chain including similes and metaphors, fairy tales, myths, and even jokes.

A name in some cultures is so sacred and powerful that it is considered magic. Hence, the sorcerer commands, "Open, Sesame" to reach another plane of existence.

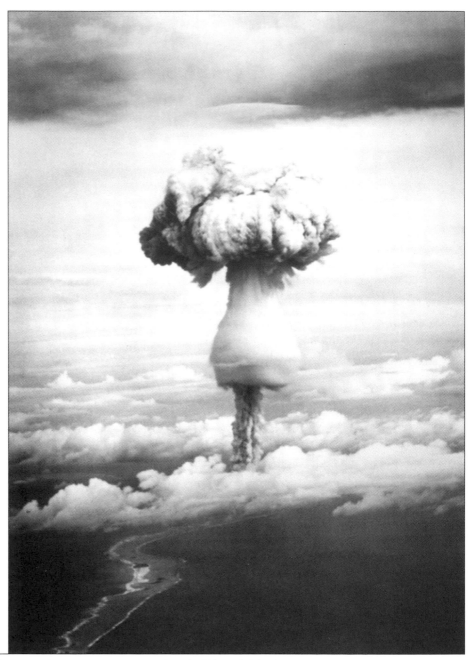

Figure 6.1 **"George, a thermonuclear test, was conducted at the Marshall Islands on 8 May 1951. Atomic Energy Commission Chairman Gordon Dean said of the successful test, "George was a very good boy." Photograph courtesy of National Nuclear Security Administration/Nevada Site Office.**

Members of certain Native American tribes refuse to divulge their child's real name for belief that the mere whisper of it will rob the child's soul of vitality.

Today, we actively choose names for our children, dogs, cats, horses—adopting along with the name itself, the associations, sacred or not, that we attach to the name. A name is at once connotative and denotative, more than a string of phonemes, and thrusts the named object into an imaginative realm with objects bearing the same name or a related name, and into an associative realm that challenges the deep recesses of thought. It can suggest beauty or heritage. It can highlight strengths or disguise weaknesses.

Every parent has considered the power of a name, and so has every automobile maker since the naming of the Edsel.

Scott L. Montgomery writes in *The Scientific Voice*: "To name a thing is to do more than merely give it birth within the realm of literary perception, oral or written. It is to create an object for study. Giving a name to something is one way to claim and possess a new region for investigation." In the technical vocabulary, making up the scientific voice, "Names probably comprise as much as 50% or more." Montgomery cites as examples the taxonomies that have developed for biological and botanical species, chemicals, minerals, particles, forces, stars, and the elements (Montgomery 1996, 197).

Following Montgomery, a bomb test with a name becomes an object, one which can be measured, compared to others of its kind, and discussed within all sorts of contexts—historical, scientific, and political. However, even in the self-proclaimed objective world of science, names cannot be separated from the question of culture. "Names," as Montgomery rightly observes, "are linguistic entities that implant culture in the larger sense into the depths of science" (197). What then, can one make of the "chosenness" of the code name of a nuclear weapons test? What clues might the names provide us for seeing into the nuclear weapons culture?

One idea is that the code-naming of military operations and other potentially violent projects works towards increasing the distance between image and reality; code names sweeten the task of thinking about the unthinkable. In his classic 1946 essay, "Politics and the English Language," George Orwell described how governments mint nice-sounding phrases to describe less than pleasant realities. "Such phraseology is needed," says Orwell, "if one wants to name things without calling up mental pictures of them" (Orwell 1989, 49). Orwell's illustrations have become standard classroom

"Names ... are not innate in any object but are decided upon by some person or group at some moment in time. Every name represents a distinct choice" (Montgomery 1996, 197).

examples of political euphemism: "Defenceless villages are bombarded from the air, the inhabitants driven out into the countryside, the cattle machine-gunned, the huts set on fire with incendiary bullets: this is called *pacification*. Millions of peasants are robbed of their farms and sent trudging along the roads with no more than they can carry: this is called *transfer of population* or *rectification of frontiers*" (49).

A bomb test named Bambi might be discussed comfortably, whereas a bomb test named Holocaust might be a bit off-putting, even to the weapons specialist. This small example illustrates the idea that assigning a name to nuclear projects is one way to disguise or hide a truth, or to invoke a modernism, to spin the atom.

But, it is also true that choosing names for nuclear tests follows a history of military code names existing well before Trinity. Students of military science know that military and intelligence operations have taken cover behind code names as long as there have been enemies to outwit.

Code names were widely employed in the American Civil War, and in both World Wars, not to mention in the recent Iraq conflicts with offensive names like Operation Desert Storm. Many narratives set during the battles of World War II are enlivened with Navajo Code Talk, or the musical code for the invasion of Normandy based on the motif formed by the four opening notes of Beethoven's *Fifth Symphony*. Even the beaches of Normandy were assigned English-language code names—Omaha, Utah, Juno, Sword, Gold—names by which they are still known to Americans.

During World War II, the assignment of code names to military operations fell to the Army's Operations Division, where a scrambled list of 10,000 suitable words was culled from English dictionaries and atlases. To determine the suitability of the code name, the Army probably applied logic similar to British Prime Minister Winston Churchill's, in a memo of 8 August 1941. The memo was penned as the Prime Minister faced the task of approving a list of code names for forthcoming British operations, where many young men were sure to lose their lives. It was written in the inimitable Churchill style, establishing a sort of operational guide for assigning military code names to sensitive projects. In Churchill's memo, we can sense his concern for considering the psychological and associative power of a name.

I have crossed out on the attached paper many unsuitable names. Operations in which large numbers of men may lose their lives ought not to be described by code-words which imply a boastful and overconfident

Literature students learn early in their studies that names of characters can provide clues to their nature. Charles Dickens gave us some of the more obvious examples with Little Nell, Bumble, Tiny Tim, and Mr. MiCawber. Thomas Pynchon created the insecure but ripe Oedipa Maas, married to disc jockey Mucho Maas. And the list of gauche guests at *The Great Gatsby*'s party includes Mrs. Ulysses Swett, the Ripley Snells, the Smirkes and S.W. Belcher.

sentiment, such as "Triumphant," or conversely, which are calculated to invest the plan with an air of despondency, such as "Woebetide," "Massacre," "Jumble," "Trouble," "Fidget," "Flimsy," "Pathetic" and "Jaundice." They ought not to be names of a frivolous character such as "Bunnyhug," "Billingsgate," "Aperitif" and "Ballyhoo."... After all, the world is wide, and intelligent thought will readily supply an unlimited number of well-sounding names which do not suggest the character of the operation or disparage it in any way and do not enable some widow or mother to say her son was killed in an operation called "Bunnyhug" or "Ballyhoo." (Kahn 1996, 162)

Code names, like England herself, Churchill indicates, should be honorable, traditional, sensible and positive. But, Churchill is clear that code names should not in any way reveal details of the military operation.

The Codes of Los Alamos

Following the military tradition, the story of the Manhattan Project abounds with code words and code names. From the outset, General Leslie Groves, military director of the project, imposed on his band of physicists, chemists, mathematicians, and technicians at Los Alamos a strict set of operating procedures, involving tight security measures, coded language, and compartmentalizing—a strategy he devised in an effort to hinder information exchange across academic disciplines or laboratory halls. Work on specific pieces of the bomb was assigned to an insulated compartment, so that ideally the right hand would not know what the left was doing.

General Groves used a sports metaphor to justify the strategy: outfielders should not think about the manager's job of changing the pitchers, and a blocker should not be worrying about the ball-carrier fumbling; each scientist had his own work to do. He assigned each activity of the Manhattan Project its own coded title and space. There was (and still is, in some cases) the Health Group, the Ordnance Division, the Theoretical Division (called T Division), the Security Division, and the Physics Division (called P Division). In G Division, Gamma rays were focused on optical lenses to create the implosion trigger mechanism of the atom bomb. There was also a division named X.

Communication across the halls and walkways that separated the compartmentalized

units was next to impossible. The random phrase, the slip of the tongue, might fall into enemy hands and deliver up the secrets of the project. Loose lips sink ships, warned the posters hung on the walls of G, T, and X divisions. Once, as the story goes, when a Groves-trained security guard caught technicians casually chatting in the halls, he threatened to send them all off to war in Guadalcanal, the hellhole of the Pacific.

The extremes to which Groves went to shroud Los Alamos in secrecy are well documented in the memoirs written by those who lived there in the Manhattan Project years. Barbed wire ringed the entire complex, and armed military police checked passes and patrolled the perimeters. Sirens summoned workers to their jobs. Portable banks periodically rolled into town to cash checks. Scientists working on the Manhattan Project were known by their code names. Enrico Fermi became Henry Farmer, Niels Bohr was Nicholas Baker, and chemist Harold Urey traveled under the name Mr. Smith. Ernest O. Lawrence was at first assigned the code name Ernest Lawson. When that code name was leaked, security officers assigned him the new name Oscar Wilde, because Wilde had written the play *The Importance of Being Earnest*.

Even the names of the chemical elements undergoing the process of being weighed, mixed, fractured, heated, cooled, and compressed in experiment after experiment were given code names. An atom was referred to as a top. Bombs were boats. Uranium fission was urchin fashion. Uranium-235 was referred to as tenure, because 2-3-5 adds up to 10 and "ure" is short for uranium. Plutonium was called 49, its atomic number backwards. Tungsten carbide was referred to as watercress, because its molecular symbol is WC. The atomic bomb itself was referred to as the gadget or the device, never the bomb.

Time was expressed in code. A hundred-millionth of a second was a shake, a word borrowed from the old expression "shake of a lamb's tail." And, explosive energy was expressed in code. One "jerk" was the equivalent of one quarter of a ton of high explosives. Hence a kilojerk was a quarter of a kiloton, and a megajerk was a quarter of a megaton (McPhee 1973, 83). Testing the delicate points at which tenure or 49 reached criticality was called "tickling the dragon's tail."

People living in Santa Fe, New Mexico, about thirty miles from Los Alamos, knew the community only by the code name The Hill. Mail sent to The Hill was addressed to a dummy location, Box 1663, Santa Fe, New Mexico. Mail sent from The Hill was opened and read by censors.

Peter Bacon Hales summarizes General Groves' restructuring of language for the Manhattan Project: "In between the small issue of words and the large issues of power and authority came an intervening grammar of disconnection.... Creating codes—codes of obfuscation, codes of instruction, codes of punishment—the (Manhattan) District developed one of its most powerful but least visible weapons" (Hales 1997, 244).

In this regime of secrecy, the bomb was developed, step by careful step, from equation to explosion. The rationale for all the undercover coding and caution was survival, perhaps of the human race itself. Germany threatened worldwide takeover and had hinted that it was developing the atomic technology to do so. The scientists at Los Alamos later spoke of a pervasive fear that Nazi Germany would rule the world for ages to come, if Germany were first to develop a nuclear weapon. However, by late 1943, it had become clear to the Manhattan Project scientists that the Germans did not possess the knowledge needed to develop and manufacture an atomic bomb. Many of the same scientists later wondered why they continued to work under the conditions of extreme secrecy and compartmentalizing, once the working premises positing superior Nazi nuclear technology had changed.

In *Secrets*, philosopher Sissela Bok provides two thoughts on the lingering culture of codes and secrecy at Los Alamos. First, she says, after the German situation became known, "Secrecy prevented feedback and criticism from the outside … and the pressures engendered by the moral commitment and the actual circumstances of war were extraordinarily strong." Second, she says, "Secrecy gave the excitement and the sense of uniqueness and power … that led to the continuation of the project" (Bok 1982, 200). In any case, the same Groves-style operating procedures governed the later stages of bomb development and testing, and remained in place far after the war had been won. Arguably, the contemporary weapons laboratories at Los Alamos and Livermore still function in the same manner.

When the time drew near for testing the Los Alamos gadget, the honor of choosing the secret code name for the test was bestowed on Oppenheimer. Two different stories account for his decision to name the test Trinity. Both rely on the fact that Oppenheimer was well-read in just about every academic discipline one can name: the sciences, poetry, religion, the arts, philosophy, and linguistics. The most common story of the naming of Trinity is one told by General Groves in his recollections of the Manhattan Project. When he asked Oppenheimer, several years after the fact, why he had chosen to code name the bomb test Trinity, Oppenheimer answered:

Why I chose that name is not clear; but I know what thoughts were in my mind. There is a poem of John Donne's, written just before his death, which I know and love. From it a quotation:

"As West and East

In all flatt Maps—and I am one—are one

So death doth touch the Resurrection."

That still does not make Trinity; but in another better known devotional poem, Donne opened, "Batter my heart three person'd God." Beyond that I have no clues whatsoever. (Halberstam 1993, 34)

It is quite possible that the phrase "Batter my heart" leaped to the mind of the contemplative Oppenheimer as an echo of the battle raging within his own heart. He knew that developing the gadget might spell endgame for the world, a fear at odds with his keen sense of duty to design and develop an atomic bomb before Nazi scientists. Author David Halberstam writes that Oppenheimer seemed a divided soul, part weapons creator, part romantic innocent seeking solace in poetry. Once Donne's phrase "batter my heart" materialized in the scientist's mind, the imaginative leap to the name Trinity—or the three-personed God—seems automatic.

Historian Marjorie Bell Chambers gives another version of the naming of the Trinity test. She recalls that Oppenheimer had studied Sanskrit and had been reading the Hindu *Bhagavad Gita*. Based on this, she conjectures that Trinity refers not to the Christian paradox of god in three persons but rather to the Hindu concept of a three-personed God: Brahma, the Creator; Vishnu, the Preserver; and Shiva, the Destroyer (Szasz 1984, 41).

One can't help wonder whether Oppenheimer offered the name as a prayer for the future of the race. There was still a chance that Trinity might serve as both the alpha and the omega of the atomic age, that those who witnessed it and knew its name might somehow put the atomic genii back into the bottle, and that a resulting death of the old weapons era would herald a new era of world peace.

What we do know, forty years later, is that the genii roams strong and free, and that whatever the wellspring of the name, Trinity holds first place on a list of 1,054 nuclear weapons tests conducted by the United States between 1945 and 1992.

The Thin Red Book

I n late 1994, I picked up a copy of a thin red DOE publication that lists all 1,054 test names (U.S. DOE 1994), and I fell, more than willingly, down a rabbit hole and into a lexical wonderland.

I read like a child through the 59 pages of code names. Oddly enough, the act of pronouncing the names was, as Orwell implies, pleasurable, like pronouncing the names of apples offered for sale in grocery-store bins. With delight, my tongue lingered on the names Umbrella, Tamalpais, Wrangell, Hudson, Sunset, Dulce, Harlem, Bumping, Pike, Handicap, Noggin, Imp, Hoopoe, and Zucchini. Tests were named for fair cities across the continent: Wichita, Androscoggin, Cimarron, Oakland, Santa Fe, Muleshoe, Nash, Santee, Muskegon, Abilene, and Waco. Or for a river running through a fair city: Truckee, Feather, Humboldt, Hudson, Housatonic, Kennebec, Kootenai, Platte, and Suwannee. Names of New Mexico counties—homelands of the weapons designers—praised in Los Alamos letters and diaries for their beauty, richness of wildlife, and cultural complexity, became names for nuclear tests: Otero, Eddy, Valencia, Colfax, Hidalgo, Lea, Ana, Rio Arriba, Socorro, Caron, De Baca, Chavez, and Mora.

Nuclear tests were assigned names that confirm the literary erudition of the scientists gathered at Los Alamos. The fairy king and queen in *A Midsummer Night's Dream*, Oberon and Titania, became names of tests, and there is a test named Romeo, but alas no Juliet. Weapons designer Ted Taylor named one of his designs Hamlet, after Shakespeare's philosopher prince. Hamlet made nuclear history by proving to be the most efficient kiloton weapon ever tested. Its detonation, in the Marshall Islands, was characterized by high efficiency, high compression, and high criticality proving that, across the centuries, "There are more things in heaven and earth, Horatio, Than are dreamt of in your philosophy" (The Riverside Shakespeare 1974, 1151).

The name of King Arthur's sorcerer Merlin is on the list of nuclear tests. Names of gods and goddesses of the Roman pantheon are there as well: Ceres, Vesta, Mars, Juno, Neptune, and Diana. It is fitting that the names were taken from the Roman pantheon rather than from their earlier Greek archetypes, since the Romans, like the Americans, excelled in engineering feats and battle strategies. The Greeks built beautifully proportioned theaters throughout their countryside and colonies, for staging tragedies, comedies, and satyr plays, but the Romans, giving thanks to their gods, used

The code names King (the official test name for Taylor's Hamlet design) and Mike were assigned to two tests in the Operation Ivy series conducted in the Marshall Islands, in 1952. The names may have provided mnemonic clues to the predicted yields of the bombs. King yielded kilotons of energy and Mike megatons of energy. Two new elements were discovered in the debris from Mike, which bore the classified code-name Project Panda. A few weapons scientists wanted to call one of the newly discovered elements—number 99 on the Periodic Table—pandemonium. Instead, the name einsteinium was settled on the new element.

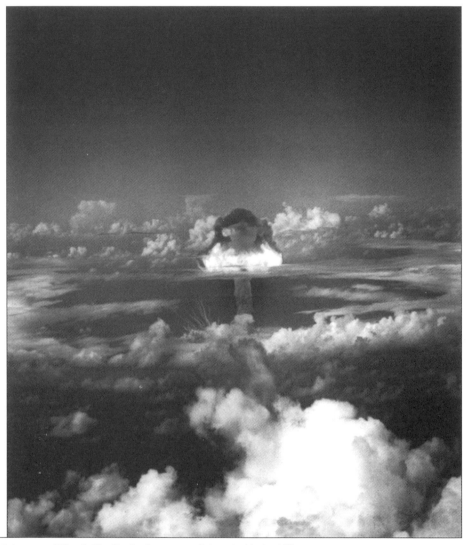

Figure 6.2 **A bomb privately named Hamlet by its designer was detonated in test King, undertaken at the Marshall Islands on 15 November 1952. Photograph courtesy of National Nuclear Security Administration/Nevada Site Office.**

the same theaters for staging gladiator contests, and in at least one instance, flooded a Greek theater with sea water to form a giant tank for staging a mock naval battle.

Tests named Ajax and Dido Queen link the battlefields of myth and history to preparations for the battlefields of the future, intimating at, however unintentionally, the existence of a Western cultural legacy of war and weapons. Weapons test Ajax was exploded on 11 November 1966, on the flats of the NTS. If the Greek bard Homer sings true, this date would come some 3,000 years after Great Ajax, the Achaean warrior, rescued the body of his friend Achilles from the battlefield of Troy. Dido Queen was conducted on 5 June 1973. This test name alludes to the mythical widowed Queen of Carthage, who is a major figure in Virgil's epic *The Aeneid*. In the poem, Prince Aeneas, a Trojan warrior and contemporary of Achilles, leaves the ashes of Ilium, or Troy, to begin a quest that will end in the founding of the city/republic/empire of Rome. On his sea journey west from Troy, he lands on the shores of Carthage, on the North African coast, and falls under the spell of lovely Dido. Aeneas is divided between his head and his heart, destiny and Dido. Rome awaits, but so does Dido. The problem is resolved when Aeneas secretly sets sail from Carthage and steers for Italy, mustering the proper gravitas to fulfill the destiny that lies ahead. The curse of Queen Dido, as she prepares to throw herself on a funeral pyre for love of Aeneas, sows enmity forever between the seed of Aeneas (Italy) and the children of Carthage (North Africa), condemning at least that part of the globe to eternal warfare. Virgil writes: "May they contend in war / Themselves and all the children of their children" (Virgil 1981, 119).

So, generally the names of the tests sound innocent enough. Many of them are beautiful, connected to the natural world, or suggestive of bucolic landscapes, venerated history, or classical literature. And, because of these associations, the list of names forms an Orwellian rhetoric of euphemism. For there is no doubt that each name, in actuality, signifies an experiment with deadly atomic forces, and all together the 1,054 names represent over fifty years of preparation for an extremely hot Armageddon.

United States Nuclear Tests -- By Date					
Test	**Date (GCT)**	**Location**	**Type**	**Purpose**	**Yield Range**
Operation Bedrock -- Continued					
777 Futtock	06/18/75	NTS	Shaft	Safety Experiment	Less than 20 kt
778 Mast	06/19/75	NTS	Shaft	Weapons Related	200 to 1000 kt
779 Camembert	06/26/75	NTS	Shaft	Weapons Related	200 to 1000 kt
Operation Anvil					
780 Marsh	09/06/75	NTS	Shaft	Weapons Related	Less than 20 kt
781 Husky Pup DoD Test	10/24/75	NTS	Tunnel	Weapons Effects	Less than 20 kt
782 Kasseri	10/28/75	NTS	Shaft	Weapons Related	200 to 1000 kt
783 Deck	11/18/75	NTS	Shaft	Weapons Related	Less than 20 kt
784 Inlet	11/20/75	NTS	Shaft	Weapons Related	200 to 1000 kt
785 Leyden	11/26/75	NTS	Shaft	Weapons Related	Less than 20 kt
786 Chiberta	12/20/75	NTS	Shaft	Weapons Related	20 to 200 kt
787 Muenster	01/03/76	NTS	Shaft	Weapons Related	200 to 1000 kt
788 Keelson	02/04/76	NTS	Shaft	Weapons Related	20 to 200 kt
789 Esrom	02/04/76	NTS	Shaft	Weapons Related	20 to 200 kt
790 Fontina	02/12/76	NTS	Shaft	Weapons Related	200 to 1000 kt
791 Cheshire	02/14/76	NTS	Shaft	Weapons Related	200 to 500 kt
792 Shallows	02/26/76	NTS	Shaft	Weapons Related	Less than 20 kt
793 Estuary	03/09/76	NTS	Shaft	Weapons Related	200 to 500 kt
794 Colby	03/14/76	NTS	Shaft	Weapons Related	500 to 1000 kt
795 Pool	03/17/76	NTS	Shaft	Weapons Related	200 to 500 kt
796 Strait	03/17/76	NTS	Shaft	Weapons Related	200 to 500 kt
797 Mighty Epic DoD Test	05/12/76	NTS	Tunnel	Weapons Effects	Less than 20 kt
798 Rivoli	05/20/76	NTS	Shaft	Weapons Related	Less than 20 kt
799 Billet	07/27/76	NTS	Shaft	Weapons Related	20 to 150 kt
800 Banon	08/26/76	NTS	Shaft	Joint US-UK	20 to 150 kt
Operation Fulcrum					
801 Gouda	10/06/76	NTS	Shaft	Weapons Related	Less than 20 kt
802 Sprit	11/10/76	NTS	Shaft	Weapons Related	Less than 20 kt

Figure 6.3 **A copy of a page from U.S. Department of Energy, United States Nuclear Tests: July 1945 through September 1992. The document lists the names of all the 1054 Nuclear Tests conducted by the United States. Courtesy of the U. S. Department of Energy.**

Patting the Bomb

Author Carol Cohn offers us a valuable and refreshing framework for examining Orwellian euphemisms commonly employed within the nuclear establishment. While attending a summer workshop on nuclear weapons and arms control, she took a field trip to the New London, Connecticut, Navy base, where she was invited to pat a nuclear missile. "What is all this patting?" she asks her reader. "It is … what one does to babies, small children, the pet dog. The creatures one pats are small, cute, harmless, not terrifyingly destructive." Why is it, she asks, that domestic, "even warm and fuzzy, names have been assigned to missiles, warheads, bombs and military maneuvers, removing them, in effect, from the reality of their deadly purposes and rendering them in the public imagination pets to pat" (Cohn 1989, 57).

Cohn is referring to the domestic connotations of the terms Missile Silo and RVs (reentry vehicles), but her analysis might apply as well to the domestic nomenclature assigned to nuclear weapons tests, including the categories satchels: Carpetbag, Purse, and Portmanteau; hearthside games: Chess, Lowball, Rummy Draughts, Hearts, and Backgammon; and country house and garden features. Cottage, Farm, Hutch, Garden, and Puddle Grove.

Conceding that ordinary abstraction—assigning say numbers instead of code names—would perform the same distancing function, Cohn claims, "These domestic images are more than simply one more way to remove oneself from the grisly reality behind the words…. The images evoked by these words may also be a way to tame the uncontrollable forces of nuclear destruction. Take the fire-breathing dragon under the bed, the one who threatens to incinerate your family, your town, your planet, and turn it into a pet you can pat" (57).

Harvard professor Elaine Scarry observes that a great number of weapons and military missions that can kill or maim were assigned code names from the realm of vegetation because "vegetable tissue, though alive, is perceived to be immune to pain;

thus the inflicting of damage can be registered in language without permitting the entry of the reality of suffering into the description" (Scarry 1985, 66). More than 50 nuclear tests were assigned botanical names, from Apple, Apple-2, and Zucchini in 1954 to the more than 34 tree names used for 1958 Marshall Islands tests, including Sycamore, Maple, Aspen, Walnut, Linden, Redwood, Elder, Cedar, Sequoia, Olive, and Pine.

Scarry theorizes further that the names of steel, wood, iron, and aluminum implements are used in military operations because they refer to materials of "unequivocal nonsentience" (66). Atomic tests named for tools and implements include: Piton, Bevel, Hatchet, Bit, Adze, Rivet, Scissors, Spoon, File, Drill, Auger, and Winch.

Iron implements and tools are metonymic reminders of primitive aggression. For instance, we do hatchet jobs on others, place forks in our opponent's arguments, and drill those we wish to overpower. President Truman, while waiting in Potsdam for word of the success or failure of Trinity, exclaimed: "If it explodes—as I think it will—I will certainly have a hammer on these boys" (Halberstam 1993, 24).

Fathers and Sons

Whether euphemism or irony was deliberate on the part of those who named atomic tests or operations—Apple, Climax, Operation Teapot—is a question I can't answer. However, semanticists and psychologists alike have long noted that many of the images at work in naming bombs, and discussing bomb tests, are deliberately paternalistic and sexual, linked to copulation and birth. In these instances, the lexicon might manifest or echo the psychology of desire. Records of the conversations among, and between, weapons designers and test administrators are filled with references to bombs as offspring.

At Los Alamos Scientific Laboratory, on the eve of Trinity, there was much discussion over whether the bomb would be a boy (a success) or a girl (a fizzle). In addition, many tests were assigned names that suggest the designer or test director felt a parental kinship with his procreation. Bomb tests were named Little Feller, Danny Boy, Johnnie Boy, Small Boy, Husky Pup, Tiny Tot, Little Dan, and Little Feller II, and, of course, the most famous bomb of all was named Little Boy.

With some sleuthing, we can piece together the story of the naming of Little Boy, and follow the birthing imagery as it unfolded. Little Boy was originally assigned the

name Thin Man, for the gaunt President Franklin Roosevelt (and Fat Man was named for the portly Prime Minister Winston Churchill), but the name was changed before it could be used, most likely because of Roosevelt's death in April 1945, four months before the bomb renamed Little Boy was dropped on Japan.

The name Little Boy shows up in a coded telegram, composed following the stunning success of the Trinity test. The message was sent early on the morning of 16 July 1945, by George Harrison, acting Congressional chairman of the Interim Committee on S-I (the bomb) to Secretary of War Henry L. Stimson, who was in Potsdam with President Truman. The telegram reads: "Doctor Groves has just returned most enthusiastic and confident that the little boy is as husky as his big brother. The light in his eyes discernible from here to Highhold and I could hear his screams from here to my farm" (Szasz 1984, 145).

The coded language unveiled the size of the test. The light in the little boy's eyes (referring to the bomb flash) would reach from here (Washington, D.C.) to Highhold (Stimson's Long Island farm, 200-miles distant). The screams (the sound of the explosion) would reach from Washington, D.C. to "my farm" (Harrison's home in Cooperville, Virginia, some 40 miles away). From these clues, the yield of the Trinity bomb, 21 kilotons, could be arrived at. The naming of the delivery doctor, "Doctor Groves" (General Leslie Groves), clinched the telegram's meaning. Less than one month later, the bomb renamed Little Boy exploded over Hiroshima.

A few more examples of paternalistic and affectionate adoptions by a designer of a nuclear bomb have slipped through the censor's pen and entered declassified documents. I mention censors because the code names of the bombs themselves, as opposed to the code names of the bomb tests, are still classified, with the exception of Fat Man and Little Boy. A bomb privately named Shrimp by its designer exploded in the catastrophic Bravo test on Bikini Atoll in 1954. Maybe reverse psychology was at work, as Shrimp, to the delight of its creator, turned out to be anything but tiny, producing a record 15-megaton yield, the equivalent of 150,000,000 tons of TNT, or 10,000 Hiroshima Little Boy bombs.

During that same Marshall Islands series—Operation Castle—weapons were tested that had been nicknamed by their designers Jughead, Zombie, Runt, and Alarm Clock. Except for Alarm Clock, these names conjure up images of a good-natured father addressing his lethargic son.

Two years earlier, megaton Mike, a cryogenic nuclear mass said to resemble a

giant refrigerator, proved in a 10.4-megaton burst that the thermonuclear physics demonstrated by good boy George might be successfully applied to nuclear weapons designs. Scientist Edward Teller wired Los Alamos from the Marshall Islands exclaiming: "It's a Boy" (Gusterson 1996, 162).

Teller is often introduced as father of the H-bomb, for his breakthroughs in design ushered in new generations of weapons. However, anthropologist Hugh Gusterson, who spent several years studying the culture within Lawrence Livermore National Laboratory (formerly the Lawrence Radiation Laboratory), observed that within the weapons labs there were debates among designers about whether Teller was really the father of the H-bomb or whether he had in fact "been 'inseminated' by the mathematician Stanislaw Ulam and had merely 'carried' it" (Gusterson, 1996, 162).

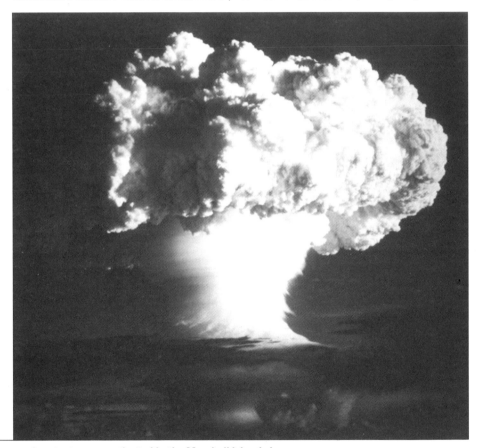

Figure 7.1 **Mike, a thermonuclear test, was conducted in the Marshall Islands in 1952 as part of Operation Ivy. Photograph courtesy of National Nuclear Security Administration/Nevada Site Office.**

In 1954 Teller described his role in the H-bomb design and development using explicit images of copulation and conception:

It is true that I am the father in—[the] biological sense that I performed a necessary function and let nature take its course. After that a child had to be born. It might be robust or it might be stillborn, but something had to be born. The process of conception was by no means a pleasure; it was filled with difficulty and anxiety for both parties. My act ... aroused the emotions associated with such behavior. (Rhodes 1986, 773)

Images of insemination are undeniable in the transcript of a June 1949 meeting of the Joint Congressional Committee of Atomic Energy. Senator Bourke Hickenlooper of the Joint Committee and Dr. Robert Bacher of the Los Alamos Scientific Laboratory were discussing the 1948 Operation Sandstone:

Senator Hickenlooper: Were not the weapons tested at Eniwetok [sic] conceived during Manhattan District days and laid aside for testing later? Dr. Bacher: If by "conceived" you mean that there was a gleam in the eye, then I would agree with you. (Hansen 1998, 31)

Carol Cohn interprets much of the sexual imagery used by weapons specialists through feminist eyes: "Sexual imagery, even if disturbing, seemed to fit easily into the masculine world of nuclear war planning" (Cohn 1989, 57). She believes that even the patting of bombs and missiles is "an assertion of intimacy, sexual possession, affectionate domination. The pleasure of patting a missile derives from the proximity of all that phallic power, the possibility of vicariously appropriating it as one's own" (56).

Physician Helen Caldicott, who made famous the phrase Missile Envy (also the title of her book), speculates about the Freudian connections between sex and birth and weapons of mass destruction. Large and potent weapons, she says, "may be symptoms of several male emotions, reflecting inadequate sexuality, a need to prove virility, and primitive fascination with killing" (Caldicott 1986, 238). Watching a movie of the launching of an MX missile, Caldicott finds the weapon a "very sexual sight indeed; more so when armed with the ten warheads it will explode with the most almighty orgasm" (238).

Carol Cohn confesses that she had always considered Caldicott's phallo-centric analyses of sexual imagery and language used within the weapons culture to be "an uncomfortably reductionist explanation," and that she had expected the men she worked side by side with "to have cleaned up their acts" (Cohn 1989, 54). To the contrary, Cohn was able to add to Caldicott's examples, gleaned from lectures she attended that were filled with "discussion of vertical erector launchers, thrust-to-weight ratios, soft lay downs, deep penetration and the comparative advantages of protracted versus spasm attacks—or what one military advisor to the National Security Council called 'releasing 70 to 80 percent of our megatonnage in one orgasmic whump'" (55).

Anthropologist Gusterson attributes the use of sexual imagery within Lawrence Livermore National Laboratory to the fact that intimacy became commonplace within the laboratory walls. He adds his own examples to the list of sexually explicit expressions used in connection with weapons testing: When a device is lowered into an underground shaft for detonation it is "married" or "mated" with a diagnostic canister full of sensitive instruments and cables. Gusterson explains, "After the bomb has been married to the diagnostic canister, it couples with the ground, producing daughter fission products that go through generations." One weapons designer confessed that he felt postpartum depression after a test (Gusterson 1996, 162).

Gusterson postulates that some weapons designers share sexual language and metaphors as a way to find affirmation in a technology associated with death. The language of babies, births, and breeding gives hope, renewal, and life to the enterprise of designing and testing nuclear weapons.

Lest we assume that the nuclear age coded language and sexual innuendo is only an American historical curiosity, more recent examples have been uttered outside U.S. borders. In May 1998 India detonated five nuclear weapons code named Shivka-I through Shivka-V. Shivka translated from the Hindi means power. In defense of India's actions, Hindu nationalist Bal Thackeray claimed, "We have to prove that we are not eunuchs" (McGeary 1998, 40). Thackeray's remark might be a delayed rejoinder to one made in the 1960s by American General Jim Walsh. Helen Caldicott tells the story that when Walsh was asked at a cocktail party, held at Strategic Air Command Headquarters in Omaha, whether America should aggressively use the bomb abroad, Walsh shouted, "[T]here is only one way to attack … and that's to rip them hard with everything we have, and knock their balls off!" (Caldicott 1986, 75).

Plowshare and Sunshine

Nowhere is Orwell's ghost more luminous than in nuclear projects named from the Bible. Project Plowshare was developed by the AEC and others in the late 1950s to find peaceful uses for split atoms. The word plowshare is a reference to the *Old Testament* prophecy of Isaiah 2:4: "And he shall judge among the nations, and shall rebuke many people; and they shall beat their swords into plowshares, and spears into pruning hooks; nations shall not lift up sword against nation, neither shall they learn war any more."

The story is told that the name Plowshare was adopted when physicist Harold Brown described to I.I. Rabi, of Lawrence Radiation Laboratory, his idea that nuclear devices could be detonated to serve the needs of business and industry, accomplishing, for example, colossal excavation projects and the explosive release of natural gas from underground bedrock. Rabi shot back, "So you want to beat your old atomic bombs into plowshares" (Pringle and Spigelman 1981, 156).

The name Project Gabriel was borrowed from biblical narratives of prophecy. In the book of Daniel, the angel Gabriel interprets one of Daniel's dreams or visions to mean: "[A] king of fierce countenance, and understanding dark sentences, shall stand up." In the New Testament book of Luke, it is Gabriel who announces to Mary the impending birth of Jesus.

Project Gabriel, despite the seraphic name, was one of the most cynical and sinister of nuclear projects. Sometimes referred to as Gabriel's Horn, Project Gabriel called for the assessment of nuclear fallout patterns from the 1946 Operation Crossroads. The emphasis was on tracing the path of strontium-90, known to be a bone-seeker and a dangerous fallout particle. In 1955 the strontium-90 tracing project was subsumed within a new plan, named innocuously, Project Sunshine. Its mission expanded the goals of Project Gabriel to include assessing absorption in crops and people of strontium-90 worldwide, from all atomic testing. Among substances tested were alfalfa, animals, dairy products, human bones, and rainwater.

The name Project Sunshine, a clever deployment of euphemism, originated as part of the crusade of public health official Dr. Merril Eisenbud to reduce the public relations problems arising from public fear of fallout. Eisenbud often went before cameras and microphones to tell people they were not receiving radiation from bomb fallout, but rather natural doses of sunshine units. The problem is not merely that

"Surely the Hebrew prophet Isaiah could not have imagined that nearly three millennia after he predicted, 'And they shall beat their sword into plowshares,' his hope would be adopted by a nation wrestling with the most powerful instrument for destruction ever created by Homo Sapiens" (Buys 1989, 38).

euphemisms have been employed in the weapons culture to mask danger or otherwise fool the public, but that the use of euphemisms can change the way we think about an event, a person, an object, or the wide world around us. Science fiction writers, including Orwell and his contemporary Aldous Huxley, understood that if you call black "white" for a long enough period of time, the black, well, is white. While radiation never quite became sunshine units in the public mind, the effort to make the equation stick continues today.

Administrators of Project Sunshine collected samples of crops, soil, and bones at over 100 stations in the United States, and from 20 foreign countries. The goals of the project were classified, and cooperating institutions were told that the samples were being collected for nutritional studies. During a second phase of Project Sunshine, cadavers were purchased from pathology labs so the bones might be tested for strontium-90 uptake. The AEC itself, in an internal memo, described the process as body snatching: "Human samples are of great importance and if anybody knows how to do a good job of body snatching, they will really be serving their country" (Agency Sought Cadavers … 1995, A3). During a third phase of Project Sunshine, radioactive particles were deliberately released from the Hanford, Washington nuclear reactor so that their trajectories might be traced around the world.

The dark directives of Project Sunshine are the subject of continued research, interpretation, and debate. In *Darkness in El Dorado*, anthropologist Patrick Tierney chronicles the entrance of Project Sunshine into the land of an Amazonian tribe, called the Yanomami. According to Tierney, in 1956 the AEC established a bone-sampling center in Venezuela and trafficked in native blood and bones. The Yanomami was selected because the primitive populations live in areas where soils are low in calcium. Because strontium-90 finds its maximum uptake in individuals with bones low in calcium, the Yanomami were chosen to serve as ideal markers for the high end of the strontium-90 uptake curve.

Tierney also claims that the AEC injected the uninformed Yanomami and Maquiritare Indians with radioactive iodine. The study determined, "Yonomami have astonishing capacities to concentrate radioactive iodine-131 in their thyroid glands" (Tierney 2002, 307). Jay Stannard, who authored an analysis of the Sunshine Project study confessed, "I don't think the tracer experiments benefited the patients, but they increased our knowledge" (307).

This brief look at patting bombs and assigning names like Sunshine and Gabriel to

disturbing nuclear projects is meant to demonstrate that language can indeed be used to make the unthinkable thinkable. But, present in the narratives is a nagging subcurrent. Within the nuclear weapons culture, language works daily to separate insiders from outsiders, to marginalize the unknowing, even when the language seems innocent enough. Carol Cohn reveals that when she began a yearlong study among defense intellectuals engaged in U.S. nuclear strategic practice, her goal was to come to terms with the question, "How can they think this way?" Gradually, as she became more engaged with their information and their arguments, she found that she had to address a new question, "How can I think this way?" (Cohn 1989, 53) Acquiring specialized insider knowledge and using arcane language became "thrilling" (59). She had almost crossed over to the inside. Proof that she caught herself in time is the witty and self-aware tone of the article.

Partly as a result of the Los Alamos history of codes and secrecy, and partly because working on nuclear weapons demands arduous and lengthy scientific training and rare skills, a unique insider nuclear weapons culture, sometimes likened to a secular priesthood, has flourished on American soil. The power that attends this priesthood is increased as the language becomes more technical and rarified, until the priests can participate with confidence in projects like Sunshine, and give statements like "The Yonomami have astonishing capacities to concentrate iodine-131 in their thyroid glands." Elsewhere, I have used the term nuclear colonialism to examine the language used to site nuclear proving grounds. The term takes on wider meaning in light of the Yanomami experiments, where colonialism, even in the traditional sense, is a narrative theme. In actuality, the use of insider language and euphemism by nuclear experts, whether, as we've seen, to select testing sites, to promote atomic testing, or to disguise goals of projects like Gabriel and Sunshine, is evidence of a colonial power structure, and it works daily to marginalize everyone outside the priesthood.

Dirty Harry

The legacy of any given nuclear test—or its connection to other historical or cultural events—has more than once cast a backward shadow over its name, creating an opportunity for semantic skewering. The most widely known example of this kind of hindsight irony concerns the 1953 Harry test, which, because of fallout over St. George, is known in Utah as Dirty Harry.

The name of a test detonated in 1962 apparently slipped by agents in charge of political correctness and double entendres. The name is Dead. Maybe it was related in some way to another sleepy, low yield test in the same series named Dormouse.

A 1965 underground test at the NTS named Screamer accidentally released radiation, in the way steam escapes a boiling pot when pressure lifts the lid. The incident sent test-site workers scrambling, no doubt practicing the name of the test. A 1966 underground test code-named Red Hot earned its name in the same way, by accidental release of radiation. In 1968 Imp mischievously spilled 4,200 curies of radiation into the air, and in the same year, a Department of Defense (DOD) test named Milk Shake shook the site so hard that radiation was once again accidentally released. The test Faultless (described in chapter eleven), undertaken in 1968, was named with the hope that it would demonstrate the geologic stability of an area in Central Nevada. When detonated underground, the megaton explosion created massive fault blocks on the surface of the site, with abrupt land drops in some areas of over eight feet, sending its code name into the pantheon of satire.

Tests conducted in the Johnson Island area, in 1962, were named Bluegill 3 Prime, Kingfish, and Starfish Prime, species of ocean creatures that had been irradiated in the waters off Bikini Atoll earlier in testing history. David Bradley, a physician assigned as a "Geiger man" to the Radiological Safety Section at Bikini for the Crossroads tests, describes in *No Place to Hide* how they discovered that lagoon life was radioactive. Days after test Baker, Bradley's crew netted fish from the nearby waters, sliced them in half, and laid the halves, flat side down, on photographic plates. The irradiated fish took their own photographs—radio-autographs—as Bradley called them (Bradley 1948, 28).

This auto x-ray process clearly helped marine biologists see how and where radiation was stored by fish—in the gills, the liver, the intestines, and the organs of reproduction. Since that time, we have discovered that there are similar patterns to radiation absorption and storage in humans, particularly in the organs of reproduction.

Sixteen tests conducted during the 1956 Operation Redwing series at the Marshall Islands were named for American Indian tribes, including Cherokee (the first hydrogen air-drop), Zuni, Yuma, Erie, Seminole, Flathead, Blackfoot, Kickapoo, Osage, Dakota, Mohawk, Apache, Tewa, Huron, and Navajo. We can locate irony in the very image of the government using names of American Indian tribes in operations that depended on the subjugation of the native peoples of the Marshall Islands, but the

names of individual Operation Redwing tests invite delving into the backward lexical shadow. It is likely that the uranium used to make the trigger for the giant 4.5-kilotron Navajo test came from the tribe's own land and at immeasurable cost to their health. In 1941 uranium was discovered on the Navajo reservation. Processed into what is called "yellow cake," or uranium oxide, the ore was shipped to Los Alamos for the manufacture of the Trinity bomb, Fat Man, and Little Boy. After the war, between 1946 and 1968, Navajo tribes mined 90,000 acres on the reservation for uranium ore, producing 13 million tons used to make more nuclear bombs. Valerie Kuletz, author of *The Tainted Desert*, and other scholars maintain that throughout the postwar period Navajo miners and their lands were exploited by the nuclear weapons industry.

Native American miners were paid two-thirds of what non-reservation workers earned, and their homelands were left severely polluted. Scores of Navajo miners later died of leukemia and lung cancer, as a result of their direct handling of the radioactive ore. A high rate of birth defects has been recorded among their progeny. A study undertaken by Dr. D. Calloway of the Navajo Health Authority suggests that as a result of toxic tailings and polluted ponds near the uranium mines, Navajo children suffer much higher rates of bone, ovarian, and testicular cancer than the U.S. average (Kuletz 1998, 24–27).

Members of the Tewa tribe inhabited the mountains and valleys that now make up the Los Alamos National Laboratory complex. The rocks and springs worshiped by their ancestors are certain now to be dusted with the radioactive elements that escaped from the laboratory and field experiments conducted over the past sixty or so years. The Apache tribe shares a piece of history with the atomic bomb. In 1945 two hundred members of the tribe lived within the projected fallout path of the Trinity test. The Los Alamos medical division proposed that tribal members be evacuated before the test. However, General Groves fumed over whether such an action might compromise the secrecy of the test. Word might even leak to the newspapers. "What are you?" Groves shouted to one of the medical officers supporting the Apache evacuation, "A Hearst propagandist?" The Apache remained, neither forewarned nor forearmed, in the shadow of the bomb (Pringle and Spigelman 1981, 189).

Although it's a bit of a stretch, we can locate historical irony in the name of the seventeenth test in the Redwing series, Lacrosse—a game played by Iroquois tribesmen "since the Creator gave us the game," and a popular sport at Anglo-American prep schools and on Native American reservations from New York to California

(Seabrook 1998, 30). The game played a part in military strategy at least once before Operation Redwing. In 1763, British soldiers camped on the shores of Lake Michigan threw open the gates of their fort, the better to view a game of lacrosse being played between the Ojibwa and Ozaagii tribes. The British were so engrossed in the game that they were caught unawares when the Indians flung the lacrosse ball through the fort's gate, and commenced a cleverly planned massacre of the soldiers.

One can have a field day with tests named after flowers. While tests named Zinnia, Dianthus, Canna, Harebell, and Beebalm were underway at the NTS, botanists at Brookhaven National Laboratory, in Upton, Long Island, were quietly beaming powerful gamma rays of cobalt-60 onto the center of the world's first atomic garden. Reporter Daniel Lang visiting Brookhaven observed that near the edges of the garden the plants grew normally. However, upon more careful examination, he noticed that closer to the source—the beam of cobalt-60—the plants looked more and more grotesque. Trees "squatted" on the ground; a strawberry was a "repulsive, lopsided blob"; tobacco plants grew leaves half an inch wide instead of the normal six inches. The Brookhaven scientists developed a carnation that bloomed with snow white and blood red blossoms on the same stem (Lang 1959, 82).

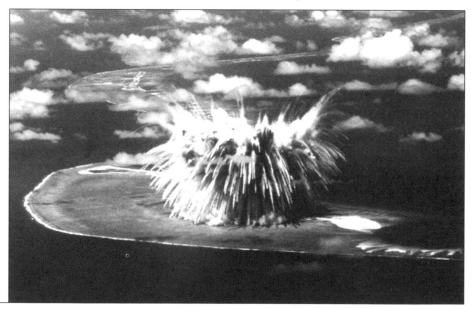

Figure 7.2 **Seminole, part of Operation Redwing, was detonated at the Marshall Islands on 6 June 1956. Photograph courtesy of National Nuclear Security Administration/ Nevada Site Office.**

Occasionally, a name used to identify a nuclear event began as an off-the-cuff quip, but, after use in private circles, took on quasi-official status. In 1949, when American scientists discovered through the analysis of radioactive fallout that the Soviets had tested an atom bomb, they immediately dubbed the bomb Joe One for Joseph Stalin. (The Russians called their test First Lightning.) Later in atomic history, when India detonated its first nuclear weapon underground, in 1974, Americans referred to it as Smiling Buddha, because (according to which urban legend you believe) the Indian Prime Minister, Indira Ghandi, or her Director of Atomic Research, Dr. Raja Ramanna, after seeing proof of the bomb's success in the form of a subsidence crater shaped like a smiling face, is said to have exclaimed, "The Buddha has smiled" (When the Buddha Smiled).

While Los Alamos scientists referred to the atomic bomb as the gadget, the hydrogen bomb from its earliest theoretical design was the super. In 1942 a formal status report was issued from the Executive Committee of the National Defense Research Council to Vannevar Bush, of the same body, dramatically announcing the super bomb: "If this unit is used to detonate a surrounding mass of 400 kg of liquid deuterium, the destructiveness should be equivalent to that of more than 10,000,000 tons of TNT. This should devastate an area of more than 100 square miles" (Rhodes 1986, 421).

Author Richard Rhodes captured in thrilling words the avant-garde nature of calling the hydrogen bomb the super: "[F]rom the pre-anthropic darkness where ideas abide in nonexistence until minds imagine them into the light, the new bomb emerged already chased with the technocratic euphemism of art deco slang: the Super, they named it" (417).

Playing off the nickname super, the first AEC Chairman, David Lilienthal, referred in his personal diary to the hydrogen bomb as Campbell's, as in Campbell's Soup. Campbell's (or the soup-er) was joined by Wheaties, when an atomic project earned the pop-culture tag Project Wheaties. That name referred to the goal of President Eisenhower to develop peaceful uses for atomic energy, as he outlined in the famous "Atoms for Peace" speech, delivered to the United Nations General Assembly on 8 December 1953. The name Wheaties was coined because the initial brainstorming session for President Eisenhower's speech took place at a breakfast meeting at the White House. The final address given to the General Assembly was an international hit, reprinted in over 100 languages. However, it wasn't long before the Project Wheaties /

Atoms for Peace model earned a new name. Critics skeptical of Eisenhower's vision of internationally shared atoms and cheap power began slyly to call his plans Kilowatts for Hottentots (Pringle and Spigelman 1981, 122).

For aficionados, a catalogue exists of the names of the United States nuclear tests (U.S. DOE 1994).

Weapons Effects and Civil Effects

Behind the resplendence of an atmospheric atomic test—the blinding flash, the rising fireball, the distinctive mushroom cloud—scientists, technicians and military personnel were at work experimenting with and documenting the less visible effects of the detonation. Weapons Effects experiments and Civil Effects Tests were designed to measure the results of atomic heat, blast, and radiation on a variety of animate and inanimate objects, situated at varied distances from ground zero: included were mice, pigs, guinea pigs, dogs, rabbits, dummies, mannequins, tanks, ships, airplanes, motel units, bomb shelters, airstrips, potatoes, wheat, corn, breakfast cereal, and even peanut butter and jelly. The scientific lab reports, which were published following each of these experiments, form an eerie record of the largely unseen and only partially reported Weapons Effects and Civil Effects experiments, and create an opportunity for further examination of rhetorical strate-gies used to promote and justify nuclear testing.

Atomic Weapons Effects experiments, like bomb tests, began in humble ways. On Trinity eve, dozens of mice were hung by their tails on a piece of rope, strung like socks on a clothesline. They were carefully counted, then placed at a measured-off distance from ground zero, calculated to prevent them from frying in the heat of the blast before scientists could observe the effects of large doses of radiation on their biological systems. However, the mice died of thirst before the bomb was exploded (Pringle and Spigelman 1981, 189). The premature deaths of the Trinity mice brought to a dismal finish the first Weapons Effects experiment on a biological species.

Simple beginnings of mice and rope gave way to ever more numerous and complex experiments. In *No Place to Hide*, physician David Bradley sums up Weapons Effects experiments conducted at Bikini Atoll, during the 1946 Operation Crossroads: "What started as a simple laboratory experiment, to determine the effectiveness of the Bomb used above and under water, became the most complex and intricate project imaginable" (Bradley 1948, 42). As Bradley further explains, the U.S. Navy wanted

to test "almost everything that floats: American ships, German ships, Japanese ships, flattops, submarines, battleships, cruisers, destroyers, landing craft, ships made of riveted plates, ships made of welded plates, floating dry docks made of reinforced cement, even seaplanes" (47).

Marine biologists studied weapons effects on an array of marine life; oceanographers studied weapons effects on the coral reef; and the Naval Medical Research Group studied weapons effects on goats, pigs, guinea pigs, and more mice.

Following Operation Crossroads, Weapons Effects experiments continued to metastasize, the result of a feverish quest by atomic scientists and military strategists for more and more information about the effects of heat, blast, and radiation.

The Plumbbob Papers

The 11 August 1951 issue of *Collier's* magazine featured an article entitled "Patty, the Atomic Pig." The article was based on an actual incident in which a piglet—part of the Noah's Ark of goats pigs, rats, and other experimental animals assembled for the July 1946 Operation Crossroads nuclear test at Bikini Atoll—was later found swimming in the radioactive waters of the Bikini lagoon. The *Collier's* story, presented as a whimsical fairy tale, began: "Once upon a time, there was a great group of generals, admirals, scientists, newsmen and curious people who wanted to know more about atomic explosions." In the tale, Patty not only survives but grows to be a "very cute six hundred pound porker" under the benevolent care of government scientists (Boyer 1998, 253).

Each Weapons Effects experiment was written up in a laboratory report. The sanitized names of the reports belie their creepy contents: "Biomedical and Aerosol Studies Associated With a Field Release of Plutonium," "Secondary Effects of Blast Displacement," "Tertiary Effects of Blast-Displacement," and "Blast Biology—A Study of Primary and Tertiary Effects of Blast in Open Underground Protective Shelters."

Opening the pages of these reports, we step behind the tourist view of testing and enter into the scientific world of the atomic experiment. To read them is to enter a parallel universe where the words sound familiar enough, but linked together they create images that step from the realm of science fiction: dogs dosed with plutonium, pigs dressed like pilots, mannequins cut to pieces, and soldiers marched into nuclear ground zero. The reports are extraordinary chronicles, not only because they describe astonishing experiments, but also because they include weights, measures, quantities, and calibrations of all sorts, for dogs and pigs and mice, for their food rations and living quarters, and for recovered mannequin body parts. Most of the data of quantification seems appropriate to a laboratory report, and yet some of it is curious, creating a unique discourse at once reinforcing the objectivity of the science and undercutting it.

In one Weapons Effects experiment, undertaken during Operation Plumbbob and documented in the report "Biomedical and Aerosol Studies Associated with a Field Release of Plutonium," explosives were used to release plutonium into the air in order to expose animals to the plutonium and study its effects on their lungs. Some of the

animals were collected from the field immediately following the plutonium release and studied for acute effects of plutonium inhalation; others were left in the field to breathe it for days, weeks, even months before being driven to an AEC laboratory for study of chronic effects of plutonium inhalation.

The resulting report of the experiment describes how prior to the explosion eighty-three dogs were flown from Buffalo, New York, to Indian Springs Air Force Base, near the NTS, in boxes measuring 15 x 24 x 22 inches. Shipped along with the dogs were 10,000 pounds of supplies inventoried in the report, ranging from string and masking tape to surgical instruments. The dogs were placed in kennels heated to temperatures of 72 to 75 degrees Fahrenheit, to acclimatize them to their new desert home. They were fed measures of "Kasco Meal, moistened to firm pudding consistency" (Operation Plumbbob: Test Group 57 1961). As a result, they fattened up so quickly that they were placed on diets by AEC veterinarians.

The acute exposure subjects were placed in pairs into custom-designed exposure cages, measuring 12 x 6 x 6 feet, neatly divided into 6-foot cubes, one for each dog. The cages were positioned at exposure stations spaced 500, 1,000, and 2,000 feet from the detonation site. Sunshades, normally part of the cage design, were removed "so there would be no possibility of the animals being sheltered from the cloud." And so, "In general," the report notes, "animal comfort was found to be good … the dogs were not subject to loneliness" (Operation Plumbbob: Test Group 57 1961).

The explosion commenced, dispersing the plutonium over the desert and the un-sheltered dogs. As soon as the area was declared safe enough for crews to enter, the dogs were transported from their desert cages to a decontamination area, where they were vacuumed and then bathed in 10 gallons of warm sudsy water. They were dried, inspected for radioactivity, and then transported to an autopsy trailer in Mercury, Nevada, where they were killed with "Lethol, Ethanol, or Nembutal" and "their carcasses bled out and skinned in a skinning shed … erected near the trailers in order to ensure privacy during this phase of the autopsy procedure" (Operation Plumbbob: Test Group 57 1961).

Animals tagged chronic subjects, including sheep and burros, as well as dogs, were left in the field for periods of 4, 8, 16, 32, 64, 96, and 128 days. Then they were transported to Mercury for autopsy in the manner described above.

In another animal experiment undertaken during Operation Plumbbob and written up in the report "Blast Biology," 24 dogs, 8 pigs, 50 rabbits, 100 guinea pigs, and 380

mice were loaded into underground bomb shelters for the purpose of subjecting them to blast, thermal radiation, and fallout from a full scale atomic test (as opposed to exposure to plutonium released by a non-nuclear explosion).

Numbers and curious details again characterize the report. The 24 dogs were numbered with a thick, black indelible marker: K-1, K-2, K-3, and so on, then placed in stations counterclockwise to their numbers. Harnesses were snapped to restraining lines that were fastened to the walls or ceiling of the shelter. Sufficient slack was left in the line so that the "harness would not interfere with the possible trajectory of the animal," but would ensure his recovery. The report contains more odd comfort details: the dogs had been kept well-fed and disease-free, like their counter-parts in the plutonium experiment. Furthermore, the report describes how the dogs were conditioned to calmly face their doom: "[A]ll the dogs were trained to the harness and the muzzle and to being restrained as in the shelters in order that they would become accustomed to the procedure" (Operation Plumbbob: Project 33.1 1959, 18).

Another animal experiment was gruesomely nicknamed the "Charge of the Swine Brigade." Pigs were dressed in flight jackets and army uniforms, some treated for flammability and some not. Other pigs were left bare, with different brands of sunscreen and lotion applied in geometric patches to test their protection against what the scientists called "atomic sunburn." The pigs were positioned, like the dogs in the exposure experiment, at varied distances from ground zero, where the heat of the blast fatally burned most of them. Reports on this experiment emphasized the tender care and feeding of the pigs in the days preceding the detonation, earning the sty its nickname: Pork Sheraton.

The comfort and quantification details placed next to the details of death impart to the reports a distinctive tone—both subjective and objective, fuzzy warm and frigidly cold, all at once. Why is canine loneliness or the lack thereof part of the report? Why is the privacy of the skinning process observed? Why is the accommodation of the dog to harness or the care and feeding of the sacrificial swine so carefully recorded? Can comfort be measured like plutonium uptake to the lungs, or dismemberment? The rhetoric employed and the details selected lead us to wonder (as in the naming of atomic tests) whether a deeper motivation might be at work.

Social scientist Max Weber described the modern scientific method, born of the enlightenment and consisting of weighing and measuring, calculating and calibrating, as robbing the world of its enchantment, its mystery, in the name of "instrumentalized"

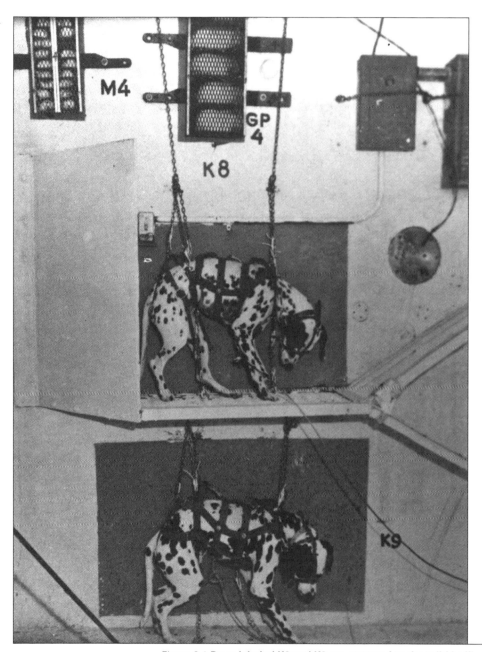

Figure 8.1 **Dogs labeled K8 and K9 are strapped to the solid baffle and shelf on wall 4 of shelter 8001 awaiting an atomic blast. Photograph courtesy of the U.S. Department of Energy and the Churchill County Museum and Archives, Fallon, Nevada.**

rationalization. For Weber, a disenchanted world is stripped of ethical meaning. Quantification—the reduction of the world to numbers (as in the dogs), weights (as in the pigs), measures, and graphs—becomes the language with which we describe our dreams, passions, hopes, fears, and pain, and with its use we gradually lose touch with the rhythms of the body, the song of the earth, and the music of the spheres. In line with Weber, the documents produced by atomic Weapons Effects experiments are discourses of disenchantment.

For Hugh Gusterson, the NTS animal experiments can be analyzed within an enlightenment tradition that separates mind from body, and statistics from flesh and bone. Quoting critic Susan Griffin, Gusterson contends that the "dominant philosophies of this civilization have attempted to posit a different order of being over and against bodily knowledge. According to this order of being, we are separated from nature and hence above natural process. In the logic of this order, we are meant to dominate nature." He continues, "This separation of the worlds of mind and body is particularly extreme and piquant in the case of nuclear weapons scientists" (Gusterson 1996, 102).

Animal experiments conducted at the NTS can be seen as discourses of disenchantment as well as discourses of politics, power, and propaganda. "The mammalian bodies become bodies of data to be used in a myriad of ways," writes Gusterson. "They reinforce the power of the bomb; they help to construct stable regimes of truth around that power" (108). And, they ensure that existing regimes remain in place.

Civil Effects Experiments

Whereas Weapons Effects experiments measured the bomb's effects on biological species and military equipment, Civil Effects experiments were designed to help the Office of Civil Defense Planning predict damage to American food supplies and infrastructure (as well as to mice and men).

During Operation Plumbbob, card tables were set up on the bare desert floor of the NTS and stocked with packaged foods like those found on supermarket shelves: oatmeal in a cardboard box, flour in "multi wall paper," milk in cardboard cartons, and peanut butter in a glass jar with a screw cap. Fifty bushels of wheat were spread in the open on 18- to 20-foot tarpaulins. Plywood boards held corn in the husk, unpeeled

"The disenchanted world is stripped of all ethical meaning; it is devalued and objectified as the material and setting for purposive-rational pursuit of interests. The gain in control is paid for with a loss of meaning" (McCarthy, in Habermas 1984, xix).

potatoes, fruit, soya beans, and cotton seed (Operation Plumbbob: Project 38.1–I).

Previous to Operation Plumbbob, Civil Defense authorities had begun to experiment with the effects of a nuclear explosion on the kinds of structures that made up the typical American town. During Operations Upshot-Knothole, Operation Teapot, and later Operation Plumbbob, test-site crews erected scores of structures here and there on Yucca Flat, as if giants were playing monopoly on a test-site game board: First houses, then airplane hangars, low-slung partitioned units resembling motels, a forest of pine trees planted in concrete blocks, an underground parking garage, a fire station, and a bank.

For the 1953 Annie test (called the St. Pat Blast, part of Operation Upshot-Knothole), two wood houses of modern design and size were framed on Yucca Flat. One was placed 3,500 feet from ground zero, representing six city blocks from the epicenter of the blast. A second was built 7,500 feet from the epicenter, representing twelve city blocks. Post-blast reports described the first house as "crumpled into matchwood, crushed into the desert, what remained was only wreckage, charred where it faced the blast." The house placed farther from the bomb was severely damaged both inside and out like "a giant hand had clenched [it]. . . . Floors sagged on splintered joists. Roof beams were buckled and rafters pulled from the ridgepole. Doors and windows, sashes and all, had been blown into the house" (Matthews 1953, 842).

Two years later, in preparation for the 1955 Apple II test (part of Operation Teapot) the setting was expanded. An entire small town was built, 19 structures in all. Homes were placed next to models of a school, a fire station, a radio station, and a library. A mock utility grid provided virtual telephone service and electricity to the village, and food was flown in from Chicago and set on the dining room tables inside the homes. Only one building survived the blast: a two-story home, the charred remains of which can still be seen on the site.

Following Annie and Apple II, improving data collection from the past Doom Town experiments became another goal of Civil Defense planners. For the Priscilla test of Operation Plumbbob, wherein the bomb was detonated above ground from an anchored balloon, a two-story frame house was constructed and populated with a mannequin family of four—father, mother, female toddler, and male adolescent. The mannequins were seated at a dining room table set with fine china and polished silverware; the rest of the house was adorned with furniture and paintings. The houses designed for the Plumbbob series were improved versions of houses that had been built earlier for Apple II and Annie.

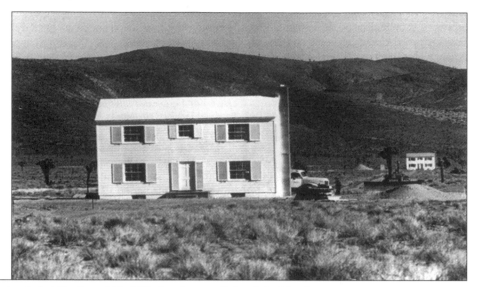

Figure 8.2 **A house constructed at the Nevada Test Site in advance of atomic test Annie.**
Photograph courtesy of National Nuclear Security Administration/Nevada Site Office.

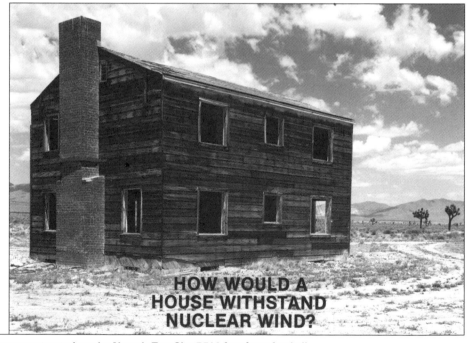

Figure 8.3 **This house was constructed on the Nevada Test Site 7,500 feet from Apple II**
ground zero. It has been partially restored to document the historical importance of the
above-ground testing period. Photograph courtesy of Peter Goin.

Civil Defense planners sought improved data collection on likely blast damage to people. For the Apple II test, mannequins were dressed in tuxedos, evening gowns, Levis, silk pajamas, straw hats, wool hats, cotton shirts, and rayon underwear, all donated by Las Vegas haberdashers, department stores, and milliners. Unfortunately, in the aftermath of the test, much of the clothing, and almost all the dummies and the mannequins, had been burned, some even vaporized, leaving those in charge without the necessary information to analyze the performance of the textiles or the "translation" of the dummies and mannequins. In another example of Orwellian euphemism, the planners used the word "translation" to refer to violent movement of an object across space by the effects of blast pressure.

Because of lessons learned from Apple II, for Priscilla, standardized anthropomorphic male dummies were fashioned after the 50-percentile design representing the average American guy—5 feet nine inches tall and weighing 165 pounds. The standardized models were dressed in coveralls that had been stamped with a sequence of numbers, from shoulder to toe, to facilitate post-blast identification of severed and scattered dummy (body) parts. Max Weber's phrase "disenchanted discourse" seems an appropriate lens through which to read the manner in which the coveralls were reportedly prepared. The lower right arm of the coverall was stamped with 1; the lower left was stamped with 2; the right half of the torso was stamped with 5; the left of the torso with 6. The numbers marched down the dummies to 45, stamped on the lower left leg, and 46, stamped on the lower right leg.

The dummies were then stationed, like the dogs, at pre-determined locations, their postures representing scenarios in which an American might be caught in a surprise atomic attack: a man standing on a street facing in the direction of an atomic explosion; a man standing on the street facing away from an atomic explosion; a man seated while the bomb exploded, and so on. Each was mapped so that after the blast, investigators might determine "velocity and distance of translation ... caused by blast winds" (Operation Plumbbob: Project 33 1957, 29).

Camp Desert Rock

For the 20,000 troops gathered next to the NTS at Camp Desert Rock to participate in Operation Plumbbob, there were no surrogate dummies, dogs, or pigs. Instead troops were there, preparing to participate in atomic maneuvers, because of a consensus within the military that "America's atomic war fighting capability would be crippled unless servicemen were cured of the 'mystical' fear of radiation" (ACHRE Report). After testing in Nevada began, the opportunity was presented to the military to deal with this mystical fear by conducting troop maneuvers and training exercises in the shadow of the mushroom cloud.

Consequently, for the Plumbbob series, military drills were planned to assess the psychological stresses on the soldiers resulting from simulated atomic warfare. During Smoky, soldiers were marched into ground zero to get them used to functioning in the heat of the fireball, with a view of the rising cloud. During Galileo, troops were asked immediately after witnessing the shot to perform a rifle disassembly/assembly to test their reactions under extreme stress. And, during the same test, 16 volunteer soldiers were squeezed into four small bomb shelters, four men to each shelter, to gauge the stress generated in that scenario. During the Hood shot, the Marine Corps practiced a helicopter airlift from near ground zero, and soldiers were marched into ground zero.

What was the result of all the painstaking numbering of dogs and coveralls, placement of food on tarpaulins, setting tables with china and silver, and preparation of frightened soldiers? Well, following the detonations, bomb shelters were opened and assessed for damage, dummies photographed, houses (or debris) examined, animals autopsied, soldiers examined and administered exams, and the ensuing reports eventually published.

The report "Blast Biology—A Study of the Primary and Tertiary Effects of Blast in Open Underground Protective Shelters" records that of the 24 dogs, 8 pigs, 100 guinea pigs, and 380 mice loaded into the underground bomb shelter, two pigs stationed outside the shelter were instantly killed by the blast, as were two guinea pigs inside the shelter. Dog K-1 was found severely injured lying in the middle of the shelter. Two mice were killed by "dog K-1 who struck wall two and crushed portions of the mouse cage." The report contains a photograph of wall two, documenting that "blood and excrement can be seen on the wall." Surviving animals were "sacrificed for post mortem studies except dogs K-8 and K-14 and 110 mice" saved for studies of radiation effects

(Operation Plumbbob: Project 33.1 1959, 29).

The foodstuffs were analyzed for fallout contamination. Of the 18 types of commercial packaging tested, loose-weave cloth and burlap proved totally inadequate to prevent contamination by fallout; other materials, including glass, cardboard, and multi-wall paper provided varying degrees of protection. The news was not as good for the raw agricultural products. Tests indicated that many crops would be inedible following exposure to atomic attack. Fruits, soya beans, and cottonseed remained contaminated after repeated washing. The wheat, after milling, was cleansed of "a considerable amount of contamination," but not all.

The translation of the dummies was measured, where possible. One upright dummy was translated 255.7 feet away from the blast and 43.7 feet to the right. A prone dummy landed 124 feet from his original station. The carefully numbered coveralls were not recoverable.

Researchers measured soldiers' stress levels by chemically analyzing blood and urine samples and by analyzing participants' responses to a subjective stress exam. They concluded that "neither conversations with the experimenters or the biological data revealed any stressful responses," a conclusion that many atomic veterans now dispute (Cases). Lab reports were written and filed.

Poets might find ripe material in the incongruities: the scene of dogs fed well then conditioned to die without a whimper, or the tableau of mannequins seated at tables set with fine bone china and gleaming silver, artistically arranged to face fiery annihilation. The documents viewed this way constitute Gothic literature.

Scientists might cite the documents as good examples of the scientific method in action, as objects and subjects were counted, weighed, measured, and positioned. It is true that knowledge was gained about the biological effects of heat, blast, and radiation on humans and animals. But, as Scott L. Montgomery explains, scientific discourse can never be completely clean and objective:

> No doubt the more interesting view such analyses offer is to show just
> how messy and politically driven scientific effort can be. It is not merely
> that they can prove the ideology inherent in the image of the model
> community of Science, bound by the adhesives of agreement, confor-
> mity and verification. A detailed look at the rhetoric of science gets us
> closer to something almost at the other end of the spectrum. What it

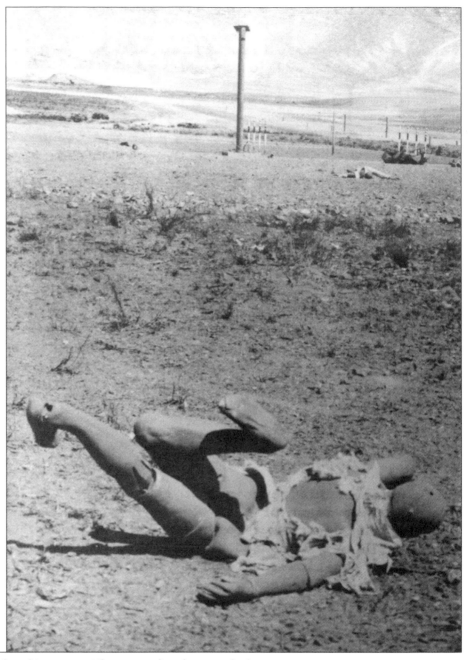

Figure 8.4 **A dummy designed to represent the average American man is shown after the detonation of one of the Operation Plumbbob tests. Photograph courtesy of the U.S. Department of Energy and the Churchill County Museum and Archives, Fallon, Nevada.**

can show us is conflict at many levels of work and thought. (Montgomery 1996, 40)

Political Science

As Hugh Gusterson discussed, the data (the bodies) processed from Weapons Effects experiments became truths that reinforced the power of controlling political and scientific agencies. At the NTS, the objects of the atomic experiments were transformed into words and statistics which, considered rhetorically, reinforced the power of the bomb, the power of the weapons industry, and, finally, the power of the scientists to control the bomb and human destiny.

Extending Gusterson's ideas even further, words and images that reinforce and promote existing structures of power can be classified as propaganda. From the initial understanding of Weapons Effects and Civil Effects experiments, the words and images employed did reinforce and promote existing structures of power, and the propaganda value balanced or outweighed the value of scientific data gathered.

In 1951, as testing in Nevada commenced, the Office of Civil Defense issued a booklet, *Survival Under Atomic Attack*, which argued that the dangers of nuclear attack and fallout had been wildly exaggerated, and that preparation was the key to survival. Through this booklet Americans were trained to—if caught suddenly by an atomic attack—duck and cover, jump in a ditch, roll up the car window, or dive under a raincoat or a few sheets of newspaper.

Historian Guy Oakes, among others, has explored ways in which these Office of Civil Defense handbooks, like the Civil Effects Tests conducted during atomic testing in Nevada, might be examined as propaganda. Oakes, in *The Imaginary War*, contends that the real motive of Civil Defense planners was not to protect Americans from the bombs, but to manage politically destabilizing fear. His argument is that military preparedness requires that people maintain a managed level of fear. Political and social stability, or avoidance of panic, requires that people maintain a managed sense of hope, on a level that will balance but not cancel out the fear. Americans could be expected to respond to a threat of nuclear attack in an organized and disciplined fashion only if they were trained to delicately balance fear with hope. To that end, Civil Defense literature promoted actions known to be useless in an atomic attack. (Duck and cover. Jump in a ditch. Seek shelter.)

The experiments conducted on mice and men at the NTS during atomic tests played an essential role in strengthening panic-resistant morale and emotional self-discipline. Photographs taken of the projects and their results were published in the popular press, helping to preserve within the Cold War psyche that necessary delicate and precarious balance of anxiety and optimism in the face of possible atomic warfare. Following each atomic test, images of death and images of survival were published. They supplied the terrifying ocular proof of what a nuclear attack could mean to an uncommitted or unprepared nation, and the hope that survival was possible for the committed and prepared citizen who reinforced his home or built a bomb shelter.

As one example, after the completion of the 29-kiloton Apple detonation, *National Geographic Magazine* reported, "Designs for better family and public shelter may be one result [of atomic testing in Nevada]" (Matthews 1953, 839). A headline in the *New York Times* proclaimed, "Family Could Survive in A-Bombed Home." The story opened, "An American family crouched in an inexpensive basement shelter can survive an atomic blast, even though the explosion crushes their home like a giant's hand" (Family Could Survive … 1955).

Another example of how NTS Civil Effects Tests were spun into propaganda is a civil defense film called *Operation Doorstep*. The film was made from live footage taken of the 16–kiloton Annie shot. The two-story wood frame home set six blocks from ground zero is described as unreinforced. It is shown blown to bits, its mannequin children twisted and dismembered. But wait. The camera moves through the rubble to a tiny corner of the basement shelter, where a female mannequin stands intact, smiling from the ruins. She is proof, says the solemn movie narrator, of the possibility of the survival of those who take proper shelter. A second home, this one a single-story model set 12 blocks from ground zero and described as reinforced, is shown still standing. The mannequins are all in one piece. Its occupants, we are told, had prepared well for an atomic attack. In the same film, power substations and power lines constructed on the test site lie in twisted heaps, but the camera focuses on two power poles still standing. There, right there, is evidence that the American infrastructure could, with proper preparation, be salvaged following an atomic attack (Operation Doorstep 1953).

An undisputable fact supporting the view that the Civil Effects Tests were as much propaganda as they were science is that the bombs detonated in Nevada between 1953 and 1957 were obsolete baby bombs, with average yields of 20 kilotons of energy. Annie was 19 kilotons, Apple 29 kilotons, and Priscilla 37 kilotons.

While Civil Defense authorities were designing Doom Town settings and commissioning 50-percentile mannequins to be tested against the power of a 20- or 30-kiloton bomb, the Russians had already successfully tested a megaton hydrogen model in August 1953—a super bomb, indeed, which demonstrated that the Soviet Union owned the capability to build and deliver a bomb bearing a punch of at least 20 megatons, 1,000 times greater than Annie, Apple, and Priscilla.

The United States had discovered through its own Marshall Islands tests of 10.5-megaton Mike (1952) and 15-megaton Bravo (1954) that after the detonation of a hydrogen bomb any structure situated ten miles from ground zero would be instantly vaporized, along with the people inside it, cars parked outside it, bomb shelter dug beneath it, trees shading it, and any dog protecting it.

Helen Caldicott has estimated the bodily damage that would result from the blast alone of a 20-megaton bomb (excluding thermal and radiation effects). Overpressures would create winds of "up to 500 miles per hour. These winds will literally pick people up off the pavement and suck them out of buildings, converting them into missiles traveling at 100 miles per hour. When they hit the nearest solid object they will be killed instantly from fractured skulls." With the explosion of a bomb of this magnitude, Caldicott maintains that within a six-mile radius of ground zero nothing would survive. Twenty-six miles from the epicenter, wooden houses, clothing, curtains, and upholstery would spontaneously ignite. At forty miles, anyone facing the explosion would be instantly blinded (Caldicott 1986, 10).

That AEC Chairman Lewis Strauss knew the grim truth about the destructive capability of Bravo is evidenced in this stichomythic exchange between Strauss and members of the press:

> Strauss: "Well, the nature of an H-bomb, Mr. Wilson, is that, in effect, it can be made as large as you wish, as large as the military requirement demands, that is to say, an H-bomb can be made as—large enough to take out a city."
>
> Mr. Smith of United Press: "How big a city?"
>
> Strauss: "Any city."
> Press: "Any city, New York?"
> Strauss: "The metropolitan area, yes." (Oakes 1994, 60)

In a speech delivered by Val Peterson, director of the Federal Civil Defense Administration, to the Washington Conference of Mayors on National Security, Peterson informed the mayors that atomic survival will require nothing more than "a jug of water, some cheese and crackers, or the equivalent thereof, and some kind of sanitary facility" (Oakes 1994, 62).

Secret files kept by the AEC on Bravo contained information that radioactive de-
bris from the test covered an area 220-miles long and 40-miles wide. Within a distance
of 160 miles downwind of ground zero, everyone would have been killed (61). Oakes
describes the double mask of public promises on one side and private knowledge
on the other: "Throughout the Eisenhower presidency the F[ederal] C[ivil] D[efense]
A[dministration]'s public relations line glibly promised the American people that they
could survive nuclear war by keeping their heads and following a few simple rules.
Privately, the Eisenhower national security team recognized the futility of nuclear
crisis mastery, even as it promoted that doctrine to the country as the only means
of survival" (154).

Flying in the face of insider data, Weapons Effects and Civil Defense experiments
continued at the NTS, with photographs of the so-called manageable destruction
splashed wherever there was an outlet. Given these particulars, it's fair to question
how often the rhetoric of propaganda is disguised as the rhetoric of science.

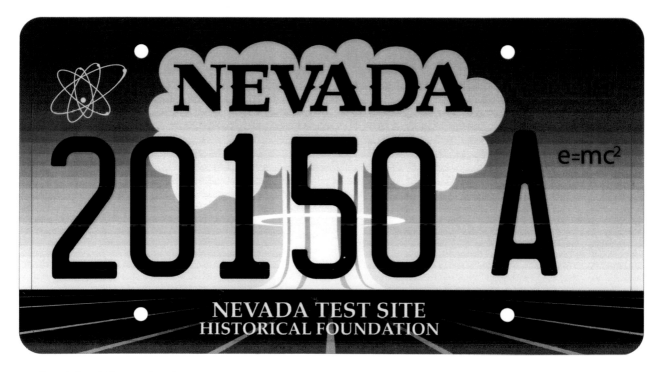

Atomic Bomb license plate. In 2001 the Nevada legislature authorized
the Department of Motor Vehicles to commemorate the state's unique
role in the nuclear era by producing a specialized license plate. The
funds raised by selling the plate to motorists were destined for the
Nevada Test Site Historical Foundation. However, in June 2002 the director of the DMV, Ginny Lewis, and Governor
Kenny Guinn decided to cancel the plate because they believed any reference
on a license plate to a weapon of mass destruction would be inappropriate
and offend the citizens of Nevada. This is an image of Richard Bibbero's
design, which was selected from about 40 others.

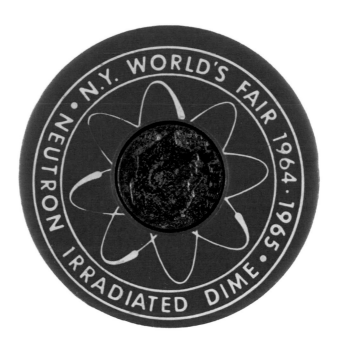

Neutron Irradiated Dime souvenir from the New York World's Fair 1964-1965.
Peter Goin Collection. Fat Man and Little Boy earrings

were sold at the National Atomic
Museum in Albuquerque, New
Mexico. Due to complaints in
part from Japanese tourists,
anti-nuclear activists, and atomic
veterans charging that wearing
jewelry commemorating nuclear
weaponry is unforgiveable, the
museum no longer sells these
earrings. Peter Goin Collection.

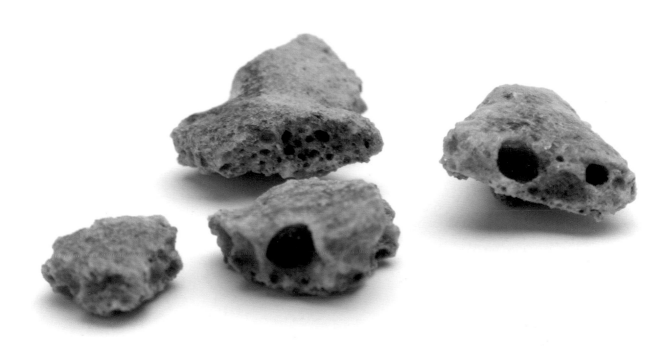

Trinitite is a mildly radioactive residue created by the world's first nuclear detonation, 16 July 1945. The atomic bomb was detonated in a remote corner of the Alamogordo Bombing Range known as the Jornada del Muerto, New Mexico. The intense heat fused sand into green glass. Peter Goin Collection.

Ferrara Pan ®

Chewy

ATOMIC
FireBall ®
MK

CANDY

The Original Intense Candy

**Caution:
Extreme Heat!**

NET WT 6.0 OZ (170G)

Nello Ferrara created the Atomic Fire Ball candy in 1954. The process of making the candy involves building single grains of sugar and tossing them into revolving pans while adding flavor, color, and other candy ingredients. An estimated 15 million round, spicy, hard fireballs are consumed each week throughout the world. Garbage Pail Kids Stickers (bubblegum). Produced by the Topps Company and originally released in 1985, the concept was to parody the Cabbage Patch Kids dolls that were quite the rage at the time. Each sticker card featured a Garbage Pail Kid character suffering from some comical abnormality and usually involving a humorous word play character name, such as Adam Bomb, Michael Mutant, and Toxic Wes. Fifteen series were released in the United States, with various sets released in Australia, New Zealand, throughout Latin America, and in Brazil. Peter Goin Collection.

Atomic Café kitchen apron. This memento is merely one example from a variety of cafés located in California, Kentucky, Maine, Massachusetts, New Mexico, Ohio, Texas, and internationally in Germany. Warheads candy is a brand of sour candy manufactured by Impact Confections. The candy was invented in Taiwan in 1975 and featured "hot" versions, although these proved to be less popular over time. Warhead candy has an initial intense sour taste that fades after about 30 seconds. The idea is that the "warhead" explodes in your mouth. The brand's mascot is Wally Warheads, a boy with puckered lips and a small mushroom cloud exploding from the top of his head. The original warheads Web site boasts more than 150,000 fans in early 2010.

Nuclear Sqworms: Sour Neon Gummi Worms. Tart and tangy wiggly neon gummi
worms are advertised as offering an "awesome nuclear charge to your taste buds."
Peter Goin Collection. Nestlé Nuclear Chocolate promoting the 1998 movie *Armageddon*. This bar is made of milk
chocolate with crisped rice and popping candy particles (information derives from the label).
The idea is that the popping sounds produced while eating the candy relate to the movie's
actor, Bruce Willis, using an atomic bomb to destroy an asteroid on a collision path with the
earth. After this candy bar was marketed, the anti-nuclear activist group Grandmothers for
Peace International urged a national boycott of all Nestlé products. Peter Goin Collection.

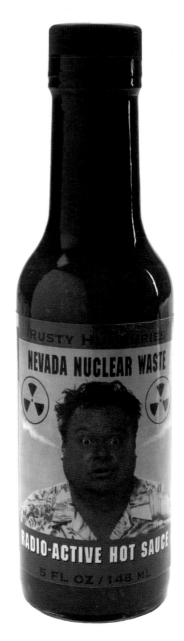

Rusty Humphries Nevada Nuclear Waste Radio-Active Hot Sauce.
Peter Goin Collection. Up 'n' Atom Carrots from the 1940-1950 era.

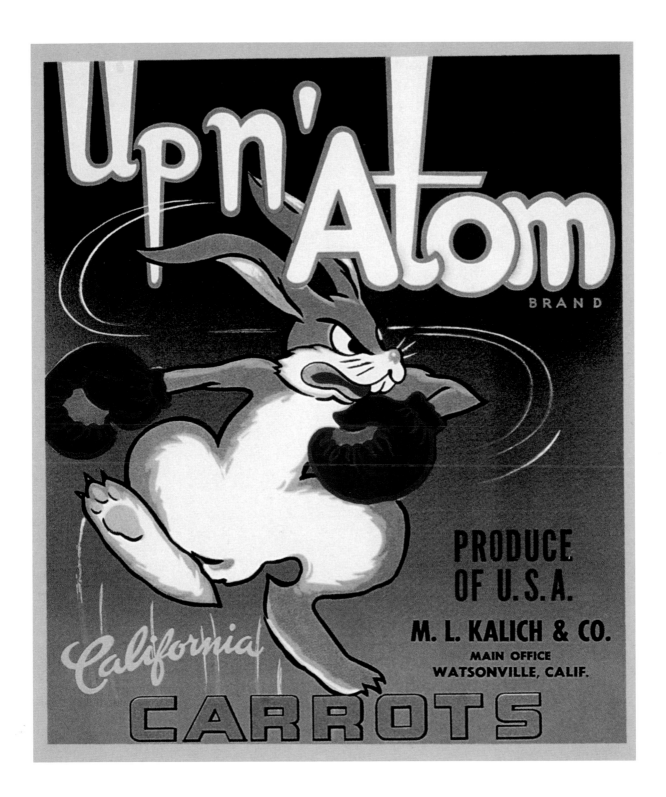

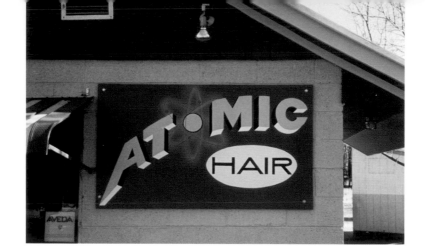

Atomic Hair salons, such as this one in Moab, Utah, also are located in California, North Carolina, Oklahoma, Texas, and Wisconsin. (Photograph courtesy of Mark Ruwedel, 1999.) Atomic Speedway, near Oak Ridge, Tennessee. The Oak Ridge National Laboratory developed the gaseous enrichment process that increased the proportion of U-235 in natural uranium. (Photograph courtesy of Martin J. Pasqualetti, circa 1987.)

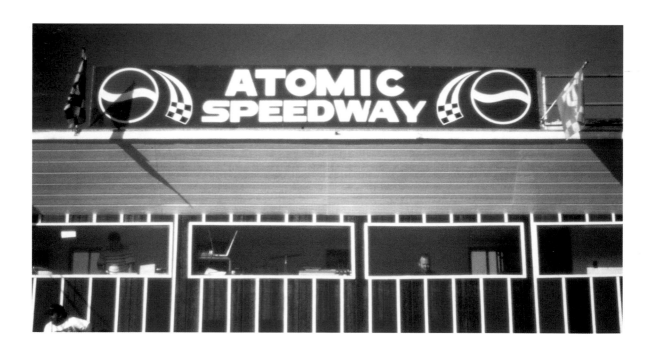

Atomic Laundry in Richland, Washington. Richland serviced the Hanford Nuclear Reservation, which was part of the Manhattan Project that developed the first atomic bomb. Many businesses exploited the nuclear theme, including the Atomic Ale Brewpub in Richland that regularly serves Halflife HefeWeizen, Atomic Amber, Plutonium Porter, and Oppenheimer Oatmeal Stout. (Photograph courtesy of Martin J. Pasqualetti, circa 1987.)

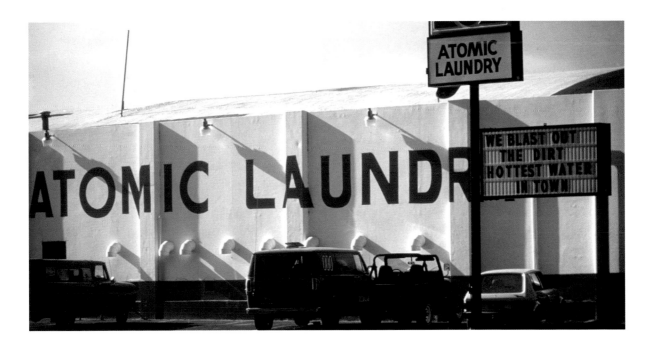

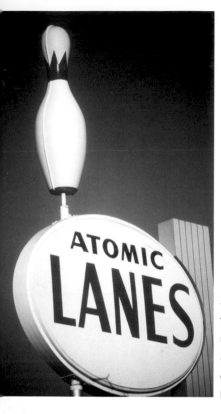

Atomic Lanes in Richland, Washington. Richland was dependent upon the jobs associated with the Hanford Nuclear Reservation, although the sense of pride has diminished as the reactors were decommissioned and the community now deals with the consequences of nuclear contamination and waste. (Photograph courtesy of Martin J. Pasqualetti, circa 1987.) Atomic Body Shop in Richland, Washington. Richland's commercial district reflected the emphasis of the nuclear culture during the plutonium-producing era. (Photograph courtesy of Martin J. Pasqualetti, circa 1987.)

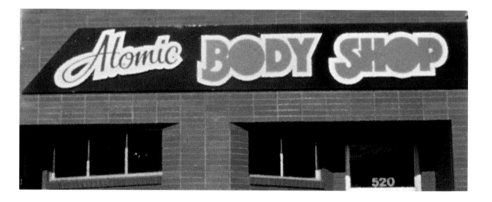

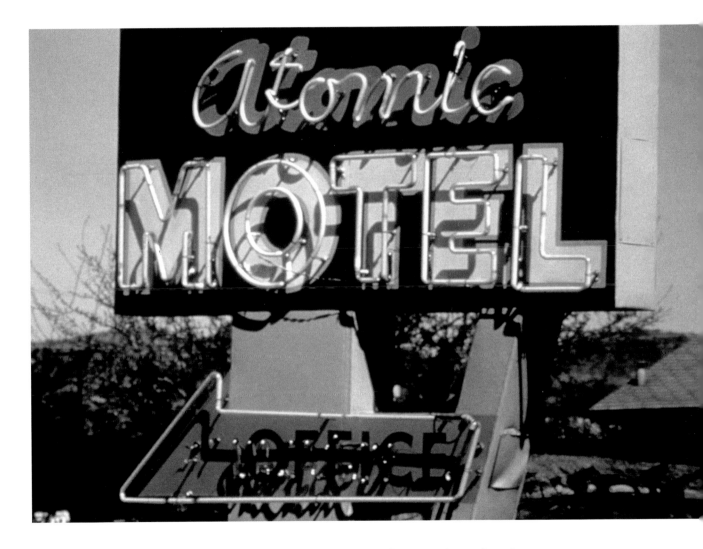

Atomic Motel, Moab, Utah. The theme reflects a nearby uranium plant, which was decommissioned in 1999. (Photograph courtesy of Martin J. Pasqualetti circa 1981.)

THE COMIC BOOK WITH GO POWER!!!

ATOMIC CITY
Special
NO. 1

STILL ONLY $2.95
$3.50 IN CANADA

it's a SW comic

HUMID CRIME RIDDEN ADVENTURE!

Black Eye

ATOMIC CITY THE COMIC BOOK WITH GO POWER No. 1, Special/Humid Crime Ridden Adventure! Black Eye Productions in Montreal, Quebec, Canada, published this "Special No.1" during the summer of 1995. The stories and art are by Jay Stephens. Numerous superheroes have nuclear themes, including the "Power of the Atom" comic that is part of the Justice League series by DC Comics, written by Roger Stern, Graham Nolan, and G. Willow Wilson. In this series, physicist Ray Palmer uses matter from a white dwarf star to create a belt that allows him to shrink to microscopic size. In this role, he is The Atom, a legendary crime fighting scientific super-hero. The Richland High School logo graphically locates the "Home of the Bombers!" Richland, Washington is the community servicing the Hanford Nuclear Reservation.

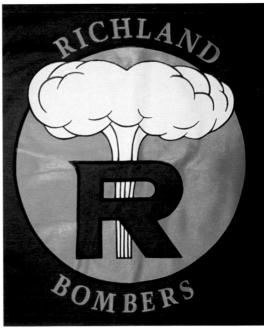

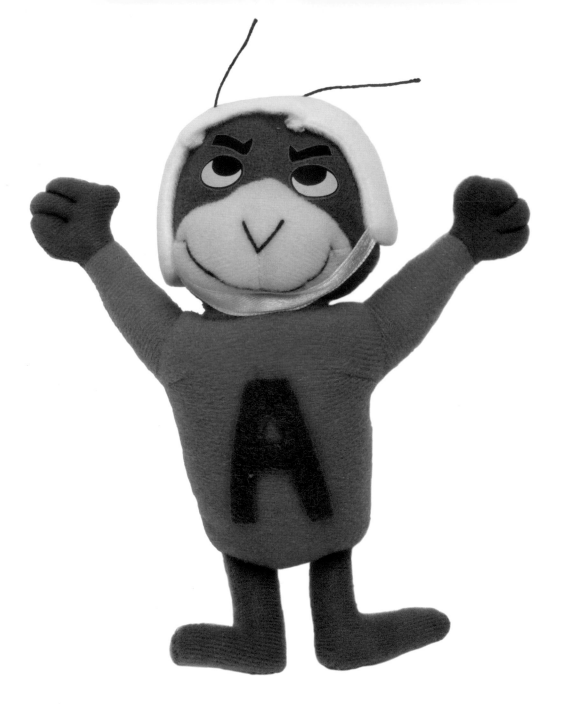

Atom Ant plush figure by Dairy Queen. This is from a collector series of 12 different cartoon figures that were included in kids' meals. For many years, the slogan of the franchise was "We treat you right!" but during the late 1990s and at the turn of the millennium, "Hot Eats, Cool Treats" was widely used. Atom Ant is a cartoon ant and superhero created by Hanna-Barbera in 1965. Allegedly, Atom Ant's name was a pun on "adamant" referring to the character's great strength, but it might also have been a parody of the Charlton Comics' character, Captain Atom. Peter Goin Collection.

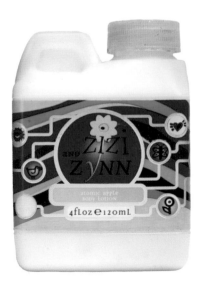

Zizi and Zynn® is a registered trademark used for Bath and Body Products, including body and skin creams, soaps and lotions, body mist, body wash, roll-on cologne, perfume and antiperspirant, eye cream, and eye makeup remover. This is Atomic Apple Body Lotion. Lara Schott Collection. Atomic needle set. Peter Goin Collection.

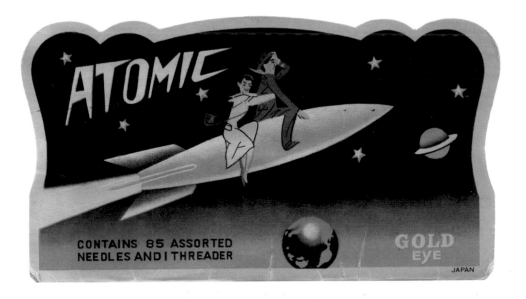

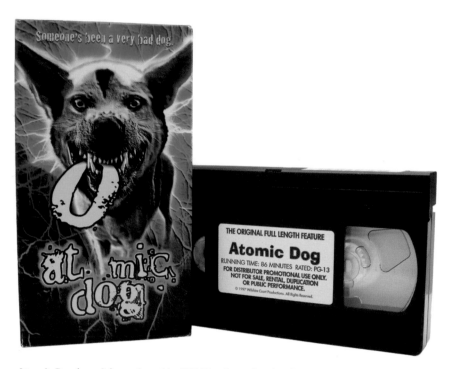

Atomic Dog (movie), produced by Wilshire Court Productions, starring Daniel Hugh and Cindy Pinkett, is the story of a dog that becomes trapped in a nuclear power plant and is exposed to radiation. This causes him to become a wolf-like hunter of great strength with special abilities such as infrared vision. This movie is about the dog's quest to reclaim his offspring. *The Atomic Café* (The book of the film). This compilation of 1960s films about what to do in case of a nuclear attack and the effects of radiation is a cult classic. The film was produced over a five-year period, and was a collaboration between Jayne Loader and brothers Kevin and Pierce Rafferty. This documentary was released in April 1982 and coincided with the peak in the international disarmament movement.

Kevin Rafferty, Jayne Loader and Pierce Rafferty

The Book of the Film

The ATOMIC Cafe

The Nuclear War card game is designed to create a humorous confrontation between sensitive world powers as each player (the game can be played by 2-6 players) seeks to influence and gain authority over an opponent's populations using diplomacy, propaganda, and nuclear weaponry. In this card game, every player often loses. The game's website proclaims, "It's a Blast!" Peter Goin Collection. Atomic Brand "The Best" Newest Space Age Fireworks postcard. Atomic Fireworks guarantees "no duds" and is a founding member of the American Pyrotechnics Association. This company is the oldest distributor of 1.4G fireworks in the South, with wholesale warehouses located in Tennessee and South Carolina. Peter Goin Collection.

Postcard of Vancouver, British Columbia, Canada and another of a faux nuclear detonation. Imagining nuclear destruction is a popular feature in contemporary culture.

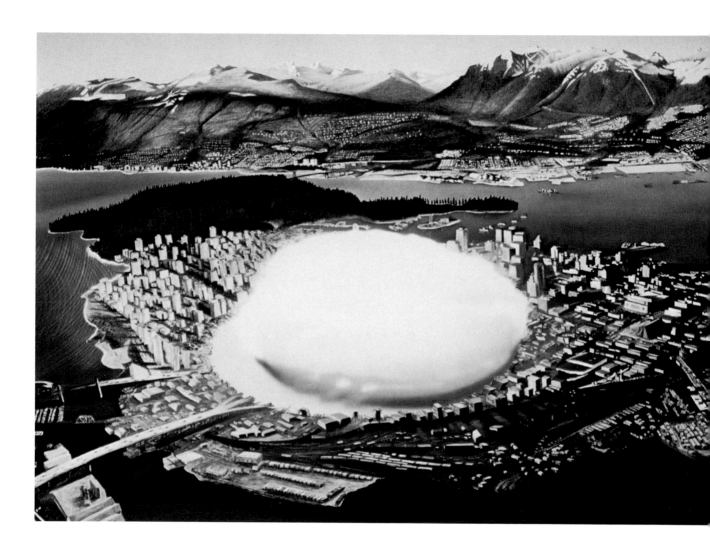

"To crush the simple atom all mankind was intent / and now the atom will return the compliment." Stone carving by DeWayne Williams, Dooby Lane north of Gerlach, Nevada. (Photograph courtesy of Peter Goin, 1999.)

Project Shoal

The August 1963 signing of the Limited Nuclear Test Ban Treaty (LNTBT) brought the end of an era of atmospheric testing in the United States and the beginning of an era of underground nuclear testing.

Upon first glance, the terms of the LNTBT might appear easy enough to honor. All nuclear tests were to be banned from the atmosphere, outer space, and underwater. In actuality, the treaty terms created enormous technical challenges for the AEC. An underground test remained legal only if announced in advance and only if it caused "no radioactive debris to be present outside the territorial limits of the State under whose jurisdiction or control such explosion is conducted" (Hacker 1994, 231).

Counterintuitively, controlling the release of radioactive debris resulting from the explosion of a bomb buried deep within the earth was not a simple task. Testing was considered successful only when data was generated and collected, so that labs could use it to improve weapons designs. The installation of the kind of equipment considered necessary for data collection required cables, pipes, conduits, and carved pathways through which radiation could later escape. Geology and hydrology created another set of challenges. An undiscovered fault could be a source of weakness. Or, underground water might create steam buildup leading to potential surface venting of radioactivity.

Not the least of the fresh worries was that the science of monitoring underground Soviet tests was young. An illegal Soviet test might go undetected. On the other hand, and of enormous benefit to the AEC, underground testing presented a new opportunity to locate nuclear proving grounds outside the boundaries of the NTS, without the public uproar associated with fireballs and fallout. Testing accomplished at those locales was referred to as off-site testing.

One of the first tests undertaken following the signing of the treaty was Project Shoal, located near Fallon, Nevada, 350 miles north and west of the NTS. The test can be viewed in retrospect as capturing the spirit and goals of the new era. It was one of

eleven U.S. underground nuclear tests conducted outside the boundaries of the NTS, and the purpose of the test was intricately related to the confining terms of the LNT-BT. Project Shoal illustrates the retooled phrases added to the AEC's public relations campaign, which was revamped and revitalized by the prospect of conducting nuclear tests in new locales.

Much of the rhetoric employed to market offsite tests continued what I previously identified as common motifs implemented to market atmospheric testing at the NTS: Supporting nuclear testing, even when it occurs next door, is your patriotic duty; We know more than You; sound science will ensure your safety; sites are scientifically selected; and radiation is natural. However, the AEC added beads to the string, alluding broadly to the economic benefits that would most assuredly arrive at the new site along with the bomb. The promises were fleshed out with the technology of the boardroom—films, graphs, commercials, and flip charts. The business of the bomb met the business of business.

Promise of Safety ... and Dollars

The signs of a singular event must have been unmistakable to the eastbound travelers on Highway 50, as they reached a point 23 miles east of Fallon, Nevada, at mid-morning on Saturday, 26 October 1963. The high basin and range desert near Fourmile Flat would have looked peaceful enough—clean, white, and spare in the late October light. Just where the highway enters a pass through the Sand Springs Range, the traveler would have been stopped at a roadblock manned by AEC officials wearing dosimeter badges. On closer inspection of the surroundings, anyone familiar with the area would have noticed that an unusual silence characterized the air space over Sand Springs Range and Fourmile Flat, which was normally buzzing with the activity of pilots training at the nearby Fallon Naval Auxiliary Air Station.

At precisely 10:00 a.m., a 12-kiloton nuclear bomb was exploded 1,200 feet underground, a few miles to the south of the roadblock. A bright magnesium flare marked the exact moment of detonation. For the length of a sigh, nothing seemed to happen. Then, observers were "jarred by a severe ground shock.... [and] [f]our seconds after the blast, a loud roar filled the air and a cloud of dust a thousand feet long began to rise over ground zero" (FE-S 1963, 29 October).

For a year leading up to 26 October, the community of Fallon was bathed in the promises of health and wealth. Consistent with the old promotional approach, the potential for accidental fallout was barely addressed. Consistent with the new promotional approach, the AEC waved a wand with dollar signs over the community. Absent from the AEC's press releases were the words: radiation, explosion, and blast. Instead, the releases were replete with phrases laden with references to jobs and money: drilling project, dollars, shaft construction, drift work, employment, and bids (FE-S 1963).

Headlines in the *Fallon Eagle-Standard* during the summer of 1963 reinforced the approach taken by the AEC, whose press releases formed the substance of the stories: "AEC to Ask for Bids on Construction Work in Sand Springs Area"; "Salt Lake Firm Low Bidder For AEC Shaft Construction"; and "Forty Miners Will be Employed." As I was living in Fallon then, I am often asked two questions. "Why was the Fallon area chosen as the site of the blast?" and "How did you and your family react to the project?"

I can, as a researcher, answer the first question. Project Shoal was a Vela Uniform test, designed to refine techniques of verifying Soviet underground tests, and detecting and pinpointing any illegal testing. Almost a decade before the Shoal test, in 1954, an area near Fallon and close to the Shoal site had been the epicenter of a magnitude 7.0 earthquake. Vela Uniform Project experts hoped to compare seismic data collected from the naturally occurring quake to seismic data produced by an underground nuclear test. The comparison, it was hoped, would help U.S. scientists distinguish (by seismic signature analysis) between an earthquake in the Soviet Union and a clandestine nuclear test. (Three other Vela Uniform Project nuclear tests were conducted offsite, two at Hattiesburg, Mississippi, on 22 October 1964 and 3 December 1966, named Salmon and Sterling, and one at Amchitka, Alaska, on 29 October 1965, named Long Shot.)

My answer to the second question is more tentative. Immersed in college life, I didn't react at all. As for my parents, they gave unquestioning support to Project Shoal. The construction firm managed by my father had paved the roads into the Nevada Test Site. He had routinely hustled us out of bed in the predawn hours of an atmospheric test, conducting his version of a dawn party, with orange juice and eggs. In his mind, the phrases "testing nuclear weapons is necessary for winning the cold war" and "nuclear technology will bring economic reward to the nation" coexisted in harmony. Given this context, my parents, and most of the rest of the community, were ideal receptors of both the old and the new AEC rhetoric.

Links between the Shoal test and patriotism were easy to forge, given the times. The communist threat was at a high pitch in 1963. Memories of President Kennedy's Cuban Missile standoff of October 1962 were fresh in people's minds, and nerves were still raw. An editorial in the Fallon newspaper of 9 July 1963, entitled "The Free Are Always in Danger," captured the mood of the moment. The author quoted a warning from a *Reader's Digest* article: "Communists are moving toward us. Today they are on our doorstep" (FE-S). AEC bulletins describing Shoal emphasized the direct relationship between the test and "keeping America safe from Communist domination" (FE-S). Promotional materials described the Sand Springs site (22 miles east of Fallon) as uniquely suited to serve a most important historical undertaking, suggesting that the fate of the free world could hang in the balance with the Shoal test (Nevada Site Selected …).

The AEC addressed the public's fear that the test might trigger an earthquake on the existing fault structure. A public meeting was held "to explain that a recent detonation which caused earth tremors in Las Vegas was many times as powerful as Shoal." Even so, the public relations team added, "[T]he tremor felt in Las Vegas was barely above the strength at which humans begin to feel earth shocks and represented a fraction of the energy at which property damage would ordinarily be seen" (FE-S 1963, 6 October).

A prop was designed by the AEC to illustrate the simple mechanics and safety of the bomb test. It was enthusiastically characterized by the local newspaper as a diorama of the emplacement rig, complete with a miniature bomb. School children could practice swinging the bomb on an erector-set model, then emplacing it in a vertical shaft. As part of the AEC's partnership approach to civic, business, and industry sectors, the diorama made the rounds to service organizations, the Lion's Club, the Rotary Club, and the American Association of University Women, among others, and was placed on display in a showcase at the Fallon branch of the First National Bank of Nevada (FE-S 1963, 1 October).

The Science of Quantification

Another well-used promotional technique was a guarantee of safety, supported by sound science and its seasoned companion, expert opinion. As in Weapons Effects experiments at the NTS, the sound science of Project Shoal relied largely on quantification. Local residents were kept informed of the numerous daily activities of hydrologists, seismologists, veterinarians, and health service employees as they measured the water levels of wells in the area; inspected and photographed every mining structure within a 20-mile radius of ground zero; visited local ranchers to explain what services were available; and collected samples of milk and water.

Near ground zero, the ancient, stolid sands played ironic host to the shiny, industrial, symmetrical buildings, machines, and vehicles equipped to measure, document, calibrate, and mediate the planned and unplanned behavior of the bomb. Wood-Anderson seismographs were installed along four lines radiating outward at azimuths of 29 and 46 degrees, 215 degrees, and 312 degrees. Expanding the concentric ring outward were twelve trailers—each with eight air sampling heads that could run all together, in sequence, or singly (Vela Uniform Project Shoal, Seismic Safety Net 1964.)

Figure 10.1 **Maine Street, Fallon, Nevada, on the eve of Project Shoal. Photograph courtesy of the Churchill County Museum and Archives, Fallon, Nevada.**

A 28-foot trailer served as the first aid station. Proximate to the first aid station were a mobile radio assay laboratory, outfitted with equipment designed to count gross alpha and beta activity; a personnel-decontamination trailer; 18 remote gamma detectors; a truck equipped with a 1,000-gallon water tank, high-pressure pump and nozzle for decontamination of heavy equipment; and a mobile laundry trailer for decontaminating clothing. Arriving in Fallon by rail was a most ominous icon of techno-safety—a "whole body" counter that resembled a giant iron lung. It was parked on a side rail, a block from the hospital, and became a destination for public school field trips. AEC documents described the operation of the modern miracle machine: "The subject being counted lay on a steel framed bed mounted on tracks laid down in the center of the room. Two small crystals were mounted on the bed to view the two lobes of the thyroid. A large, separately mounted crystal was placed in standard position over the body mid-line" (Vela Uniform Project Shoal, Final Report of Off-Site Surveillance 1964).

Marked by the flare of magnesium and the noticeable swaying of the earth, the bomb was detonated on schedule. Beneath the surface at ground zero, an immense cavity was created, and a hot, very hot bubble grew in the granite, trapping most of the billions of released radioactive particles that eventually cooled into a solid radioactive mass. Project Shoal was declared a success. The cavity was drilled between 10 December and 19 December 1963; drillers recorded temperatures of 600 degrees Fahrenheit and radiation peaking at 40-roentgens per hour. The resulting contamination of the soil was handled by "scraping the surface, mixing the contaminated soil with clean soil to reduce concentration of radioactive material, and burying the soil under several feet of uncontaminated earth" (Vela Uniform Project Shoal, On-Site Health and Safety Report 1964, 12).

In retrospect, the test can be studied as a particular historical moment, one that illustrates the Cold War context that produced a quiescent public, or as an example of the AEC's strategy for promoting nuclear testing in off-site areas. In a broader sense, Project Shoal highlights the illogic of conflating nuclear testing safety and the technology of quantification, not only at the Shoal site but everywhere nuclear testing took place. Had an accident occurred, the regimented preparation, the experts' assurances of safety, the miles of cable, and tons of scientific equipment that became the promotional tools of "guaranteed safety" might well be viewed as expensive whistling in the dark. Had the test vented the surface, which has happened many times in the history

of underground testing, the cloud could have been tracked, doctors and veterinarians called into service, radiation measured in water, milk, and air, and dosages to humans counted in the whole body counter. We can count radioactive particles and measure fallout, but we cannot remove them from food, air, water, or bodies.

Another motivation for continuing to contemplate tests like Shoal is that the consequences live on. Ideally, following an underground nuclear test, radionuclides will remain trapped within the cavity until they decay, a process taking up to thousands of years. A problem arises when the rubble chimney created by the explosion fills with water, and serves as a conduit between the cavity and any nearby aquifers. Contaminated water is an ongoing issue at Hattiesburg, Mississippi, where the county has asked the DOE for enough money to create a water distribution system designed to replace the many rural private wells in the area. And, at the NTS plutonium has been found in wells more than a mile from old test cavities. Who will bear the eternal responsibility to monitor wells and remediate contamination if it occurs?

Project Plowshare

Vela Uniform Projects like Shoal are sometimes confused with Project Plowshare tests, because in both projects some tests took place at locales other than the Nevada Test Site, and both projects received an infusion of money and enthusiasm when the nation officially adopted underground testing. The goals of the two programs, however, were quite different. The seeds of Plowshare were sewn early in our country's atomic history. In 1945, when the images of Hiroshima and Nagasaki were still vivid in people's minds, Philip Wylie wrote, "[A]tomic energy is only incidentally a military weapon" (Boyer 1985, 124). In 1946 a committee of the American Psychological Association told public officials that the way to calm public fears about nuclear bomb tests was by emphasizing peaceful uses of the atom: "The demoralizing fear which surrounds the phrase atomic energy can be reduced by presenting the facts in honest, unexaggerated peacetime terms" (124).

The idea of using split atoms to achieve peaceful ends evolved from a few scattered conjectures into an official policy on 9 December 1953, when President Dwight D. Eisenhower delivered his famous "Atoms for Peace" address to the United Nations General Assembly. Calling for adapting atomic research to further the "arts of peace,"

President Eisenhower expressed his hope that by broadening atomic research he could increase American prosperity. He wished to send out to the war-weary world an atomic-age dove with the message that the United States was determined to fashion its atomic technology to serve peaceful, as well as military ends.

The speech captured the imaginations of windmill-tilters and technocrats alike, who envisioned atomic locomotives, atomic greenhouses, atomic saws, and atomic medicines. The AEC introduced a film, titled *Atom and Eve*, in movie houses and schools. Eve, an American housewife, is depicted luxuriating in the time saved by atomic-powered washing machines, hair dryers, and toasters.

AEC's Glenn Seaborg envisioned atomic-fueled "nuplexes," a utopian model for supplying energy to housing developments. Each nuplex would be fueled by an underground atomic reactor furnishing energy to "produce enough fresh water from sea water and fertilizer from recycled refuse to grow food to take care of the needs of 50 million people" (Buys 1989, 28).

Physicist Freeman Dyson, and others, imagined a spacecraft that could be propelled out of the earth's gravity by shock waves generated by a trail of detonated nuclear bombs. The spaceship would store 2,000 nuclear bombs (referred to as "pulse units") to be used as boosters, one at a time, propelling the Project Orion spacecraft like an "interplanetary surfer" (O'Neill 1994, 20).

In 1957 President Eisenhower's atoms for peace vision was co-opted, albeit in modified form, by Lawrence Radiation Laboratory, where Edward Teller, Harold Brown, and Gerald Johnson began devising ways to retrofit existing nuclear devices (as opposed to creating new nuclear machines or products) to serve the ends of business and industry, primarily for massive excavations of canals, tunnels, and harbors. The result was Project Plowshare.

As the concept of peaceful Plowshare testing ripened, so did the idea that underground testing might be safely accomplished anywhere on earth. Plowshare fit nicely within the historical moment, and Project Plowshare administrators were eager to test explosives in other parts of the nation and world. Once the AEC agreed to support Plowshare projects, planning meetings were held at the Lawrence Radiation Laboratory. Joining the original Livermore group were representatives from the Los Alamos Scientific Laboratory, Rand Corporation, Aerojet-General Nucleonics, Princeton University, and Sandia Laboratory. Edward Teller stepped into the leadership position. His enthusiasm for taking on large engineering projects with nuclear devices was evident

in his opening remarks at the first Plowshare seminar: "One will probably not long resist the temptation to shoot at the moon. The device might be set off relatively close to the moon and one would then look for the fluorescence coming off the lunar surface, or one might shoot right at the moon, try to observe what kind of disturbance it might cause" (20).

Historian Dan O'Neill, in *The Firecracker Boys*, elaborated on some of the details of Teller's Plowshare vision:

> Nuclear explosions would dam straits to deflect ocean currents along more preferred routes. Rivers would be caused to flow upstream. Atmospheric bursts could modify climate and weather, either by seeding rain clouds or by blocking solar radiation with dust. Even earthquakes could be tamed by a series of small preemptive, underground shots along fault zones. To rescue the Arctic from its stigma as "the refrigerator of the world," atomic scientists would simply blast the ice pack, greatly roughening its surface and increasing its absorption of solar radiation. (26)

Plowshare proposals were submitted to Lawrence Radiation Laboratory from near and far. Project Carryall called for building a section of Interstate 40 in California by tunneling through the mountain range of the Mojave Desert with a series of 28 nuclear devices. Project Sloop would redesign irrigation canals in Arizona. A memo written by Plowshare division leader Gary M. Higgins, addressed to Nevada Senator Alan Bible in February 1963, lists forty projects that had been proposed as candidates for Plowshare funding, including excavating a harbor at Ilo, Peru, dredging a canal through the Isthmus of Kra on the Malayan peninsula, excavating a harbor at Arica, Chile, and redesigning the Upper Amazon River "to remove rapids … that presently limit river vessels." On the table was a plan to eliminate the Aswan High Dam by diverting the Nile River "through a range of hills into Waddi Gabgadda, where a much higher dam would be built." The cost estimate for the Aswan project in 1963 was $1,000,000,000, a figure that reifies the optimism driving Plowshare (Higgins 1963).

The plan that Edward Teller came to favor above the rest was dubbed the Panatomic Canal, its lofty and forbidding goal to build a new Panama Canal with the detonation of 262 nuclear bombs, yielding 270 megatons of energy. The largest technical and promotional problem faced by Teller was that nuclear bombs, as the world knew,

"If your mountain is not in the right place, drop us a card."—Edward Teller

produced radioactive fallout. Plowshare planners hoped that that by finding the right depth to bury the devices, earth could be moved and fallout contained at the same time. If the devices were buried too deep, there would be no crater. If they were buried too shallow, too much radioactivity would be released. It was a tricky business. The 1,280-foot-wide Sedan Crater on the NTS is the result of one of several Plowshare experiments aimed at discovering the right mix of depth and yield for effective and safe nuclear excavation. The 104-kiloton device was buried 635 feet below the surface, and detonated on 6 July 1962. The mix was only partially successful. Twelve million tons of earth was moved. However, radioactivity was detected off the site, and for several weeks following the test public health officials measured increased levels of iodine-131 in milk produced in the Salt Lake City area (Kirsch 1997, 200). The 320-foot-deep crater, spectacular to behold, remains radioactive.

Project Chariot

A Plowshare test codenamed Project Chariot became Teller's vehicle for securing support for the Panatomic Canal. Chariot called for the excavation of a keyhole-shaped harbor in Cape Thompson, Alaska, by the detonation of 2.4 megatons of nuclear energy (eventually scaled back to 280 kilotons). That the harbor would be icebound for ten months of the year did not seem reason enough to abandon the plan. Excavation technology needed proof-testing, and Chariot was Teller's way of accomplishing that. Throughout the fall of 1960, public relations officers and technical coordinators flew over the tundra in a Cessna-180, landing and presenting promotional material to businessmen in Juneau, Anchorage, and Fairbanks, Alaska, and to native villagers in Shishmaref, Kivalina, Noatak, Kiana, Sealwik, Noorvik, Point Lay, Wainwright, Barrow, and Point Hope.

At about the same time Teller was planning Project Chariot, in a place far distant, the Colombian author, Gabriel García Márquez, was writing a short story, "Death Constant Beyond Love." Márquez is one of the great storytellers of colonialism, and he well knows that the color of money helps achieve colonial ends. In the story, a jaded urban magistrate campaigning for reelection in the backwater visits a barren village in the far reaches of Colombian civilization. He wants to gather votes from the isolated villagers, but he is too old, cynical, and weary to campaign very hard. Instead, he conducts a cheap political rally that features a series of painted cardboard props carried by sycophants across the

stage and behind the podium from which he addresses his ragged constituency. In front of the audience rolls a painted sailing ship laden with painted cargo, followed by a painted marketplace teeming with painted fruit. Painted cardboard shrubs bear painted cardboard red roses. Fantasy merges with reality. The provincials hail him as the savior of the land's economy. He wins the day, and, for a while, the local beautiful virgin.

Cardboard Roses

Like the cynical colonial magistrate in Márquez's story, Teller apparently viewed Point Hope natives from the vantage point of cultural superiority. A classified summary of Chariot, by the Lawrence Radiation Laboratory, described Point Hope in the language of the expendable other: "In the vicinity of the job site there are no known activities such as mining or trapping. The only known population in the area is a community of Eskimos at Point Hope. These people are destitute and gain their existence from the sea, the Kukpuk River and the local reindeer herd" (Summary of Project Chariot). The employment values of the Lawrence Radiation project planners were transparent: mining and trapping are better occupations than fishing and hunting.

Dr. George Rogers, a well-known Alaskan economist, was worried about disturbing the hunting patterns of the Eskimos in the region. Teller attempted to straighten him out, while confirming his own view of the Eskimos as objects on which to experiment. "[Teller] gave me the pitch again," wrote Rogers. "Then I said well, the Native people, they depend on the sea mammals and the caribou. He said, well, they're going to have to change their way of life. I said what are they going to do? Well, he said, when we have the harbor we can create coal mines in the Arctic, and they can become coal miners" (O'Neill 1994, 33–34).

Teller flew to Alaska to launch Chariot in person, wooing support for the project. The *Fairbanks Daily News-Miner* summed up a speech he delivered to faculty at the University of Alaska with a headline that underscored Teller's focus on economic incentives and his version of what constituted progress for the natives: "Alaska Can Have Massive Nuclear Engineering Job." The article begins, "An opportunity for Alaska to have a $5 million earthmoving job done at no cost to the state was outlined here yesterday." It goes on to say that Teller and the AEC would spend two thirds of the

five million dollars "in direct outlays for goods and labor," and the real boon to the state's economy would arrive in the wake of the nuclear explosions, when the keyhole harbor would begin to serve as an export avenue for coal. "Black diamonds," said Teller, "can pay off better than [Alaska's] gold ever did or will" (33).

Using images made palpable with overhead projectors, film projectors, films, flip charts, pie charts, and bar graphs, the AEC courted Alaska by presenting their version of Márquez's cardboard roses and fruit—designed to mix together in the public mind images of nuclear bombs and economic prosperity. In the small Alaskan villages, Eskimo populations were less interested in coal than in protecting their traditional fishing and caribou hunting. The AEC tactics were met with unbridled skepticism. At Point Hope, the campaign backfired. AEC's Russell Ball introduced the spirit of Plowshare with one of the promotional props—a color film called *Industrial Applications of Nuclear Explosives*, produced by Lawrence Radiation Laboratories. Author Dan O'Neill describes the reactions of the Alaskan natives to a viewing of the film:

> [T]he first thing the Eskimos saw after the title faded was a white flash followed by a churning red fireball lifting off the earth…. Over the quavering strains of the music track they heard the smooth, euphonic tones of a narrator: "Now that man has learned to control a vastly greater force than chemical explosives, his thinking has turned to methods which will make effective use of this power within industry. The potential applications? Consider just one. The development of a harbor in the hard rock of a remote coastal area."
>
> The still-growing mushroom cloud dissolved, and in its place appeared, in animation, the Ogotoruk Creek valley. The audience recognized the green, rolling hills where they hunted caribou, and the slanting limestone cliffs along the coast where they gathered crowbill eggs. Graphic overlays dissolved in to show the keyhole-shaped outline of a harbor and the location and depth of the nuclear explosives….
>
> The green valley floor instantly heaved into a massive dome and blew apart in streamers of dark rocks and boiling dust. The audience cried "Yeeeee! Ahhh!" (O'Neill 1994, 119)

Notwithstanding what appeared to be a stunned reaction to the film, the Point

Hope natives had done their homework, and the questions they raised were probing and specific. How long will it take for the radionuclides to decay? What would the AEC do if something unexpected did happen? What might be the effect of radiation on the fish? Would the test interfere with caribou and seal hunting? Is there a lesson to be taken from the Bikini experience? How would the test affect the traditional gathering of crowbill eggs?

AEC's Russell Ball at first responded by invoking the insider voice to soothe the outsider: "All I can say is, briefly, is that the studies we are conducting of your people, of your hunting, of your fishing, of your catching seals and so on, all of this will guide us in finding the right time of year for such an experiment. Only if these studies show that we can pick a time that will not be of harm to your people, only then would we do the experiment. We have your welfare at heart; we cannot afford to do you harm" (125).

Ball called forth scientists and experts to speak to the safety of the site and the scientific soundness of the project. Among them was Dr. Rausch, a parasitologist who was endowed with what O'Neill describes as intimidating speech mannerisms—talking with "great precision, as if he took in the world in data bits and processed them with robotic exactitude." Although he spoke outside his academic specialty, Rausch assertively predicted the quantity and nature of the fallout: "[T]he amount that will escape, to begin with, will be quite a small part of the total yield. And the half-life of the radioactive elements that are produced will be so short that some will be gone in a matter of hours; some will take longer" (119–120).

In answer to questions about the Marshall Islands testing and the potential for contamination of fish, Rausch retorted with the "no one injured" response: "[Marine biologists] found no evidence that fishes were destroyed or that there was any significant amount of radiation in them" (121).

One of the Point Hope Eskimos, Kitty Kinneeveauk, grasped the difference between We and You. She rose from the audience, assumed her full five-foot-height and said what was on the minds of most of the marginalized Alaskans in the audience: "So, I've been thinking about we really don't want to see the Cape Thompson blasted because it is our homeland. I'm pretty sure you don't like to see your home blasted by some other people who didn't live in your place like we live in Point Hope" (125).

The Point Hope Village Council unanimously voted their opposition to Project Chariot. Soon after, questions similar to those posed by the Point Hope natives began to surface in newspapers and during other public meetings. By mid 1961,

the *Anchorage Daily Times* reported that Chariot was "running into rough weather in Alaska." A story in the *New York Times* suggested that the project might contaminate the food chain. Alarmed environmentalists from around the nation joined Alaskans opposed to the nuclear project. The project was dead, or, to use O'Neill's metaphor, Chariot's wheels had been spiked. The natives rejected the cardboard roses and elitism with a paean to place.

Other Plowshare Experiments

Many of the largest underground tests conducted at the NTS were Project Plowshare tests, and they left behind some of the most distinctive features found on the test site today, including Sedan Crater and Schooner Crater. Another result of Plowshare is almost paradoxical in that the stated peaceful purposes of the Plowshare tests did nothing to defuse growing political protests against almost every form of nuclear energy, peaceful or not. Public reactions to many of the planned Plowshare tests, especially to Project Chariot, united under one anti-nuclear umbrella, environmentalists and peace activists, groups whose goals had previously not been closely linked.

In all, four Plowshare projects were completed outside the boundaries of the NTS: two in New Mexico and two in Colorado. None of them measured up to the grandiose goals established by Edward Teller and his colleagues, nor did they yield convincing evidence that nuclear explosions could be used to safely expedite large civil engineering projects. All of them were marketed to communities with the old "safety and sound science" campaign, coupled with the new promise of economic prosperity.

In 1961 Project Gnome, a 3-kiloton nuclear test was conducted near Carlsbad, New Mexico, as an experiment to determine whether the heat created by an underground nuclear explosion could be used to generate steam, and ultimately electricity. The community of Carlsbad was courted with a promise that the prestige gained through national press exposure would reap ongoing economic rewards. However, the steam venting from the emplacement shaft was too radioactive to utilize, and data was lost due to equipment failures.

In 1967 Project Gasbuggy, a 20-kiloton test, was conducted near Farmington, New Mexico. It was designed to liberate natural gas from the unyielding sandstone

Most Project Plowshare tests were named for land or sea conveyances: Sedan, Hand Car, Sulky, Planquin, Gasbuggy, Cabriolet, and Schooner. Planned but not completed were Wagon, Ketch, Sloop, Yawl, Carryall, Chariot, and Phaeton.

beneath the Carson National Forest. Despite the failure of Gnome, Gasbuggy was promoted within New Mexico as a harbinger of prosperity to follow. Advance press releases touted the new "eight mile paved road," courtesy of the AEC, and predicted that hunters would experience a better deer hunt because of the new access. On 10 December 1967, the day of the test, the *Santa Fe New Mexican* proclaimed: "A Bang-up Gasbuggy Today Could Double U.S. Natural Gas." Two days later, the same paper brightly proclaimed that Gasbuggy "holds promise for a new era of economic development in the United States" (Wolff 1991, 8).

Professor of psychology Christian Buys has analyzed the incongruity that Gasbuggy press releases incorporated only passive and peaceful language to describe a violent nuclear explosion. The image of a seed sown in the ground became the prevailing metaphor. On the day of the test this nuclear seed sown 4,250 feet below the ground blossomed as promised (Buys 1989, 32). Gas was in fact liberated, but residual radioactivity rendered the product unmarketable, a dilemma that the AEC thought it could solve by experimenting further on Rocky Mountain natural gas deposits.

To that end, in 1969 a 40-kiloton device was exploded underground near Grand Junction, Colorado, as Project Rulison, and three 30-kiloton devices were exploded near Rifle, Colorado, as Project Rio Blanco.

The Rulison test was a nuclear joint venture between government and industry, including the Austral Oil Company and CER Geonuclear Corporation. The extent to which the economic benefits of the test were trumpeted is suggested in a manuscript penned by Fred Smith of Cedaredge, Colorado, a town about 30 miles from Rulison. Smith launched a personal campaign against the test, later stating: "The leaders of the Uranium Capital of the World had sold out body and soul to the AEC many years ago, and the manager of the Chamber of Commerce saw this even as merely something that was good for the restaurant and hotel business" (34). As might be expected, because of the news of Gasbuggy's less than desirable gas products, AEC assured Coloradans that suitable methods for cleansing the radioactive gas would be found, and using the "radiation is natural" refrain, stated that "any flaring which occurred after the blast would produce radiation not more harmful than that received on a round trip between New York and Denver in a jet airplane, or [with a regional touch] the dose from solar radiation a person would receive by spending two weeks at a Colorado ski resort" (33).

One issue that ultimately sealed the fate of Plowshare was ironically an economic one: a failure on the part of the AEC to identify areas of responsibility with their

business partners. Who would pay for the bombs used by industry? How much economic support could industry expect from the government? What kind of cooperative agreements could be drawn to protect interests on both sides? Who would define safety limits for radioactivity in the gas? Who would assume liability in the case of a nuclear accident?

The biggest problem, however, was the failure by the AEC to discover ways to cleanse the products. The liberated gas remained contaminated, and was impossible to market. "The image of radioactive natural gas issuing from every stove-top," author David Kirsch wryly states, "proved hard to dislodge" (Kirsch 1997, 212).

Project Faultless

The Limited Nuclear Test Ban Treaty (LNTBT) ushered in a new era on the Nevada Test Site, as well as at off-site locales. Gone were the flocks of reporters gathered at News Nob to view the dazzling light show and track the ascent and path of the mushroom cloud. Gone were the Doom Town settings, bomb shelters, and exposure cages. The bright suns became like Walt Whitman's "dark suns I cannot see." "It lost its thrill," said a Nevada site worker. "In atmospheric tests you can see what's happening, the fireball, the stem; you can see the earth being sucked up" (Rogers 2000, B1). Those dark suns came with a high cost: more testing and larger tests.

In 1962 almost all of the nuclear weapons tested underground at the NTS were of very low yield, less than a kiloton. During 1963, the year the LNTBT was signed, the largest underground weapon test undertaken on the NTS represented a big step upward in yield. Bilby measured 249 kilotons. However, the momentum toward higher yields swelled between 1968 and 1970, and tests named Boxcar, Benham, Milrow, and Jorum all released at least a megaton of energy.

The growing yields of the tests were consequences of the nation's race with the Soviet Union to develop ever-larger nuclear warheads. In the mid-1960s, the military was developing the Spartan anti-ballistic missile, capable of carrying and delivering a multiple megaton warhead. As warheads increased in yield and their designs were improved, they were routinely tested underground at the NTS. Project Plowshare played a role in the pattern of increasing yields, as most of Edward Teller's nuclear engineering plans called for moving megatons of earth with megatons of nuclear energy.

At the same time, testing bombs underground at the NTS was becoming politically, if not actually, problematic. During some of the larger underground tests, shock waves and ground tremors caused high-rise hotels and casinos in Las Vegas to sway for several minutes. Gaming entrepreneurs worried about tourist jitters, and the AEC regularly processed claims for broken windows.

Fears of groundwater contamination at the NTS added to jitters all around the Las Vegas valley. So, with some haste, the search for a supplemental test site was launched. By 1965, the list of potential supplemental sites had been narrowed to Amchitka, Alaska, and a plot of land in Central Nevada, between Eureka and Tonopah, in the Hot Creek Valley. The Hot Creek Valley seemed ideal on the surface—close enough to the NTS for efficient transport of equipment and personnel, and far enough away from Las Vegas to assuage some of the public's fears and frustrations.

Enter Howard Hughes: Hughes was a walking paradox—at once a mysterious hermit and a well-known casino and airline mogul. His unpredictable behavior and an immense bank account made him a force to be reckoned with in Las Vegas politics. At about the time the LNTBT was signed, Hughes began to exert pressure on the AEC to move underground nuclear testing away from Las Vegas. The Hughes organization, upon learning of the AEC plans to evaluate the area in Central Nevada, urged the AEC to move quickly to officially recognize the area as a supplemental test site.

Hughes's involvement can be reconstructed from memos and correspondence held in the DOE archives in Las Vegas. What emerges is a scenario where Hughes was apprehensive, to the point of paranoia, over radiation releases and groundwater contamination from underground testing. He was prepared to actively interfere with the testing at the NTS of any nuclear weapon with a predicted yield of more than one megaton.

In May 1967, James E. Reeves, manager of the NTS, received a phone call from Hank Greenspun, editor of the *Las Vegas Sun*, advising Reeves (and the AEC) that Hughes was nervous and worried about the scheduled Scotch test (part of the cocktail- and cheese-named series). AEC's Edward Bloch met with Robert Maheu, who claimed to be Hughes's right hand man, in Maheu's private apartment at the Desert Inn Golf Course. Maheu, according to Bloch, asked several questions "obviously trying to determine if we were going to expand our activities at the test site with larger and larger yields with increased probability of damage to structures in the Las Vegas area." Bloch explained, "[W]e had been gradually increasing the size of the yields of the shot.... We discussed the Central Nevada development" (Howard Hughes File).

The stakes were raised and hopes soared within both the AEC offices and the Hughes hierarchy that the central Nevada area would prove suitable for testing high-yield nuclear weapons. What the AEC did not know was whether the site was capable, in geologic terms, of safely containing (without surface venting or fault blocking)

large underground nuclear bombs. A calibration test, Project Faultless, would help answer the question.

As early as 1966, an AEC public relations team had traveled to Tonopah, Nevada, to prepare the residents for the calibration test and to initiate a marketing campaign there and in surrounding communities. The team left behind the film that had alarmed the Point Hope Eskimos, but they brought slides of the Shoal test, as a demonstration of what residents could expect from an underground atomic test. Left undisclosed was the difference in yield between Project Shoal and Project Faultless. Project Shoal tested a relatively small, 12-plus kiloton bomb, whereas the classified, predicted yield of Faultless was 600 to 900 kilotons, at least 50 times the size of the Shoal device. (The actual yield of Faultless is now placed at 1 megaton.)

A transcript of the Tonopah public meeting provides a rare opportunity to examine not only the words used to promote the test, but the context in which they were applied. As we have seen in similar off-site projects, the AEC stressed national security, their previous safety record, the role of experts, the soundness of the science employed, and the economic advantages sure to accompany the test.

The AEC's Robert Miller began by stating that the AEC and the Department of Defense had "been able to maintain reasonable parity with the Soviet Union by conducting an aggressive and certainly expensive underground nuclear test program." Alluding to the underground nuclear test program as certainly expensive established the context for his references to economic benefits throughout the presentation.

> We think we have interfered as little as possible with [those living in communities adjacent the Nevada Test Site and their] way of life, and we sincerely hope that we have contributed something to their economy.... We need places for our engineers; we need places for our technicians; we need fuel for our vehicles.... A large amount of money and effort will be expended in studying the water area systems of this area.... We propose to have a minimal impact upon the City of Tonopah except that which we may contribute to its economy. We are extremely generous [in paying damage claims] when we go off-site. (TPM 1966, 8)

The degree to which the economic benefits became the focus of the meeting is the subject of a letter sent by Peter Damele, a rancher in Austin, Nevada, to Nevada

Senator Alan Bible, shortly before the detonation of Project Faultless.

> The AEC spokesmen and representatives of the Government have said a lot about the economic benefits to the local communities, when the AEC moves in men and equipment. Indeed I understand that different states exerted all out effort and influence to get the test sites located in them, because of the tremendous amount of money this program would bring in.

> This kind of temporary prosperity is hollow and false and is promoted by people who can see no farther than their cash register. It is prosperity for a few local merchants and gamblers, at the expense of the state's lands and water resources. Land and water, that is if they are not damaged, will produce far more real prosperity than this testing program. (Damale 1967)

The "no one injured" tale, as told by Robert Miller to the citizens gathered in Tonopah, is worth repeating, if for no other reason than that it confirms that the previous public relations patterns still governed the discourse:

> At the Island of Amchitka in the Aleutian Chain, which is an island about thirty miles long, we conducted a deep underground nuclear event. On Amchitka there were a number of sea otters, and the Island of Amchitka was the island where after deplenishment by hunting and I suppose some natural biological action, the sea otter became almost extinct, and it found itself again on the Island of Amchitaka and began to breed, and the sea otter today is strong.... When we finally detonated, after doing the things to protect them, we fired. The sea otters lay on the beaches. They didn't move. In fact some of us had to go down and kick them, and they still didn't move. It was predicted that out of several hundred sea otters on the island that we might injure two or three. Happily enough, we couldn't find the two or three. We never found one that was injured. (TPM 1966, 6)

The real insight is provided by the voice used by the AEC spokesman: an authoritative, expert, insider, scientifically smug voice. In response to a question about the safety of the project, the phrases march down the transcript as a series of "We" followed by technical descriptions: "We will run infrared surveys.... We will run aeromagnetic surveys.... We will award a contract for the drilling of three holes. We will drill these to 2,000 feet. We will take thermal measurements" (TPM 1966, 11).

The transcript illustrates a technique linguists refer to as "code-switching," a deliberate shift in diction and content aimed at getting closer to a given audience. Miller and AEC's Bill Smith played up being regular, good fellows. Miller told the audience that "Bill Smith and I both served in the wars" (TPM 1966, 4), and added later in the meeting "We are happy to attend this 'little get-together.'" Mr. Smith laughed, saying, "I used to have a noisy Boy Scout Troop and therefore I am used to speaking without a microphone" (TPM 1966, 10). The project was even compared to oil exploration: "The clearest analogy to what we are doing goes to petroleum exploration. It is going to be necessary to drill a few holes . . . in order that we may sort of calibrate our data" (TPM 1966, 8).

With the benefit of hindsight, it is easy to pinpoint ways in which the impending Faultless test was explained to the public in terms that were simply not truthful. The statement that perhaps one test would take place was false. The perhaps was a done deal. Faultless was already well past the design phase and into implementation; the bore hole was drilled for Adagio, already code named and waiting in the wings.

Observe is Not the Same as See

Robert Miller, Bill Smith, and AEC Public Information Officer Henry Vermillion strove to conceal the truth gap by using words like direct, open, and honest. For instance, Miller said, "I hope to dispel fears that may have been generated perhaps by a program that hasn't really addressed the subject directly" and "[A]ny area we might be in would be entirely open." Henry Vermillion explained, "[W]e would like to be with you, to answer your questions as honestly as we can."

As the test approached, the AEC's pledge to honor openness was utterly compromised, dismantled one step at a time. Euphemisms took the place of sincere efforts to open the test to public scrutiny. The first compromise affected the pledge to allow

the public to view the nuclear test. AEC officials knew that closing off the test area to the public would leave the whole endeavor vulnerable to the wild speculations they sought to quell in public meetings, like the one held in Tonopah. Unfortunately, though, an unclouded view of the event would most certainly reveal the classified predicted high yield. Thus, AEC ingeniously proposed televising closed-circuit images of ground zero to the AEC base camp, 30 miles away, where visitors would be allowed to watch the proceedings. As a memo they wrote explains, the AEC rationalized that to "observe does not mean 'see,' but rather be on hand at a select area.... [T]he 'observer' site might be established with no line of sight to ground zero" (Information Materials… 1967, 3).

The same memo includes a statement that the military had its own position and wanted to ward off any unofficial observation of the predicted 14–16 foot ground swell, even on closed-circuit images: "We believe that the policy of reasonably open 'observation' of Faultless will be met without providing closed circuit television. We believe that news media and other observers will be satisfied with feeling the ground shock.... " The military was of the further opinion that closed circuit television was "tantamount to releasing still and motion pictures of the 14–16 foot ground rise expected" and that any view of the shot "would increase publicity of the event and establish a precedent for live picture coverage in weapons test areas" (Information Materials … 1967, 5).

The military's position prevailed, and an obscure sentence was crafted to use in invitations sent to the public to observe Faultless: "We have gone as far as we can go in arranging for you to be in this base camp area where you can feel the earth shock from the test and receive other information about our activities" (Information Materials … 1967, 4).

A Test Site is Not A Test Site

AEC memos expose an internal disagreement over what to call the new central Nevada testing locale. A 1968 Bureau of Land Management map labels the Hot Creek area as the "Central Nevada Test Site." Throughout the mid-1960s, AEC correspondence refers to it simply as Test Site, or Supplemental Test Site. These designations apparently created public relations problems, resulting in a memo issued to AEC staff in December 1967: "The supplemental



test area being developed by NVOO [Nevada Operations Office] in Central Nevada is not and should not be referred to as a 'supplemental Test Site'.... The term 'Project Site' will be used to identify the areas immediately surrounding the holes drilled in Central Nevada for testing.... The terminology 'supplemental Test Area' has evolved to refer to the area in general.... It is requested the term 'Supplemental Test Site' not be used to designate the Central Nevada area in public utterances, correspondence, or in any material which could come to the attention of individuals outside the immediate AEC-NVOO contractor complex.... We prefer that if the terminology 'Supplemental Test Site' is used in reference to Central Nevada it be only in 'Official Use Only' material" (Vermillion 1968, 1–2).

Taken together, the memos signify the culture change that had occurred between the 1963 Shoal event and the 1968 Faultless event. In publicizing Faultless, the bandaged finger wobbled cautiously, very cautiously, back to the flame. Gone was the straightforward approach of erecting grandstands and inviting VIP's to witness the test.

Faultless was detonated on 17 January 1968, resulting in the predicted large swelling of the surface at ground zero, then the unpredicted collapse of a huge block of earth. The goal was for the earth to crater but not crack. Two steep fault ridges can still be seen today north and south of ground zero, extending for thousands of feet. The site was anything but faultless, ending the disagreements over its suitability. Its future as an underground nuclear test site was finished.

Calibration studies of Amchitka Island were more successful. Three large devices were tested there, in regions unpopulated except by the sea otters. (At 5 megatons Cannikin, detonated in 1971, was the largest underground test undertaken by the United States.) Even so, Amchitka was not a wholly satisfactory supplemental test site, and was not widely used because of its distance from the weapons laboratories and its harsh weather.

The failure of Faultless sowed disappointment throughout the nuclear establishment, which saw the result as complicating nuclear warhead development and high-yield testing. Howard Hughes continued to lobby against large-scale testing near Las Vegas. His staff visited Vice Present Hubert Humphrey in Washington D.C., seeking the formation of a committee to analyze safety research and application in the underground test program.

John Meier, of the Howard Hughes organization, gradually took on the role of communications facilitator between Robert Miller, Manager of the NTS, and Hughes.

According to a memo, dated 27 March 1969, Meier was coaching Hughes to understand that national security matters were driving testing policy, not the local AEC office. The memo further states, "Meier has convinced Hughes that there is no profit to be gained by local news media battles" (Howard Hughes File).

As an interesting footnote to the Hughes story, in late 1969 his corporation proposed a Plowshare type project to divert the waters of Lake Mead. When the AEC expressed confusion over Hughes's position on nuclear testing, Meier told Miller that Hughes had objected to high-yield nuclear testing, but not to testing in general, and that it was clearly in the Hughes organization's financial interests to support the administration's nuclear position. There was, stated Meier, a "division of opinion" within the Hughes Tool Company over this apparent contradiction, and "they were in a difficult public relations situation of their own making" (Howard Hughes File).

One of the last documents in the Hughes file at the DOE archives is a note sent to AEC's Miller from the Hughes Tool Company, thanking the AEC "for the privilege of serving you" and offering "to furnish Hughes products where they can be of value to your operations." The influence of a solicitous new potential trading partner apparently altered Hughes's personal resistance, shifting the stance of the Hughes Tool Company to a position where they were inclined to exchange polite business thank you notes with the AEC.

Managing Nuclear Wastes

With the 1992 suspension of underground nuclear testing, many of the images of the Cold War nuclear age—missile warheads, red alerts, fallout shelters, and countdowns—have lost some of their power to scare us. Yet, risky nuclear activities continue in the form of nuclear power production, stockpile maintenance, weapons research and development, medical research, and nuclear waste management. The task of managing nuclear waste is so vast and troublesome that it has ushered in a new, but less theatrical nuclear age.

And, wastes there are. The radioactive waste left by the production and testing of just one bomb includes enriched uranium, plutonium, tritium, and depleted uranium. It includes any containers in which the radioactive elements have been transported, stored, or mixed, and any uniforms, shoes, gloves, and masks that came in contact with radioactive elements. It includes the laboratory equipment—beakers, test tubes, funnels, and pipes—that touched radioactive material during the assembly of a bomb; the miles of cable and hundreds of instruments used to measure effects of atomic detonations; any radioactive elements and components remaining from a "fizzle" or incomplete fission; and any equipment exposed by plan or by accident to radiation: cars, animal cages, army tanks, jeeps, airplanes, telephone wires, computers, and missile silos. After a bomb is removed from the national stockpile and dismantled, the disabled bomb parts are classified as nuclear waste, too.

Waste accrues from nuclear medical treatments and diagnostics, including CT scans and x-rays administered at hospitals, universities, and clinics. It remains behind from thousands of experiments in nuclear physics. A majority of the medical and laboratory waste is designated transuranic (TRU) waste and has been shipped or is scheduled for shipment to the Waste Isolation Pilot Project (WIPP)—an underground repository at Carlsbad, New Mexico, where the TRU waste, loaded into 55-gallon soft-steel drums, is buried in salt caverns.

In an article entitled "Hot Dogs," in the *Bulletin of the Atomic Scientists*, the author reported that carcasses of 828 dead, radioactive beagles were placed in 55-gallon drums, designated as TRU waste, and disposed of in shallow trenches at Hanford, Washington. The beagles were subjected to experiments over a period of twenty-seven years at the Institute of Toxicology and Environment Health at University of California, Davis, where they were exposed to radiation and fed radioactive food.

More dangerous and longer-lived waste is called High Level Nuclear Waste (HLNW), and consists of waste that has been produced for over fifty years at 113 nuclear power plants in America, and by a fleet of nuclear-powered submarines, more of it accumulating every day. The majority of the HLNW consists of commercial-spent fuel.

Inside a nuclear power plant, 12-foot-long zirconium-clad fuel rods, filled with pellets of uranium oxide, are lowered into water. The uranium-235 decays, releasing enough heat to convert water to steam, which powers the turbines. Spent fuel is a rather misleading term for what is left inside a fuel rod after the uranium-235 has decayed to plutonium-239 and other highly radioactive and long-lived elements. The paradox of the process is that plutonium-239, and other byproducts of the fission process—the so-called spent fuel—poses a greater hazard for longer periods of time than does the uranium from which it was transmuted. Plutonium has a half-life of 24,000 years, meaning that only half of it will decay over 24,000 years.

When a power plant is eventually decommissioned, after an average life cycle of fifty years, the core of the reactor will be designated nuclear waste. The site of the power plant will be surrounded by a barrier of barbed wire and kept off-limits to the public. But the spent fuel rods will remain highly dangerous, essentially forever.

At present, most of the spent fuel rods are stored next to the reactors they once fueled, racked in water baths resembling Olympic-size swimming pools. They are closely monitored as they cool down, awaiting transfer to other storage systems. At some power plants, the spent fuel rods have been transferred to dry casks—heavily shielded and air-cooled concrete containers shaped like the gigantic barrels from which Gulliver might have drawn wine during his travels in the land of giants. The dry casks are a temporary storage solution, considered to be safe for at least 100 years.

We yearn for a modern Hercules to clean up the wastes. The mythical Greek hero was challenged to cleanse the stables of Augeas, King of Elis, filled with mountains of manure continually produced by the king's 10,000 horses. Hercules solved the problem by diverting the waters of the rivers Alpheus and Peneius to run through the mucky stables and carry away the manure. However, the quandary of nuclear Augean stables would stump even Hercules. Water added to nuclear waste yields contaminated water. Neither could Hercules call upon Boreus or any of the other winds to just blow it all away. To what corner of our earth could radioactive material be safely blown?

In 1961 three maintenance technicians at the AEC's National Reactor Testing Station in Arco, Idaho, were killed when a reactor overheated and threatened to "go supercritical," spraying the three workers with radioactive steam. The heads and hands of the unfortunate workers were judged too radioactive for conventional burial, even in lead-lined coffins, and were marked "for disposal as high level radioactive waste" (Monmonier 1997, 97).

The Nuclear Waste Policy Act

Proposals for cleaning our nation's nuclear stables have included transporting HLNW to outer space, shelving it in deep seabed tombs, and injecting it into the earth's core. For three decades, however, the solution endorsed by the DOE, the nuclear industry, and Congress has been to store the wastes in an underground repository. The drive to identify a suitable site and build a subsurface repository has been fueled by a promise made to the nuclear industry by the federal government, shortly after the dawn of the nuclear age, when scientists, engineers, and politicians alike predicted that easily and safely generated nuclear power would become too cheap to meter, tidily solving the nation's growing energy needs. Riding on this optimism, Congress passed legislation pledging that the government, by the year 2000, would take ownership of the spent fuel.

Since then, a series of new laws has increased the urgency to site and build a repository. In 1982 Congress passed the Nuclear Waste Policy Act (NWPA). It called for the selection of two HLNW repository sites: one east of the Mississippi River, where more than 70 percent of the spent fuel has been generated, and a second in the West. The thinking behind the NWPA was that the selection of two sites rather than one would balance the politics, lower the risks of transportation accidents, and create better opportunities for examining different types of host repository material—granite, salt, and tuff—to determine which natural geologic formation might best guard against invading water or escaping radioactive particles. Granite, the mother of all rocks, was thought to be the most stable and impervious host. Eventually, nine sites were nominated in the East, most of them in granite, and three in the West: Deaf Smith County, Texas, in salt; Hanford, Washington, in basalt; and Yucca Mountain, Nevada, in welded tuff.

In 1986 the NWPA was amended to remove the eastern states from the list of potential sites. The following year another amendment passed that removed Deaf Smith and Hanford, as well. Left was Yucca Mountain, 90 miles northwest of Las Vegas, Nevada. The plan was to shelve spent fuel rods, housed in canisters, in eternally dry subterranean tunnels carved into the welded tuff, like niches carved in a Roman columbarium.

In 2000, following the letter of the law, the DOE took ownership of the spent fuel, without having built a repository or solved the nuclear waste dilemma in some other manner. Four years later, on the recommendation of Secretary of Energy Spencer

Abraham, President George W. Bush officially nominated Yucca Mountain as the site for HLNW. However, in early March 2009, Secretary of Energy Steven Chu announced that Yucca Mountain, the site under study for over two decades, was no longer an option for storing HLNW. And it appears that President Barack Obama's budget eliminates funding for the project.

The issue of just what to do with the wastes, now and forever, rests on the legislative table ticking like a metronome. The nuclear industry has not given up on the Yucca Mountain site, and has filed lawsuits to force the DOE to remove the waste from power plant sites. The license application to build and operate a Yucca Mountain repository is still pending before the Nuclear Regulatory Commission (NRC). "Yucca could always come back," warns Matthew Wald in *Scientific American* (Wald 2009, 53).

The Obama administration's position reflects the reality that the plan to build a HLNW repository at Yucca Mountain has been fraught from the outset with political, scientific, and economic difficulties. Various lessons can be learned from the DOE's failed strategies to win Nevada's support for the project. Examining those strategies should be useful to those who consider the waste storage options that lie ahead.

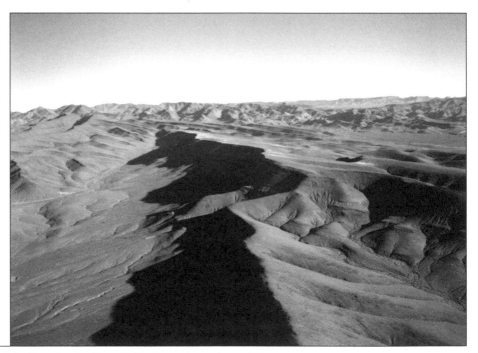

Figure 12.1 **Yucca Mountain, Nye County, Nevada. Photograph courtesy of the U. S. Department of Energy.**

One of the obstacles the DOE failed to overcome was Nevadans' resistance to the repository project. The 1987 Nuclear Waste Policy Amendments Act was vilified throughout the state and labeled the "Screw Nevada Act." Since then, opinion polls taken in the state have held steady with 80 percent surveyed opposed to the project. Rather than acknowledge the validity of opposing viewpoints, DOE has relied on many of the same rhetorical devices implemented in the past to sell nuclear sites to the public at risk: the science is sound, radiation is natural, no one has ever been injured (during the transportation of nuclear spent fuel), Yucca Mountain is already a waste-land, and Nevadans should do their patriotic duty. No wonder the strategy has failed. There remain throughout the Silver State deep misgivings concerning the DOE's truth-fulness, issuing from a collective memory of broken promises, politicized science, and rhetorical manipulation.

How much has the state's nuclear history affected Nevadans' reactions to the planned Yucca Mountain Project? The results of a risk perceptions survey, adminis-tered in Las Vegas several years ago, strongly suggests that respondents' opinions were related to their perceptions of various NTS activities, a finding labeled a "risk perception shadow." The results of the survey consistently showed that "the more the NTS is perceived as harmful, the more negative the attitude toward the reposi-tory" (Mushkatel, Nigg, and Pijawka 1993, 247). Additional questions relating to acci-dents and accident reporting, also trust issues concerning the NTS, were examined in the survey. One question asked, "What proportion of accidents at NTS do you believe the government has reported to the public. Have they reported all accidents, most accidents, some accidents, or very few accidents?" (252).

Only 3 percent of Las Vegans surveyed believed that the government had re-ported all accidents at the NTS. Only 4 percent of the respondents believed that if the repository were built the government would report all of the accidents, while 40 percent believed that few, if any, repository accidents would be reported.

Sound Science

For Nevadans, perhaps the most exasperating phrase used by the DOE is the exhausted and tarnished claim that sound science is at work to ensure the safety of the public. Spencer Abraham's 2002 recommendation of the Yucca Mountain site to President Bush contended that "sound science supports

"History doesn't repeat itself, but it rhymes." Attributed to Mark Twain.

the determination that the Yucca Mountain site is scientifically and technically suitable for the development of a repository" (Abraham 2002). To critics the sound science is voodoo science, one that relies on computers to predict political, social, environmental, and even cosmic events over almost unfathomable periods of time. Current congressional legislation mandates that the wastes remain isolated from the accessible environment for at least 10,000 years. However, as a practical matter, unshielded fuel rods will remain lethal for much longer than that, given the fact that the plutonium encapsulated within the rods has a 24,000-year half-life. Scientists studying Yucca Mountain have identified the so-called "peak dose" time for release of radionuclides from the proposed site into groundwater at a jolting 350,000 years from now.

The other cloud hanging over the phrase sound science is the question, "Whose science is sounder?" Because prediction of future repository conditions relies on selective data, almost every scientific finding made by DOE scientists in support of repository safety has been challenged with conflicting data generated by other scientists, either working independently or under contract to the Nevada Nuclear Waste Projects Office. Such a scientific tangle creates a Rashomon Gate at Yucca Mountain, leaving claims of truth and sound science mired in conflicting accounts.

The Big Beige Book

A companion to the DOE's sound science argument is the equally fatigued argument that radiation is natural, even benign. In 1991 the American Nuclear Energy Council (ANEC) funded newspaper advertisements in the *Las Vegas Review-Journal* featuring the photograph and testimony of Dr. Dale Klein, a well-respected scientist (now a member of the NRC). "Technically, there's radiation just about everywhere," Dr. Klein is quoted as saying, "[Y]ou don't have to fear radiation, it's everywhere—you need to understand it. You get radiated from your house, smoke detectors, walking in the sun, your office, taking a plane trip....People who say it's harmful are using scare tactics that have no basis in scientific truth" (ANEC 1991).

Similar language describing radiation can be found in a document produced in 1992 to inform the public about the Yucca Mountain Project. Entitled "DOE's Yucca Mountain Studies," the brochure is an updated version of *Atomic Tests in Nevada* (The Little Green Book), albeit with a beige cover, and like the prototype green book

it has been handed out to thousands of school children in the Las Vegas area. To read it is to enter a time warp. The DOE authors explain: "We live with radiation every day … radiation is one of the most scientifically understood, precisely detected and strictly regulated of all potentially harmful agents" (DOE's Yucca Mountain Studies 1992, 2). And, they assure their readers, the "DOE's work is checked by experts" (4), and "for more than thirty years there has not been a single death or injury during transportation due to the radioactive nature of the nuclear waste being transported" (19).

Engineering Safety

Another corollary to the sound science argument is that safety can be engineered—a transparently hollow statement used to convince the public of the soundness of the project. The suggestion of "engineering" Yucca Mountain constitutes a complete retreat from the characterization of the mountain itself as a suitable geologic barrier.

The concept of engineering safety was part of the "Project Nutmeg Report," in which the idea of paving the desert was put forward as a method of reducing fallout. At the NTS, a few small test patches of concrete paving were given a trial run against the power of the bomb. But, for reasons of economics and tight schedules, the test site floor remained un-engineered, and the fireballs continued to suck up dirt and sand to form fallout debris.

Engineering a repository was not considered necessary to safety when Yucca Mountain was first nominated. In 1980 the DOE claimed: "Geologic barriers [as opposed to engineered barriers] are expected to provide isolation of the waste for at least 10,000 years after the waste is emplaced in a repository and probably will provide isolation for millennia thereafter" (State of Nevada Comments … 2000).

The expectations that the mountain would serve as a solid barrier and container have been dashed by data gathered since 1990. Of greatest concern is the discovery of chlorine-36 within the mountain. Because chlorine-36 is a residue from atmospheric weapons testing in the Pacific, its presence deep within the mountain proves that water has traveled from the surface down 800 feet to the repository horizon in less than fifty years, overturning all previous estimations of groundwater travel time.

The DOE's response to evidence of the mountain's porosity was to shift study away from the natural characteristics of the mountain to methods of shoring up the

repository with engineered barriers. The following excerpt from the *Environmental Impact Statement* is a clear confession of this design shift: "The waste packages, which would be designed to remain intact for thousands of years (at a minimum) would be part of an engineered barrier system inside the mountain and would isolate spent nuclear fuel and high level radioactive waste from the environment" (U.S. DOE 1999).

David Applegate, in a 2006 essay "The Mountain Matters," traces the DOE's move away from depending on the mountain to depending on man-made structures: "The DOE has sought to minimize the site's perceived liabilities by adopting a design that relies almost entirely on engineered barriers—fuel cladding, waste containers, and drip shields—to keep water from mobilizing the waste during the repository's regulatory compliance period" (127). In response to this I would say, with great sarcasm, "If engineered barriers are really that failsafe, high-level nuclear wastes could be entombed just about anywhere in the nation—beneath the pentagon, under New York harbor, or within the footprint of a nuclear power plant."

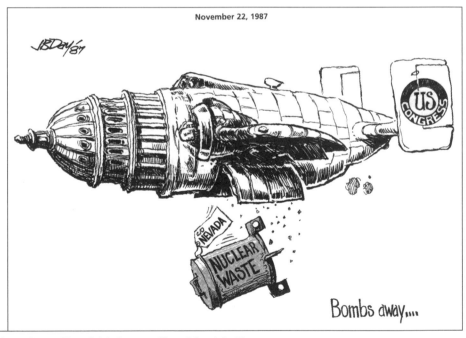

Figure 12.2 **By Jim Day from *Screw Nevada! A Cartoon Chronicle of the Yucca Mountain Nuke Dump Controversy*, 2002, ©Stephens Press, LLC.**

Wasteland Rhetoric

The state of Nevada continues to be portrayed as an aesthetic and cultural nowheresville thinly populated by weirdos. So the befuddled Nevadan of the 1950s press lives on. The resurrected imagery may have garnered support for the Yucca Mountain Project in some parts of the nation, but in Nevada and many other parts of the West it has solidified the opposition.

Examples are easy to find. In a 5 January 2002 article published in the *New York Times*, Evelyn Nieves describes Amargosa Valley, adjacent to the proposed Yucca Mountain repository:

> Amargosa Valley is a town of 1,500 people spread over 455 square miles, with a couple of combination gas station-bar-restaurant-casino-convenience stores, an opera house, a brothel and a lot of sand, scrub, and sky.... Debbie Lee lives in a compound of trailers and old cars with nine children and grandchildren, six goats, eight dogs, and a dozen cats.

At the conclusion of the article, the author describes Ms. Lee, with family and friends, joking "like stand-up comics about living near the ends of the earth, glowing in the dark, and waging a losing war against what they call 'mutant flies.'"

Like the images peppering newspaper and magazine reports about early testing at the NTS—beer bottle houses, gaming tables, prostitutes, and donkey's tails—the mutant flies and old cars form a derelict backdrop that helps create or produce a suitable site for a nuclear project. The waste repository site and nuclear proving grounds become sacrifice zones, or colonies of a sort, made to seem suitable with embedded imagery. Stating the obvious can strengthen a claim that this wasteland/wastelander language supports a form of colonialism: no one chooses freely to live next to lethal radioisotopes. Nuclear sites are chosen by others, and foisted on those at the bottom of the political / sociological / geographical ladder.

That the Department of Energy is keen to the advantages of wasteland rhetoric (as was its predecessor, the AEC) becomes apparent when you visit the Yucca Mountain Project website. Entering the Yucca Mountain Youth Zone, you are greeted by Yucca Mountain Johnny, an affable cartoon character dressed in miner's clothing and goggles. Johnny answers the question "Who lives at Yucca Mountain?" with the

simple response "No one lives at Yucca Mountain." The "closest family lives about 14 miles away in Amargosa Valley," he says. There is no nod to the wildlife or natural beauty of the region or to any humans other than members of the nearest family—creating the impression that one lonely homestead stands in the entire area, smack in the middle of ugly, government-owned emptiness.

Las Vegas journalist Geoff Schumacher sums up the injustice of wasteland rhetoric. "Dump supporters often refer to Yucca Mountain as being wasteland only suitable for nuclear waste dump," says Schumacher, reminding us of former Energy Secretary Spencer Abraham's description of the mountain as being in "the middle of nowhere." He continues, "There is an assumption that the middle of nowhere somehow deserves less consideration than more populated locales.... Second, it assumes that the relatively small number of people who do live in the area are deserving of less consideration than the large numbers of people congregating elsewhere. How can such a moral equation be justified?" (Schumacher 2002, M5).

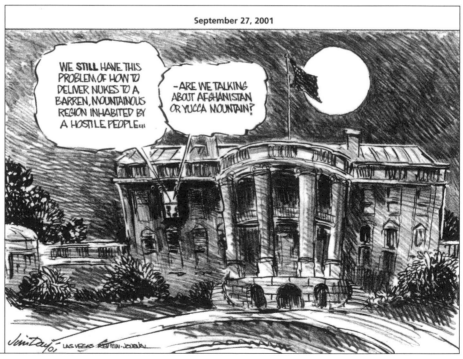

Figure 12.3 **By Jim Day from *Screw Nevada! A Cartoon Chronicle of the Yucca Mountain Nuke Dump Controversy*, 2002, © Stephens Press, LLC.**

Formally exploring wasteland rhetoric as it has been applied to the promotion of the Yucca Mountain Project, Soren Larsen and Timothy Brock, authors of an article in the *Geographical Review*, divided the images employed by newspaper reporters into three groups: the spatially abstract frame, the pronuclear Cold War frame, and the beauty/sacredness frame. Spatially abstract images, Larsen and Brock explained, were employed to describe the mountain literally, as a geologic ridge about 90 miles northwest of Las Vegas. Those who live in the state, or close by, used them most often.

About 50 percent of the news stories examined contained images of Nevada described through a pronuclear Cold War frame, with descriptors like desert, remote, desolate, isolated, and barren. The journalistic framing of Yucca Mountain has had distinct effects, claim Larsen and Brock. They cite a *Boston Herald* piece, which asserts that "the mountain is isolated on the vast government reservation where hundreds of nuclear bombs were exploded during half a century of weapons testing," and they cite an *Omaha World-Herald* article that concluded, "Nevada has already done a lot, being the site of open-air and underground nuclear weapons testing. But, it is well-suited, without danger of serious inconvenience, to take this additional step for the common good" (Larsen and Brock 2005, 226). Other negative phrases fitting within the pronuclear Cold War frame were "hellishly dry desert ridge," "volcanic heap," and "ugly mountain ridge" (Larsen and Brock 2005, 226).

The third frame consists of the rarely implemented "beauty/sacred" images of the mountain and the state. These are portrayals that speak to the hearts of Nevadans for whom Nevada is not a wasteland, but a land of beautiful desert expanses, framed by carnelian-hued mountains as far as the eyes can see. There are 170 peaks higher than 2,000 feet, and more than 30 mountains measuring above 11,000 feet within the boundaries of the state.

"Every place has a language," writes Paul Starrs in *Black Rock*. What we call place is "a library of smells, feelings, texture" (Goin and Starrs 2005, 237). Those who call Nevada home have visited this library—the smell of sage after the welcome rain; the sting of a hot, dry breeze in June; the texture of dusty playa and pooled water against the nearby cool mountain rock and fresh running streams. Bumper stickers affixed to Nevada cars and pickup trucks shout "Nevada is not a Wasteland," words raised like fists against the judgment of unappreciative eyes.

The Western Shoshone tribe consistently combats the wasteland argument with the images of beauty/sacredness, and claim that the Ruby Valley Treaty of 1863 gave

them legal title to Yucca Mountain. Their intimate relationship with their mountain can be traced back at least 12,000 years through archaeological studies of projectiles and tools found in site digs of ancient caves throughout the state. Through their traditional songs and stories, the Shoshone lift Yucca Mountain to mythopoeic heights. The mountain is mother, grandmother, and power rock. The tribe sings, "How beautiful is my mountain."

According to Native American belief, all the "elements of the contemporary world are functionally integrated: weather, soil, plants, animals, and people being bound together so a change in one component necessarily modifies other components.... These elements are integrated with world components that existed in the past, before the existence of humans, back to the beginning of time. Indian people express the belief that this timeless, world-wide integration was created by the supernatural" (Stoffle, Halmo, Olmsted, and Evans 1990, 12). Following these beliefs, entombing nuclear waste within mother earth, where it might poison soil, plants, animals, and people, is a crime against sacrosanct mountain, earth, and cosmos.

In 1997 the Shoshone tribe engaged in a modern version of the Ghost Dance, hoping to exorcise with song and dance the threat of the arrival of nuclear waste to their native land. Three Native American organizations sponsored an Honor the Earth concert in Las Vegas, featuring the Indigo Girls and Bonnie Raitt.

The strong beliefs of tribal members take on even more significance when set against the cold equations and predictions of enlightened western science. Max Weber's disenchanted world reclaims a moment of enchantment.

The MX Missile Project

In Nevada, the history of the ill-fated MX Missile Project is a prophetic tale, pitting environmental justice and beauty/sacredness imagery against the nuclear establishment, a few years before Yucca Mountain was even placed on the nuclear-planning map.

It began in September 1979 when President Jimmy Carter announced his decision to base 200 nuclear missiles on a specially constructed racetrack that would shuttle them, day and night, amongst more than 4,500 underground silos dug deep into the sands on both sides of the Utah–Nevada border. The plan was given the nickname Shell Game, based on the assumption that the Soviets could not guess the location of any missile at any given moment.

The Ghost Dance was a frenzied and heartbreaking ritual adopted from the Plains Indians in the late nineteenth century by the Paiute prophet Wovoka, in hopes of turning back the white man's march to the West. Wovoka preached that a new skin would grow over the old earth, covering the white men and their deeds. In the resulting new world, buffalo herds would be replenished, and ghosts of the great-departed chiefs would appear. It was believed that those who danced the Ghost Dance carried the magic feather that would lift them to the new world, and make them invincible to bullets (a belief that drove Ghost Dancers straight into the cavalry guns). (Adapted from La Barre 1970, 41).

The MX plan was the result of over twenty years of Cold War research into the Air Force's fear that the nation lacked missile mobility. The installation of the system called for technological feats of staggering proportions. Each missile would be larger than anything in the U.S. arsenal, 70-feet long and 92 inches in diameter, over twice the weight of a Minuteman III. A 201-foot long, rubber-tired vehicle, the largest in the world, would transport it. Custom-designed roadways would connect components of a system covering 12,000 miles. Each missile would travel its own loop, with 23 shelters available to shuttle into. Forty-seven Great Basin valleys were mapped out to accommodate the missiles, shelters, and roadways that were to make up the system. Thomas L. Clark, of the English Department at the University of Nevada, Las Vegas, and Matthew Glass, of the Department of Philosophy and Religion at South Dakota State University, undertook independent semantic analyses of the rhetoric applied by advocates and opponents of the MX system. Both studies are interesting, because of the similar language employed by today's advocates and opponents of the Yucca Mountain Project.

Twenty-four million dollars was dedicated by the U.S. Air Force to launch a public relations campaign in Nevada and Utah for the MX Missile Project. Glass outlines ways in which wasteland imagery was writ large in the entire campaign. At first an idyllic image of the West emerged, which was quickly eclipsed by the image of the region, the Great Basin, "as a wasteland or sacrifice area" (Glass 1998, 258–259). Publicity sketches of the completed project might have been lifted from the 1957 "Atomic Tests in Nevada," the so-called Little Green Book that featured cartoons of cowboys easily adapting to the atomic bomb. The Air Force brochure depicted "cattle grazing next to security fences, and buckaroos on horseback contemplating the view across valleys dotted with cattle, sagebrush, and unobtrusive MX shelters." An opponent to the site selection process, quoted in Glass, theorized that the U.S. Air Force wanted to convey to the public and Congress that there was "nobody out there but sagebrush and Indians" (259).

A brochure distributed by subcontractor Boeing Aerospace featured a black and white photograph of endless barren desert with the caption: "[T]his is the land chosen for the new MX strategic deterrent missile." House and Senate members holding key positions on MX Missile Project appropriations subcommittees were flown over the area at high altitudes, making them wonder what, if anything lived below. Edwin Firmage, a Mormon activist and professor of international law at the University of

Utah, summarized the public relations campaign in an editorial written for the *Salt Lake Tribune*: "[T]he administration evidently considers Utah and Nevada to be the most expendable part of our nation" (260).

The MX proponents reinvented the semantics of sacrifice, calling on Nevadans and Utahns to consider the national good. Air Force Brigadier General Guy Hecker told Nevadans living directly in the shadows of the proposed silos that if and when the system was employed against the Russians they would be the lucky ones. "It will be a case of the living envying the dead," he told them. "All of the solutions are ugly…. But of all the uglies, the MX is the most attractive" (Fry 1980, 42).

One facet of Thomas L. Clark's semantic analysis is his examination of ways the potentially sinister images of the MX missile system were altered to produce the image of a friendly game. He explains that this "shell game" description of the MX Missile Project was complemented by official descriptions of the plan's trains, racetracks, and drag strips, as if the military establishment was "a group of juveniles playing with model trains" and "race cars, rather than a group of top level strategic planners playing in the biggest game of all—war" (Clark 1980, 12).

Matthew Glass describes how opponents of MX responded to all of the military gobbledygook with the "rhetoric of place." He believes it may have been the undisguised nature of the wasteland discourse that welded the diverse groups into solid opposition to the plan. Mormons, Western Shoshones, ranchers, priests, nuns, and academics found ways to speak "about their commitments, their loyalties to the land and people of the region, in short the way their traditions uphold images of the region in which they lived" (Glass 1998, 261).

The Western Shoshone drew on tribal tradition and religion to invoke the Great Basin as a web of power, citing their creation lore, which speaks "of their people being placed in the Great Basin by the Creator." A tribal spokesman claimed, "[T]he Shoshone Nation had a duty to protect the sacred homeland." Mormon leaders spoke to their own sacred traditions; to them the Great Basin "literally was Zion, the Promised Land." In counterpoint to the military directive to Chief Juda's people in the Marshall Islands, to behave as God's chosen people and allow the detonation of atomic weapons on his soil, Mormons decried the placement of MX missiles on their homeland as "an attempt to blot out the Lord's chosen people." Instead of challenging national security arguments, the sound science, or the politics of site selection, they focused on the culture and history of a beloved place, speaking with what Glass calls

"See, one of the serious illusions we live under in the United States, which is a major part of the whole system of indoctrination, is the idea that the government is the power—and the government is not the power, the government is one segment of power. Real power is in the hands of the people who own the society; the state-managers are usually just servants" (Chomsky 2002, 117).

a "moral voice" (266–267). Eventually the voices of morality prevailed. In 1981 the U.S. Air Force canceled plans to build the system.

The plot of the MX missile story in Nevada is similar to the tale of the ill-fated Project Chariot in Alaska. In that instance, Point Hope resident Kitty Kinneeveauk stood up to the AEC to sing her song of homeland. In the Nevada story, MX opponents discovered power and truth in voices celebrating place.

THE RHETORIC OF PREDICTION
Thirteen

With or without the Yucca Mountain storage option, the greatest challenge facing High Level Nuclear Waste (HLNW) disposal strategists is predicting social, political, and environmental conditions and events over tens of thousands of years—a period of time during which the wastes, assuming they are stored and not reused, must be kept isolated and dry.

Predicting Human Intrusion

A DOE exercise conducted in 1992 illuminates the radical extent to which the planning of any HLNW storage facility relies on prediction. The DOE gathered together a blue ribbon body made up of prominent linguists, astronomers, geologists, architects, artists, and anthropologists, and charged them with devising ways to warn future populations against inadvertent intrusion into subsurface nuclear waste repositories. The catalyst for the formation of the panel was the imminent opening of the Waste Isolation Pilot Project (WIPP), located in subterranean salt caverns beneath Carlsbad, New Mexico, and designed to receive transuranic (TRU) waste packages for permanent disposal. (The WIPP site has since opened and is receiving waste.)

Participants were divided into two panels: the Futures Panel and the Markers Panel. The Futures Panel was asked to envision future scenarios of political and social breakdown that might lead to a breach of the WIPP seals. Members of the Markers Panel, after examining the scenarios imagined by the Futures Panel, were asked to design the world's most impervious historical marker, one that must survive any imagined upheaval, and must communicate the concepts of danger and death through at least ten millennia. The frustration expressed by both panels underscores the intricate relationship between the necessity to safely isolate nuclear wastes over millennia and the outer limits of scientific prediction.

Members of the Futures Panel assigned working names to the projected scenarios of an upcoming world, where lethal wastes are buried beneath the soil. In the Mole Miner Scenario, an independent drilling device called a "smart mole" moves laterally through rock and salt, and penetrates several canisters of waste, contaminating underground water that eventually reaches human populations. In the Doom and Gloom Scenario, worldwide political and environmental upheavals bring about a period of minerals scarcity. Drillers, desperately looking for natural resources, breach the repository, sending plutonium and other lethal radionuclides into the air for rapid dispersal. The Seesaw Scenario postulates a gradual disappearance of institutional memory, and markers written in English become unintelligible nonsense. When the seesaw tilts upward, and humans begin rebuilding a society, the cryptic markings beckon to the curious like the mystifying Stonehenge beckons to many of us. In the twenty-sixth century, archaeologists undertake a dig, releasing radionuclides into the accessible environment.

In a scenario called A Feminist World, women dominate a twenty-first-century society, in which extreme feminist values prevail, and twentieth-century science has been discredited as misguided male aggressive epistemological arrogance. In this scenario, the defiant Feminist Alternative Potash Corporation begins mining operations at the repository site, dismissing warning signs as an example of "inferior, inadequate, and muddled masculine thinking" (Ali 2005).

Not all the imagined scenarios predicted a breach of the repository. One called Nickey Nuke and WIPP Worlds foresaw the construction of a Disney type theme park at the site, visited each year by hundreds of thousands of tourists, who would journey there to hear about the adventures of Nickey Nuke and learn about the dangers of the buried radionuclides. In this optimistic futureland, the legends of Nickey Nuke were told and retold until the lesson had become as deeply implanted as the story of Adam and Eve.

The Markers Team, in turn, designed repository-warning signs to ward off curious future citizens. Team "A" proposed turning the surface of WIPP into what they called a "Landscape of Thorns"—one-square-mile of randomly spaced basalt spikes, 80-feet high and placed at angles of various degrees (like the earth with bad hair). Team "B" proposed a "Menacing Earthworks" that was 30-feet high and shaped like the trefoil symbol for radioactivity. Another suggestion was to install a pictographic panel of stick figures running from the site, faces distorted by Edvard Munch-style screams. Another team envisioned a square mile of massive, irregularly carved boulders, which

they called "Forbidding Blocks," a Stonehenge of sorts. There was even a renewal of the idea of a nuclear priesthood—a scientific order cloistered at the site, dedicated to handing down from generation to generation knowledge that dangerous radionuclides lie beneath the surface.

The notion of an atomic priesthood was articulated as early as 1914, in H.G. Wells' science fiction novel *The World Set Free*. The protagonist, Holsten, succeeds in setting up atomic disintegration in a minute particle of bismuth. The explosion leaves Holsten with a blistered chest, an injured finger, and the breathtaking burden of his discovery. Wells wrote, "He had a vague idea that night that he ought not publish his results, that they were premature, that some secret association of wise men would take care of his work and hand it on from generation to generation until the world was riper" (Wells 1994, 326).

More vividly, in Walter M. Miller's *A Canticle for Leibowitz*, the idea of a nuclear priesthood is allied to preserving language, as well as knowledge. Miller's novel, published in 1957 (perhaps not coincidentally the same year of Operation Plumbbob), is set in the New Mexican desert some ages and ages hence, after a nuclear holocaust has forever altered our world. A band of monks has assumed the task of safeguarding a hand-drawn rendition of a circuit board, retrieved from an "ancient" bomb shelter, and the few written words remaining from a twentieth-century language the monks call "Pre-deluge English." The words are thought to contain sacred keys to understanding the lost culture of the past, a time before "The Deluge, the Fallout, the plagues, the madness, and the confusion of tongues." One of the monks, Brother Francis, approaches the preservation duty with special reverence and has lovingly copied the ancient words and the diagram onto supple lambskin, creating beautiful, if absurd, illuminated manuscripts. The reader is slowly allowed in on what amounts to a tragic joke. The words had been scribbled on a scrap of paper (now a holy relic) in the days before the holocaust by a man identified only as Leibowitz (Saint Leibowitz to Brother Francis). Preserved and sanctified are the words: "Pound pastrami. Can Kraut, six bagels—bring home for Emma" (Miller 1959, 25).

I think about those monks in the desert, their disconnected and fragmentary knowledge of past languages and cultures, and their labors to interpret the past from what little remains. There are important associations to be made between the setting of Miller's novel, the awkward outcomes of the DOE WIPP exercise, and the responsibility of managing and marking sites for storing nuclear wastes.

Mystically arranged granite boulders, spikes, molded earthen mounds, and picto-graphs as visualized by the Marker Panel have all been left behind by previous cultures. The problem is that none of these older versions of markers speaks well to those of us who live in the here and now. The Khufu Pyramid in Egypt—the last standing of the Seven Wonders of the World—is a mere 4,500 years old, and is certainly more mas-sive and expressive than an 80-foot spike. However, even though we have the ancient Egyptian Rosetta Stone, with its three scripts to guide us, we have yet to learn all its secrets. Many ancient languages have failed completely to cross the ocean of time. Minoan Linear A script, one of the written languages of Crete, the land of mysterious legendary labyrinths and the mythic Minotaur, is only about 3,500 years old, and has so far resisted deciphering. Thousands of languages are expected to disappear over the next century, joining those that became extinct in the twentieth century. Any writing left behind will, in all likelihood, sooner or later join the cryptic Minoan script, becoming gradually more mysterious and inaccessible. What language or symbol, then, can we count on to remain fixed in meaning for all time?

A prehistoric mummy, known as Spirit Cave Man, was discovered in the 1950s in Spirit Cave, near Fallon, Nevada, not far, as the jackrabbit hops, from the site of the 1963 Project Shoal nuclear test. Spirit Cave Man is one reminder of how undecipher-able the relics and symbols of the past can be. Carbon dating has fixed the era of the mummy at 10,000 BCE. Archaeological evidence suggests that he is Caucasian, not Native American. These findings puzzle the anthropological community; Cauca-sians are not thought to have been there, then. The tule matting in which Spirit Cave Man was wrapped by his Paleolithic mourners is intricately woven, unlike anything ever before excavated in America, heightening the mystery of his identity and raising doubts about how much any of us knows about the lives of humans many thousands of years ago.

What language did they speak? What songs did they sing? What gods did they worship? What did the petroglyphs they carved into rocks at the mouth of Spirit Cave mean to Spirit Cave Man? Are they directions to game trails? Expressions of magic? Art for art's sake? Warnings? The fact that we don't know the meaning of messages created in 10,000 BCE is a forceful argument against burying substances that will remain lethal for thousands of years. We might as well leave behind Leibowitz's shopping list.

Leveraging Armageddon

However we may feel about man's inability to interpret the murky shapes in the crystal ball, it has been important in nuclear experimentation to take risks based on prediction. History teaches that each step of nuclear weapons development and testing was met with questions from the public that invited the educated predictions of the scientific community. Would a nuclear explosion ignite atmospheric gases, turning the planet into a fireball? Would an underwater nuclear explosion kill all the fish in the sea? How much energy would the weapon release? At what distance from ground zero would a human remain unharmed? Would an underground nuclear test cause earthquakes or fault blocking at the surface? Would radiation be released into the environment? These are questions, indeed, for the gods and the prophets to wrestle with. Tieresias, blind seer of Sophoclean tragedy, might have voiced answers as Delphic riddles, lying in the paradox that man's fate is forever intertwined with his pride.

The Trinity test, looked at here as a tale of secrecy and codes, as a story of soaring language, shaded by cryptic site selection and meager fulfillment of scientific promise, is an account of risk, of scientific uncertainty, and of very real human struggles with the uncertainties of prediction.

Let's envision the eve of the Alamogordo test. The Manhattan Project scientists are gathered at the base camp tensely awaiting a signal by meteorologists that the test can go forward, for the following morning rain is a possibility. The tension is broken by scientist Enrico Fermi who makes a wager, as later recalled by General Leslie Groves: "I had become a bit annoyed with Fermi ... when he suddenly offered to take wagers from his fellow scientists on whether or not the bomb would ignite the atmosphere, and if so, whether it would merely destroy New Mexico" (Rhodes 1986, 664).

In fact, calculations produced sometime earlier by Edward Teller had raised the possibility of heat buildup to the point of igniting the nitrogen in the atmosphere. Oppenheimer had asked Hans Bethe to review the figures, and Bethe had reported that Teller's calculations were wrong. Nevertheless, Fermi's jest gave language to the otherwise unspoken doubt that hung in the air.

Earlier in the day, on the eve of the test, Teller and the others had received a memo from Oppenheimer reminding them to arrive at the bombsite before dawn and to be careful not to step on a rattlesnake. Following the wager episode,

Teller met up with Los Alamos scientist Bob Serber who like Teller was sleeplessly pacing the desert floor, picking his way through the wires and black boxes strewn about the base of the bomb tower. "What will you do tomorrow about the rattle-snakes?" asked Teller. Serber replied, "I'll take a bottle of whiskey." Teller then began voicing his doubts about the tests, telling Serber that "one could imagine that things might get out of control in this, that or a third manner." He then asked, "[A]nd what do you think about it?" Serber thought for a moment and then replied, "I'll take a second bottle of whiskey" (Rhodes 1986, 665).

General Groves had handled the unknowns of Trinity by instructing journalist William L. Laurence to prepare four Trinity press releases, labeled A, B, C, and D. Each began with the same sentence: "A remotely located ammunition magazine containing a considerable amount of high explosives and pyrotechnics exploded." Release A continued, "There was no loss of life or injury to anyone, and the property damage outside of the explosives magazine itself was negligible. Weather conditions affecting the content of gas shells exploded by the blast may make it desirable for the Army to evacuate temporarily a few civilians from their homes." Release B reported severe property damage. Release C described some loss of life. And release D reported "widespread destruction of property and great loss of life," and contained attached obituaries for the distinguished visitors to the event, including General Groves, Oppenheimer, and even the journalist Laurence (Hales 1997, 317).

Medical officer David Bradley, who was present at Operation Crossroads at Bikini Atoll, remembered silently posing questions that unseated the official and confident predictions of safety: "What would happen when Dave's Dream (the B-29 carrying Able) hatched its famous egg?.... Would pieces of our venerable Navy be spread all over the Pacific from the Philippines to Panama? Would a tidal wave sweep the island clean and move on to inundate Los Angeles? Would, indeed, the very water itself become involved in a chain reaction until the whole Pacific Ocean disappeared in a colossal eruption? Who was to say?" (Bradley 1948, 49–50).

Later, in our nuclear history, when the unthinkable state of nuclear warfare was not only thinkable but on everyone's minds, Herman Kahn, in a quintessentially disenchanted exercise, predicted the length of time that would be required for American economic recuperation following a thermonuclear war. Kahn, a member of the Rand Corporation faculty, became the model for the movie character Dr. Strangelove (Henriksen 1997, 218). The following were his predictions:

Dead	Economic Recuperation
2,000,000	1 year
5,000,000	2 years
10,000,000	5 years
20,000,000	10 years
160,000,000	100 years

Cascading Computer Models

Vaulting over the top of uncertainty, the DOE has maintained to Nevadans that it has an adequate understanding of geologic and hydrologic processes in order to predict the safety of the waste stored within Yucca Mountain in perpetuity.

The DOE predictions rely almost exclusively on data generated by computer models—most likely the methodology of choice for evaluating the future performance of any long-term storage facility. Once more, the problem is the phrase "future performance."

Data drawn from input into the computer models add up to what the DOE has termed Total System Performance Assessment (TSPA). Geologist Rodney Ewing describes the TSPA as consisting of "a series of cascading models that are meant in toto to capture repository performance. For the geologic disposal of high-level nuclear waste, this generally means that models must be capable of calculating radiation exposures to a specified population at a distance of tens of kilometers and for tens to hundreds of thousands of years into the future" (Ewing 2006, 71).

Orrin H. Pilkey and Linda Pilkey-Jarvis, authors of *Useless Arithmetic: Why Environmental Scientists Can't Predict the Future*, elaborate on the sheer scope of the TSPA system: "There are 13 comprehensive mega models of model clusters based on 286 individual models.... There are thousands of input parameters, hundreds of thousands of lines of equations in hundreds of computer codes and hundreds of linked mathematical models in the system.... The current methodology uses predictive science almost to the exclusion of other approaches" (Pilkey and Pilkey-Jarvis 2007, 55).

The TSPA, then, can be said to produce a distinctive language purporting to describe the future—rhetoric of prediction. This rhetoric of prediction is related to scientist Max Weber's disenchanted discourse, because the unknowable and the incal-

culable are delivered as knowable and calculable. The verbs are future tense: should, will, and would. The lexicon includes: likelihood, unlikelihood, probability, estimates, expected performance, maximally exposed individual, peak dose, mean dose, foreseeable future, unforeseeable future, and inconsequential.

I could cite hundreds of examples of the DOE's model-based conclusions expressed in predictive terms. For one, in the 2,000-plus page *Environmental Impact Statement* (EIS), the dangers posed by disruptive human intrusion, by those confused machines or humans of the future, are analyzed in fewer than 50 lines. The EIS examines exactly one human intrusion scenario. It occurs 30,000 years after the closure of the repository, when a single borehole penetrates exactly one waste package, permitting gradual water infiltration into the borehole. Based on calculations generated by analyzing this single scenario, the EIS concludes, "The peak of the mean annual individual dose from human intrusion would be 0.0002 millirem [a miniscule amount], occurring a short time after 100,000 years after repository closure. These results indicate that the repository would be sufficiently robust and resilient to limit releases caused by human intrusion" (U.S. DOE 2002, 5.7.1).

As for the likelihood that future earthquakes might occur in the vicinity of the repository, the DOE repository safety strategy plan postulates, "The primary effect of ground shaking would be to hasten rock fall in the annual likelihood of a significant earthquake at Yucca Mountain is less than the threshold for consideration.... The amount of movement on faults through the repository horizon will be too small to bring waste to the surface, and too small and infrequent to significantly impact containment during the next few thousand years" (U.S. DOE 1998, 15).

Set against the assessment by computers is indisputable evidence that Yucca Mountain is earthquake territory. On the walls of the tunnel drilled into the mountain by the DOE, run the Ghost Dance and Sundance faults, like broad, ugly scars. Since 1868, there have been 21 earthquakes of magnitude 6.0 or greater within 300 kilometers of Yucca Mountain. Geologic features adjacent to the mountain bear names that serve as sardonic reminders of the grand scale on which nature moves, when she decides to move. For example, a 1992 earthquake with a magnitude of 6.8 was centered beneath Little Skull Mountain, adjacent to the otherwise-quiescent Funeral Mountains.

As for predicting volcanic activity at the site, the DOE asked 10 volcanologists to evaluate the probability of a repository-piercing eruption at Yucca Mountain. The panel

estimated the "probability of a dike [volcanic intrusion] disrupting the repository during the first 10,000 years after closure to be 1 chance in 7,000" (U.S. DOE 1999, 3–25). In the following summary of the radiological impacts of potential intrusion, earthquakes, and volcanoes, the EIS delivers the penultimate examples of the rhetoric of prediction, using words crafted to convince the licensing body (NRC) and critics that the project is safe:

> Although future disruptive events (human intrusion, volcanic activity, seismic activity) would change radiation exposure rates, the effect of these … would be small…. It is most likely that no person would die due to groundwater contamination by radiological material in the 10,000-year period after repository closure…. Overall human health impacts to Amargosa Valley residents would be small. The reference person studied to calculate human health impacts was defined as a person who lived year-round in the Valley, consumed locally produced foods, and ingested water from potentially contaminated sources. Estimated doses to plants and animals would also be small. (U.S. DOE 1999, 5–49)

Another debate which the DOE settles with the rhetoric of prediction is the potential for major climate change. It is true that the Yucca Mountain region is arid, but it has not always been so dry. Glacial periods account for 80 percent of the past half million years in the American West. The last glacial period, known as the Wisconsin, ended 10,000 years ago. The climate at Yucca Mountain was then cooler and wetter. Elsewhere in the Great Basin, remnants from the past add to the challenge of predicting future climates. Near Wendover, Utah, archaeologists are hard at work analyzing claylike 13,000-year-old soils dug from the floor of Juke Box Cave. The cave is part of our nuclear history, named for its use as a makeshift dance hall during World War II, when airmen stationed at Dugway Proving Grounds dropped payloads of "pumpkins"— orange, concrete bombs used by the air force for practicing the release of Little Boy over Hiroshima. Today, the soil from Juke Box Cave is still moist from the waters of prehistoric Lake Bonneville, evidence of the major climatic shifts that have punctuated the geologic history of the American West. Ten thousand years ago, says Utah archaeologist Dave Madsen, the Bonneville salt flat was a pine forest. He explains, "There are places in the Southwest where the [pack] rat amber contains materials 50,000

years old. I've taken a piece of these nests, soaked it in water, and slowly the smell of a 10,000-year-old pine forest starts filling the lab. It's really something" (Reno Gazette-Journal 1998, 3).

The DOE sidesteps the potential for major or cataclysmic climate change, stating in the EIS draft, "estimates of future climatic conditions are based on what is known about the past, with consideration given to climate impacts caused by human activities....This method inherently assumes that the future will repeat the past" (U.S. DOE 1999, 5–17). Rare events, such as one-thousand-year ago storms are not included, because "they are not recognized or not enough is known about them to construct reasonable input parameters" (MacFarlane 2006b, 397).

Although the evidence I have quoted is, admittedly, selected to further my argument, anyone who opens the massive DOE volumes that characterize and analyze the project will find arrogant statements describing how the waste packages will be designed, and how humans and mother earth will behave expressed in exponential factors.

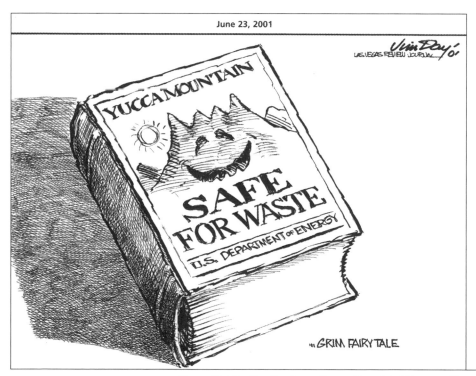

Figure 13.1 **By Jim Day from *Screw Nevada! A Cartoon Chronicle of the Yucca Mountain Nuke Dump Controversy*, 2002, © Stephens Press, LLC.**

Philosopher Kristen S. Shrader-Frechette describes the cynicism that has grown around reading documents like the DOE's Yucca Mountain EIS: "Even the DOE peer reviewers, such as D. V. Hodges, have themselves argued that it is patently absurd to think that there are reliable predictions of geologic events 10,000 years in the future" (Shrader-Frechette 1993, 77). Geologist Allison Macfarlane agrees, saying "Clearly, the scientists best in a position to judge were unconvinced that mathematical models should be the deciding factor on the suitability of a repository site" (Macfarlane 2006a, 93). And mathematician David Orrell, on examining the science of prediction in general, writes, "[M]athematical models have consistently failed to provide accurate predictions of atmospheric, biological, or economic systems—they do not know the future.... The important thing is that we do not allow an unbalanced and often fake insistence on objectivity to distance us from the world or cut off our connection to it" (Orrell 2007, 347).

Where Do We Go Now?

Throughout this book, I have endeavored to show that historically whenever nuclear sites have been chosen, the selection criteria has always been identified as safety supported by sound science. In reality, the notions of nuclear site suitability and sound science are produced by imagery, euphemism, and promotional rhetoric and are expedient, false, and foolish. As if imprinted on a Möbius strip, the phrases go round and round, immune to time and experience. The goal is to convince the public that the site is suitable because it's barren and expendable. The science is sound because experts agree, pounds of evidence have been gathered, site flaws can be remediated with engineering, radiation is naturally occurring, and future events can be scientifically predicted.

The government might restart the quest for an equitable HLNW solution by reinventing language, dropping the confident predictions about the future performances of men, mountains, climate, and mother earth, and expressing, instead, common sense in common language. The language, it would seem, is as important to the success of any plan to dispose of nuclear waste as is the science. "Language," Macfarlane says, "has become an important tool in legitimizing" both the site and the processes. "The DOE continues to use the language of validation and verification extensively when discussing its models.... The terms 'validate' or 'verify' are power-

ful signifiers of truth" (Macfarlane 2006b, 399). With wit and wisdom, sociologist Kai Erikson cuts to the root of the DOE's predicative language: "Thus the moment may have come to abandon the cool, measured language of technical reports—all that talk about 'perturbations' and 'surprises' and 'unanticipated' events and simply blurt out: 'Ten thousand years! That's incredible'" (Erikson 1994, 36).

Language issues aside, where do we go now? For the short term, we can use licensed, temporary storage alternatives. Reporting in *Scientific American*, scientist Matthew Wald says that delaying a permanent decision about how to dispose of HLNW may not be a bad thing. He explains that dry cask storage has become a "medium-term solution," and the staff of the NRC is drafting language saying that "the waste can be stored in casks for decades at reactor sites with no environmental effect" (Wald 2009, 52).

To use the borrowed time wisely, the current administration might commission a new Manhattan Project (without the secrecy), charged with testing old and new methods of utilizing the valuable waste products, rather than attempting to dispose of them. Let the giant footprints left by Oppenheimer, Serber, Bethe, and Teller be filled by those of visionaries drafted from all sectors of the scientific community— visionaries dedicated to working toward a solution to the waste problem without a predetermined endgame.

ATOMIC CULTURE IN THE SILVER STATE
Fourteen

Six decades after Trinity, Americans are deeply divided about the meaning of an event that changed the world forever, for good or for ill. All would agree, however, that Trinity's visual offspring—images of nuclear explosions, nuclear warheads, missile silos, the red button in the White House, and world-wide fallout—are here to stay, and have permanently entered the shrines of contemporary culture. Cold War atomic images are powerful and ubiquitous reminders of a world on the brink of destruction, and they influence how Americans think today about national and international politics, government secrecy, nuclear weapons, and radiation in general.

In fact, there is a current uptick in the already significant popularity of all things atomic, including merchandise, scholarly articles, and atomic tourism. Scott Zeman and Mark Amundson argue in *Atomic Culture* that the burgeoning interest is in part owing to an under acknowledged "nostalgia for a bipolar world" (Zeman and Amundson 2004, 5).

More importantly, the revival of attention paid to the atomic age may signify our individual and collective desires to come to terms with the legacy of the atom, to puzzle out its power to deliver us from evil, and from life itself. But, just how do we come to terms with this legacy? Some read about the atom and visit atomic sites and museums in quest of furthering their knowledge of the genii who escaped the bottle, or they seek guidance in forming an educated moral stance; some capitalize on nuclear imagery to create and sell merchandise; and some become gripped by a psychosis of fear, reacting predictably and negatively to anything associated with nuclear energy—or the opposite, they embrace nuclear energy in any of its aspects, christening this phenomenon as proof of progress. Others come to terms with the nuclear age by not coming to terms at all, simply not bothering to formulate questions about or responses to our nuclear history. And, I should add, some come to terms by writing books about it.

Even those who choose to ignore the political and moral significance of the nuclear age cannot ignore its effect on American culture, what historian Paul Boyer has termed the "cultural fallout." Out of abstract fear, fascination, distaste, or endorsement of nuclear bombs (and more recently nuclear waste and nuclear power plants), varied cultural objects have been shaped, including novels, poems, jokes, brand names, comic books, movies, video games, atomic tourism, commercial kitsch, and glitter. Altogether, they represent high culture, low culture, pop culture, and everything in the seams of these categories.

Candy, Comics, and Kitsch: Atomic Pop

Each of the many thousands of items of atomic culture—a piece of Mega Warheads candy, a *Teenage Mutant Ninja Turtles* episode, or a poem about an atomic bomb, is a type of rhetoric. In the preface, I defined rhetoric as a written body of images used to further an argument or to elicit an emotional response to a situation or idea, arguably giving myself a liberal field on which to advance my arguments. This definition can be extended to cover visual rhetoric as well: objects can be examined for their rhetorical power or purposes in the same manner as can words.

As an example of visual rhetoric, the image of a child printed on a wrapper enveloping a piece of Mega Warheads candy might provide an ironic contrast to the candy itself (for a child will consume a "warhead"), or it might enhance the commercial draw (as the wrapper is designed to appeal to children and sell the candy inside). One might even identify rhetoric of nuclear resistance: the very image of the warhead and child against a background of a fiery inferno might elicit a moral rejection of nuclear war. Two yellow warning signs on the wrapper caution the consumer that the experience will be "intense," a rhetoric that might appeal to individuality and rebelliousness. Or, maybe, just maybe, it suggests that nuclear war presents an attractive thrill of danger. Foremost, the image is kitsch and exhibits poor taste, poor aesthetic quality, and is neutral in value—empty, commercial, infantile, and meant only to sell as a laugh.

Whereas Warheads candy did not hit American markets until 1974 (although Atomic Fireballs candy was introduced earlier, in 1954), atomic comics appeared on the American scene within months of the bombings of Hiroshima and Nagasaki. Since then, kids have grown up under the spell of atomic comic book heroes. Images

of irradiated super humans tap into a conscious or subconscious fear of the potential unknown effects of radiation, playing off the "folk" notion that radiation in large doses might instantly create a super species. There is a subtle anti-science rhetoric to be found in the irradiated hero genre, in that scientists have assured us, since atoms were first split, that radiation is natural, and that a person exposed to excessive amounts might die but will not instantly mutate.

First on the comic book scene was *Atom Man* (1945), turned into an atomic bomb by accidentally drinking a glass of heavy water laced with uranium-235. He was followed by *Atomic Mouse* (1953), made powerful by swallowing some uranium-235 pills. Then came *Atomic Rabbit* (1957), rendered invincible from munching radioactive carrots. And finally, the most famous of them all, was *Spider Man* (1962), endowed with superhuman arachnid agility after being bitten by an unfortunate spider that had fallen into a radioactive ray gun. In 1986 a parody of atomic super-creatures, *Teenage Mutant Ninja Turtles* (who gained their unearthly talents from submersion in flowing ooze), became an overnight sensation, spawning an entire industry of action figures, t-shirts, and television contracts.

After atomic testing began in the Marshall Islands, comic book creators turned to images of nuclear testing, modernizing, and in some cases politicizing the actions of their superheroes. A 1946 edition of *Action 101* is anti-war rhetoric in comic book disguise. Superman, made temporarily insane by swallowing a drug (in order, of course, to save the life of Lois Lane), flies into the mushroom cloud resulting from Operation Crossroads (Able) on Bikini Atoll. Curiously, the radiation clears his mind and Superman borrows a camera to photograph the cloud from above to warn men "who talk against peace" (Szasz 2004, 15).

In 1951 the NTS became a fresh setting for atomic comics whose plots play off the reality of the emerging bipolar world. In what Ferenc M. Szasz calls "a creative parody" of the atomic hero genre, comic book figure Radioactive Man strays too close to the NTS during a test. Emerging from near ground zero, Radioactive Man, along with his partner Fallout Boy, becomes a "champion of freedom and defender of American values" (20).

The lead story in the 1950 comic book series *Atomic Spy Cases* was set in Nevada before the state had been designated home to atomic testing. The series exploited the McCarthy-era obsession with atomic surveillance and sabotage. The 1951 trial and 1953 execution of Julius and Ethel Rosenberg, both found guilty of spying for the

Soviet Union, increased the readership and impact of spy comics published during the 1950s. According to Szasz, in the Nevada story foreign villains obtain "the formula" but are thwarted, and our national secrets remain safe (18). The setting is incidental to the anti-communist rhetoric.

Szasz relates a 1953 episode of *Rex the Wonder Dog* set in Nevada near the NTS. Wonder Dog saves his family from an atomic blast by leading them to shelter in a cave. Here, the rhetoric mimics civil defense messages: Take shelter and you will survive an atomic blast.

The best-known atomic comics play off the super abilities of their irradiated heroes, but some comic books were, on the surface, educational and factual. Among them was the 1949 *Dagwood Splits the Atom*. Although it was produced to teach young people the basics of nuclear fission, as explained by Dagwood and Blondie, the comic book advances a promotional rhetoric: Fission is emblematic of scientific progress and cannot be other than beneficial to mankind. *All Atomic Comics*, published in 1976, was even more transparently rhetorical. A sign of the changing times, the story line promoted an anti-nuclear power agenda. The narrator, a three-legged frog, periodically introduces facts, including the 1974 death of Karen Silkwood, just before she planned to reveal falsification of safety reports at the plutonium plant where she worked. The narrator describes the mutation of frogs from waste dumped by the Amsterdam Nuclear Research Institute in Holland (Szasz 2004, 22).

The image of the mushroom cloud rose self-importantly from the pages of comic books set in Nevada, as a symbol of the bomb itself, and as a device to move the narrative forward from blast to post blast. Almost overnight, the cloud had become an icon, ubiquitous and clearly identifiable as the signature of an atomic explosion—embroidered, even, on a badge earned by the personification of upstanding American youth: the boy scout.

Political scientist Dina Titus surmises, in her essay "The Mushroom Cloud as Kitsch," that during the years of atmospheric testing the cloud was used symbolically by the government to promote nuclear testing, but that the image resurfaced in the 1980s as "nostalgic kitsch" (Titus 2004, 110). Titus recalls that in 1990s Las Vegas the Stratosphere Tower advertised Vintage Vegas Nights, using a reprinted photograph of Miss Atom Bomb from the early 1950s. In 1996 an advertisement for Nevada State Bank featured a mushroom cloud and the words: "Just waiting for the fallout? Don't panic" (Titus 2004, 117).

The 1986 movie *Desert Bloom* was set in early 1950s Las Vegas, when the bombs were about to burst. A young woman in the film moves from innocence to experience, as the nation, in parallel movement, embarks on a course leading to dangerous Cold War nuclear one-upmanship.

In 2002 the Nevada Legislature authorized the Department of Motor Vehicles to manufacture and sell a mushroom cloud license plate to commemorate the role of the NTS in American history, and to raise money for the NTS Historical Foundation's Atomic Testing History Institute. Hundreds of Nevadans applied for the plate, and hundreds more wrote to condemn it as inappropriate. The plate was manufactured and then withdrawn due to the criticism.

Proof that the mushroom cloud is truly a kitschy image is the fact that it appears as the catchy logo on a slew of popular products—Atomic Fireballs, Garbage Pail Kids trading cards, key rings, and the Nuclear War card game.

Literature of Nevada's Nuclear Age(s)

Writers who experienced in some personal way the landscape of the desert site, or the signature moments of an atomic test, or have contemplated the effects of its fallout have produced serious literary works drawing on atomic testing in Nevada. For example, some poets have transformed personal experience into elegy or lamentation. The images collectively produce rhetoric of anti-nuclear testing and anti-nuclear war.

Denise Levertov, after watching a documentary film featuring footage of test-site animal experiments, wrote "Watching Dark Circle." Here is an excerpt: "The Pentagon wants to know / something a child could tell it: / it hurts to burn, and even a match / can make you scream pigs or people /.... Men are willing to call the roasting of live pigs a simulation of certain conditions. It is not a simulation. The pigs ... are real" (Glotfelty 2008, 437–438).

Chicano poet Robert Vasquez, in "Early Morning Test Light Over Nevada," used his father's voice to describe an atomic test seen through a window, while Vasquez was yet in his mother's womb. Images of a fetus ("still a white gel") are juxtaposed with chilling effect to images of an atomic test, as witnessed from an intimate space: "When the sky flared, / our room lit up. Cobwebs / sparkled on the walls, and a spider / absorbed the light" (Glotfelty 2008, 439–440).

Giving voice to the Native American view that the land of their ancestors has been violated by atomic testing, poet Adrian Louis laments: "Taibo / ... had / to drop / hydrogen bombs / where / thousands / of years / of our blood / spirits lie" (Glotfelty 2008, 449–450).

As data on fallout from the Nevada tests became more readily available, the literary focus shifted from descriptions of atomic bomb tests to explorations of cultural and health-related themes, including the fate of down winders. Poet Corrine Clegg Hales, in "Covenant: Atomic Energy Commission, 1950s," explores the irony of the tests: "We've been expecting Such / unambiguous Russian-made tragedy / that we missed the atom bomb sneaking in through the side door, blowing / Like a tumble weed across the desert." Hales places images of the AEC monitors chasing pink, radioactive clouds against images of small children playing in Utah fields: "Eating apples, riding horses, scratching their names / In the fine dust coating every flat surface" (Hales 2002, 16).

Poet Lynn Emanuel, in "The Planet Krypton," invents an alter-ego narrator to examine bomb light and bomb legacy from the viewpoint of a girl living in Ely, Nevada, 250 miles north of the test site: "Bathed in the light of KDWN, Las Vegas, my crouched mother looked radioactive, swampy, / glaucous, like something from the Planet Krypton" (Glotfelty 2008, 448).

Among the best non-fiction works to examine the plight of down winders is Terry Tempest Williams's "The Clan of the One-Breasted Women," a chapter in *Refuge: An Unnatural History of Family and Place*. Williams makes the connection between her memory of seeing the flash from one of the Operation Plumbbob tests and the deaths of her mother, grandmothers, and six aunts from breast cancer. Rebecca Solnit, in *Savage Dreams*, applies principles of environmental justice to the siting of the NTS, arguing that indigenous peoples were erased. Her book is a chronicle, punctuated with philosophical musings, of her nonviolent trespass onto the NTS and her subsequent arrest. She explains: "[T]he Test Site, a place that however few may see it, however invisible it may be, is the hub of so many crucial lines of our history. But it was hard to remember all this while pulling thorns out of someone's sweaty foot with my hands cuffed together" (Solnit 1994, 22–23).

Among the works of testing-era fiction is Frank Waters's 1966 *The Woman At Otowi Crossing*. The narrator in the book, Turner, describes Las Vegans preparing for an atmospheric test, and observes Camp Desert Rock, where soldiers prepare to march into ground zero. In several remarkable passages, Turner ruminates on the fate of Mr. Mannequin and his mannequin family—the test-site dummies in Doom Town—soundlessly awaiting dismemberment by an atomic blast.

Downwinders: An Atomic Tale is a collaborative work by Utahns Curtis Oberhansly

and Dianne Nelson Oberhansly. In their story, a marine named Porkchop is marched into ground zero during a fictional test named Huey: "Even with their eyes tightly closed, the bones in the forearms, elbows and hands—the radiuses, ulnas, and phalanges—clear as any x-ray, glowed a bright fluorescent green.... But the platoon sergeant, Porkchop, didn't have time to be dazzled or scared shitless by his own bones" (Glotfelty 2008, 461).

A novel by Richard Miller, *The Atomic Express*, is structured as an allegory. Miller places characters representative of different political approaches to nuclear testing (military advocates, peace activists, and disillusioned scientists) in a race against a ticking, armed bomb. The novel is textured with fascinating technical details concerning the preparation of the site in advance of an atmospheric test. Miller wrote an informative work of non-fiction called *Under the Cloud*, comprised of narrative accounts of each of the atmospheric testing series carried out at the NTS, including details of yield, wind patterns, fallout paths, and military experiments. He paints a cultural background for each event by listing the movies and songs that were playing across America while Ranger, Teapot, Plumbbob, and the rest of the tests went forward. On the eve of the 1957 Plumbbob series the number one song on the billboard was Elvis Presley's "All Shook Up," followed by Gail Storm's "Dark Moon," The Diamonds' "Little Darlin,'" and Pat Boone's "Love Letters in the Sand" (Miller 1986, 251). Without belaboring the technique, Miller tempts readers of a certain age to replay the old songs in their minds—where the innocent enough lyrics lap up against the descriptions of violent explosions in imagistic dissonance.

Nevada's nuclear waste battles have been explored in literature, both fiction and non-fiction. The images suggest rhetoric of resistance to the proposed Yucca Mountain Project. Works on this topic include novels by Frank Bergon and James Conrad, essays by Richard Rawles, Corbin Harney, and William Kittredge, and poetry by Shaun Griffin.

Nevada-born Bergon sets his witty and intelligent novel, *The Temptations of St. Ed and Brother S.*, in a Cistercian monastery adjacent to a site selected by the DOE to serve as a nuclear waste dump. Conrad's novel, *Making Love to the Minor Poets of Chicago*, follows the adventures of a fictional female Chicago poet, who signs up as a tour guide for Yucca Mountain excursions, in order to clandestinely research a commissioned epic poem about nuclear waste. At the Yucca Mountain visitor's center, the new guide meets Donna Black, described by the author as a bitch, who is to be the

poet's trainer. Donna explains how the tour guides are to think and speak about Yucca Mountain: "There are no issues. There are no politics. There is no right, there is no wrong, and above all, there is no danger" (Glotfelty 2008, 480).

Rawles' essay, "Coyote Learns to Glow," applies the so-called "Coyote Principle" to Yucca Mountain. The Coyote Principle is taken from a scene in a Louis L'Amour western, where a coyote loosens a rock and exposes a mother lode of gold. Rawles asks, "What if, ages hence, the lethal Yucca Mountain mother lode is inadvertently exposed?" (Glotfelty 2008, 476–479). Corbin Harney, a Native American and essayist, believes that even without burying wastes, the day will come when the nuclear whirlwind is reaped. In his essay "The Way It Is," he explains: "The vision showed me that this place [where deep holes were drilled to emplace atomic weapons] is now beginning to fill up with water. The water is filling up those holes." Of Nevada's nuclear waste dilemma Harney writes, "Yucca Mountain lies asleep like a snake" (Glotfelty 2008, 464–468).

William Kittredge, a commanding and respected Western voice, expresses his philosophical distrust of the "quiet empire" of the military and the DOE. He argues passionately for loving a Nevada "our nation seems to think of as a vast, convenient dumpster out there waiting to be filled." The title of his essay "In My Backyard" pushes back at those non-westerners who label any resistance to the repository a parochial and thoughtless "not in my backyard" reaction. Kittredge writes: "I thought how unfair it was that this particular stretch of America should be our capital of radioactivity. Nuclear waste is so clearly a problem that belongs to others, people who commute to suburbs on one coast or another. They would be the first to stomp around and yell, 'Not in My Backyard'" (Glotfelty 2008, 470).

Poet Shaun Griffin speaks to geopolitical and environmental injustice. His poem, "Nevada No Longer," begins and ends with the plaintive passage, "Nevada is never on the map, not now / not ever." He addresses, in spare words, the map, emptiness, and marginalization themes that have worked for so long to legitimize atomic projects in the deserts of Nevada (Glotfelty 2008, 474).

Atomic Tourism

As part of the cultural fallout in Nevada, atomic tourists take tours of the NTS and visit the Atomic Testing Museum in Las Vegas. Both the tours and the museum displays are structured rhetorically, as arguments of justification and interpretation of atomic testing in the state.

The Atomic Testing Museum, a $10 million, 60,000-square-foot affiliate of the Smithsonian Institution, opened in January 2002. Partnering with the Smithsonian is the Nevada Test Site Historical Foundation (NTSHF), whose membership includes many retired test-site workers.

The storyboards on the walls of the museum are clear examples of interpretive history. As the British geographer David Lowenthal explains: "Every act of recognition alters survivals from the past. Simply to appreciate or protect a relic, let alone to embellish or imitate it, affects its form and our impressions.... Interaction with a heritage continually alters its nature and context, whether by choice or by chance" (Lowenthal 1985, 263). In applying Lowenthal's thoughts to the relics housed in the Atomic Testing Museum—the vintage film footage, the copies of old newspapers, and the photographs of the tests—they become altered relics.

Interaction with the nuclear past renders these remains of the past fossilized and emasculated. They become objects to stare at like a once fluttering butterfly pinned to velvet and displayed in a glass case. In the museum, a photo of Hiroshima, leveled by the bomb, hangs on the wall. (We already know that we won the war and that the city has risen from its ashes). Before us, on a museum video screen, Nikita Khrushchev bangs a shoe and declares, "We will bury you." (But, we know he didn't.) Another video shows children practicing to duck and cover with the cute Bert the Turtle. (But, as we know, they never had to do this.) Standing within the museum's "atomic" theater, the visitor can witness an atomic explosion. The room buckles, pitches, booms, and explodes in light as the bomb detonates. (But, we know we can always escape through the clearly marked exit doors.)

Installations in the museum interpret atomic testing in terms of innovation, progress, stewardship, and management. The Environmental Protection Agency (EPA) farm—36 acres located in Area 12 of the NTS—employed "Atomic Cowboys" to manage a herd of 100 Hereford beef cattle that foraged on the ranges of Yucca Flat. In one EPA experiment, plastic windows were installed into the sides of cows. The bovine

"Relics undergo two types of transformation. One affects them directly: protection, iconoclasm, enhancement, reuse alter their substance, form, or relation to locale.... The second type of transformation is indirect, impinging less of the physical condition of survival than how they are seen, explained, illustrated, and appreciated" (Lowenthal 1985, 264).

digestive process was carefully observed through the portals installed in the cows, and food was directly removed through the portal and analyzed for its radioactive contamination. A museum banner explains that the role of the EPA farm was to "monitor cows in innovative ways."

Project Rover, an experiment with nuclear spacecraft propulsion, is described in terms of its cancellation, and therefore as a loss to humanity. The museum label reads: "Had Rover not been cancelled by Present Kennedy, we would be on Mars by now." What is not explained is the reason for the cancellation—scientists could not solve problems of radiation containment within the craft. Other museum displays highlight how atomic testing spurred developments in high-speed photography and big hole drilling.

Interpretation, impossible to avoid, is everywhere. The first nuclear test in Nevada, Able, is described as being conducted to "make freedom possible." Chunks of rubble from the Berlin Wall and the World Trade Center are, by their very inclusion,

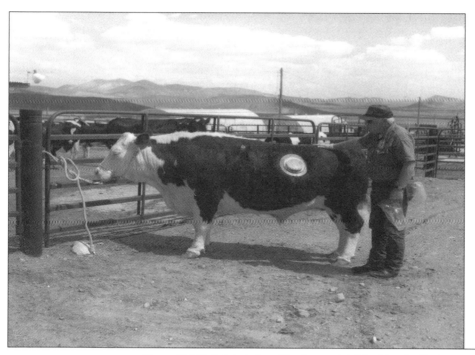

Figure 14.1 **Fistulated steer. At a farm established by the Environmental Protection Agency on the Nevada Test Site, food was removed from the stomachs of livestock and examined for radioactivity. Photograph courtesy of National Nuclear Security Administration/ Nevada Site Office.**

linked to atomic testing. Yes, they suggest, atomic testing has helped bring down communism and the Berlin Wall, and the World Trade Center tragedy has taught us that we must remain vigilant and ready to test again.

Despite occasional zealousness, museum curators have made an effort to bring balance to a culturally sensitive subject. Historical backdrops provide valuable context for understanding and evaluating the era of atomic testing. A British visitor to the museum commented on the museum's openness, observing that a full-size museum mock up of a T-16 bomb, still in the U.S. arsenal, would not likely appear in a British or French museum.

Although carefully crafted, the Atomic Testing Museum exhibitions have drawn heated criticism from down winders' organizations and anti-nuclear activists. Fallout is only briefly acknowledged and is said to have resulted from a few tests, but there is no examination of specific tests in terms of fallout patterns or later health problems, as witnessed in Nancy, Harry, and the Plumbbob series. Nor does the word "cancer" appear on any of the informational placards, prompting down winders to accuse the museum of writing revisionist history.

Even the curators of the venerable Smithsonian sister institution, the National Air and Space Museum, in Washington, D.C., were confounded by the dilemma posed by mounting atomic age exhibits. The original plan for a 1994 *Enola Gay* exhibit (*Enola Gay* was the name of the aircraft that dropped Little Boy over Hiroshima) called for presenting the current state of scholarship on the decision to drop the bomb, showing the immediate effects on the victims, and exploring implications of developing and using nuclear weapons. As soon as the exhibit text drafts were circulated, the proposed exhibit was denounced by some veterans' groups, and conservative members of Congress, as anti-American. Paul Tibbets, the often-excoriated pilot of the *Enola Gay*, called the planned exhibit "a package of insults." The initial plans were scrapped, and "reeling and shell-shocked, the Smithsonian mounted a cautious, scaled-back exhibit that simply portrayed the fuselage of the *Enola Gay* and videos of the crew, with minimal historical context on President Truman's decision to use the bomb, the bomb's human toll, or the long-term consequences of its use." The museum was then charged with historical cleansing (Boyer 1998, 246–268).

Atomic tourism, despite the battering, thrives in Las Vegas and across the nation at many places, including the Titan Missile Museum, Los Alamos County Historical Museum, White Sands Missile Range, National Museum of the United States Air

"History, created and recreated, is the mother lode of tourism." (Lippard 1999, 154)

Force, the Greenbrier Bunker, and the Savannah River Site. In Albuquerque, New Mexico, the National Atomic Museum displays replicas of Fat Man, Little Boy, and other bombs. The history of the development of nuclear weapons can be traced in the museum by walking from one replicated bomb to the next, fission to fission/fusion to fusion. Also on display is Davy Crockett, a bazooka-type missile designed to be mounted on a jeep, or carried by a three-man team on the atomic battlefield. It is a mere 30-inches long and weighs 76 pounds.

Commerce meets interpretation meets kitsch in atomic museum gift shops. The National Atomic Museum sells a Trinity t-shirt, black with a large bright white image of the mushroom cloud on the front. The shirt naturalizes the power of the bomb—you can wear an image of it every day, it's cool. You can buy a t-shirt featuring the image of Albert Einstein with a milk moustache, or an Atomic silk tie with a logo of electrons revolving around a nucleus of an atom. Miscellaneous trinkets are offered under the category fun stuff, including glow-in-the-dark toys. In 1999 the museum shop offered for sale a mismatched pair of earrings, one shaped like Fat Man, the other like Little Boy. (Fat Man, as the name implies, was a large round bomb designed with a lens system to create criticality in a core of plutonium, and Little Boy was smaller and slightly tubular, designed with a trigger mechanism to achieve criticality in a mass of uranium-235.) Like the Nevada mushroom cloud license plate, the earrings are currently unavailable, pulled off the shelf after Japanese tourists and World War II veterans expressed outrage.

A Nevada Test Site Tour

I n 2003 I joined a tour of the Nevada Test Site. In the DOE Public Reading Room in Las Vegas, where the tours then departed from, the rhetoric was polite censorship and was communicated by the euphemism "sanitized" (meaning edited and expurgated). VCRs were made available for viewing sanitized films of atomic testing, including Weapons Effects experiments and Civil Effects Tests, and the visitor was encouraged to review archival documents, many of which were also sanitized.

The tour itself was distinguished by the eagerness of the guide—a former employee of the NTS who personified Zeman and Amundson's nostalgia for a bipolar world, or, maybe better put, nostalgia for the frenetic era of nuclear testing at the NTS. We entered the NTS from the south access road, into Area 23, where the town of Mercury is located. The guide reminisced about the "glory days" of Mercury, when

it bustled with 10,000 test-site workers, who commuted daily by bus back and forth to Las Vegas. Mercury in its heyday contained a cafeteria, a steak house, a movie theater, a bowling alley, and a bank. The NTS motor pool made available 2,400 vehicles, the largest light-duty fleet available in the state. Our guide told us that the cafeteria and steak house together could seat 700 and was almost always full, and that a lobster dinner cost $8.00.

Rather unexpectedly, the guide's sentimentality extended to recounting anti-nuclear testing protests. He pointed to places where protesters had chained themselves to the gates, or attempted to sneak past the guards and onto the restricted site. Government records, he said, showed that between 1986 and 1994, 37,488 protestors entered the site, and 15,740 were arrested. He punctuated the data with the observation, "Many of them wore sandals."

A short trip north on the NTS road brought us to one of the most famous places on the proving ground, Frenchman Flat, where 14 atmospheric tests took place, including the Grable cannon shot and the Plumbbob balloon shot Priscilla. Much of the resulting debris has been left in place. The guide was silent for the most part, occasionally pointing out dome structures used for bomb shelter tests. The shelters exhibit various degrees of destruction: some are recognizable, while others are just mounds of concrete. A bank vault—built by the Mosler Safe Company and placed near ground zero during Priscilla as an experiment to determine whether money could survive nuclear war—was left standing, but the outer layer of the reinforced concrete was ripped off by the blast, exposing twisted spines of steel. (I don't know whether the currency remained negotiable.) Nearby, a lone railroad bridge spans sand to more sand, looking like the ossified remains of a gigantic Star Wars sand worm. Remnants of several other structures—a motel, a parking garage, and hangars—are heaps of rubble.

We traveled further north along the NTS road to Yucca Flat, the largest geographic feature on the test site. The majority of nuclear tests, both atmospheric and underground, took place in this area, leaving behind the most visual evidence of Cold War test site programs. We viewed what is left of Japan Town, which at one time consisted of meticulously crafted replicas of Hiroshima and Nagasaki homes and offices, constructed to meet Japanese specifications with Japanese materials. A bare reactor placed on a tower beamed high levels of radiation into Japan Town, and onto roofing tiles imported from Japan, so that radiation shielding effects of certain tiles, as observed by Americans entering Hiroshima shortly after the blast, could be studied.

Hundreds of subsidence craters of various sizes punch out the surface of Yucca Flat. The diameters of the craters range from 100 feet to 2,000 feet, usually, but not always, indicating the size of the bomb tested underground. Further on, our guide pointed to a sign on the side of the road that read Caution Tortoise. "The NTS has always cared for its creatures," he told us, apparently unaware of, or unwilling to confess any irony. "The food chain is A O.K. There are no four-winged eagles."

At the Sedan Crater site, now on the National Register of Historic Places, a viewing platform has been installed on the rim. Another large crater, left behind from Plowshare earth moving experiments, is Schooner Crater, situated in the northwest corner of the NTS, in Area 20. The guide described to us how Apollo mission astronauts trained at several of the cratered areas because they so closely resemble the surface of the moon. Apollo 17 astronaut Harrison "Jack" Schmitt, once in orbit, reported to Houston as he passed a particular lunar crater that it looked just like the Little Dan crater at the NTS.

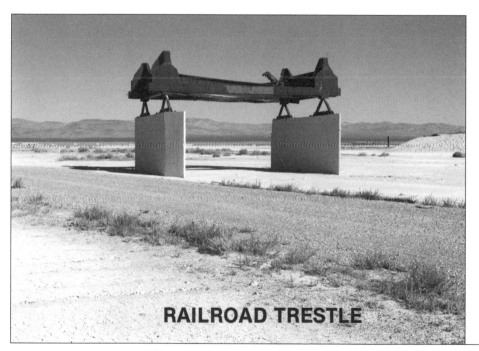

Figure 14.2 **The remains of a railroad trestle stand on Frenchman Flat in the Nevada Test Site. The trestle was constructed for test Priscilla. The resulting blast blew sections of the structure off the foundation. Photograph courtesy of Peter Goin.**

Our bus driver drove straight down into Bilby, a subsidence crater formed by the detonation of a 249-kiloton bomb. The guide pointed to his film badge and said, "It's all underground. That's the beauty." One of us asked him whether groundwater could eventually be contaminated through underground pathways. He replied, "Not a chance."

The far north region of the test site, Area 12, includes Rainier Mesa, the location of many underground shaft tests. When subcritical tests replaced underground testing in 1993, they were located in Area 12. As the adjective subcritical implies, the test is accomplished without a nuclear explosion. The plutonium is extracted from a weapon, and then chemical explosives are packed around it and ignited. The condition of the firing mechanism and the design of the weapon can be evaluated without the nuclear chain reaction of a full-blown nuclear test. At several points during the tour, the guide mentioned that the site maintains a state of readiness to recommence full-scale weapons testing; he speculated that the site could be made nuclear testing-ready in less than six months.

Beyond its moonscape features and its decayed historical settings, the NTS is now a land of acronyms and initials—a palpable example of insider jargon well mastered by our guide, and suitably mystifying to the tourist. We drove past JASPER, an acronym for Joint Actinade Shock Physics Experimental Research, a component of the new simulated or virtual approach to testing. Radiation was beamed upon Japan Town from the BREN (Bare Reactor Experiment—Nevada) tower. Less than a mile from BREN is BEEF, the Big Experimental Explosives Facility, whose function was not explained. A large portion—865,000 acres—of the NTS is now designated as the National Environmental Research Park (NERP), dedicated to alternative energy research projects. The Nuclear Rocket Development Area (NRDA), once used to test missile propulsion and space travel, has been neatly renamed Nevada Research and Development Area, in recognition of the changing mission of the NTS. I say neatly because the acronym remains the same (NRDA).

The Beaten Track

O n the day of the tour, on that particular Greyhound bus, we fellow sojourn-
ers came together from many different backgrounds, but to borrow a
phrase from Lucy Lippard, we were all on the same beaten track. The
road we traveled, the remarks of the guide, and the selected stops—all
guaranteed that we would experience the NTS as if we were players on the stage of
a tightly directed play. There was no surprise, no critical discourse, and certainly no
opportunity to stray off the beaten track, literally or metaphorically. Atomic tourism,
including tours and visits to atomic museums, is scripted. Whatever light is shed on
our atomic past arrives through a series of very dense filters.

BIBLIOGRAPHY

Abraham, Spencer. 2002. Recommendation by the Secretary of Energy regarding the Suitability of the Yucca Mountain Site for a Repository under the Nuclear Waste Policy Act of 1982. February. U. S. Department of Energy. [scanned file of document, in author's possession, accessed 10 February 2010.]

ACHRE Report: Advisory Committee on Human Radiation Experiments. 1995. [www.hss.energy.gov/HealthSafety/ohre/achre/chap-10] accessed 02 January 2009.

Adler, Lee. 1980. Second Thoughts on Nuclear Tests. *Reno Gazette-Journal*, 8 August.

AEC [Atomic Energy Commission]. Semi-annual Report to Congress. 1953. October. Alan Bible Papers, Special Collections, University of Nevada, Reno.

———. *Atomic Tests in Nevada.* 1957. U. S. Atomic Energy Commission.

Agency Sought Cadavers for Its Radiation Studies. 1995. *Washington Post*, 22 June, A3.

Ali, Harris. 2005. Review of *Signs of Danger: Waste, Trauma and Nuclear Threat*, by Peter C. Van Wyck. *Canadian Journal of Sociology Online*. March–April, 4 pages. [www.cjsonline.ca/reviews/signsofdanger.html] accessed 04 February 2010.

ANEC [ANEC Advertisement]. 1991. Do High Level Nuclear Waste Transportation Casks Emit Harmful Radiation? *Las Vegas Review-Journal*. 19 November, A5.

Applegate, David. 2006. The Mountain Matters. In *Uncertainty Underground: Yucca Mountain and Nation's High-Level Nuclear Waste*, edited by Allison M. Macfarlane and Rodney C. Ewing, 102–130. Cambridge, Mass: The MIT Press.

Ashcroft, Bill, Gareth Griffiths, and Helen Tiffin. 1995. *The Post-Colonial Studies Reader*. London and New York: Routledge.

Atom Fallout Tracked Over Nevada: Battle-Sized Bomb Blasts Desert Site. 1957. *Nevada State Journal* (Carson City). 29 May, A1.

Atomic Fallout Hits Quincy, Bay Section. 1957. *Nevada State Journal* (Carson City), 30 May, A1.

Baldwin. R. 1958. *Experiences at Camp Desert Rock VII and VIII*. Washington, D. C: Human Resources Research Office.

Ball, Howard. 1986. *Justice Downwind: America's Atomic Testing Program in the 1950s*. New York: Oxford University Press.

Barthes, Roland. 1967. *Writing Degree Zero*. Translated by Annette Lavers and Colin Smith. New York: Hill and Wang.

Bartholet, Jeffrey. 1997. Bikini Atoll's Blue Lagoon. *Newsweek* (International Edition), 01 December. [www.bikiniatoll.com/NewsweekInterview.html] accessed 06 June 2008.

Bartimus, Tad, and Scott McCartney. 1991. *Trinity's Children: Living along America's Nuclear Highway*. New York: Harcourt Brace Jovanovich.

Bateson, Gregory. 1979. *Mind and Nature*. Toronto: Bantam Books.

Batt, Tony. 1999a. Energy secretary says nuclear tests not needed, defends subcritical trials. *Las Vegas Review-Journal*, 05 March, B10

———. 1999b. Environmentalists Reject Yucca Dump. *Las Vegas Review-Journal*, 14 April, B2

Bergon, Frank. 1993. *The Temptation of St. Ed & Brother S*. Reno: University of Nevada Press.

Berns, Dave. 2002. Yucca Debate. *Las Vegas Review-Journal*, 12 January, B2.

Bhabha, Homi K. 1994. *The Location of Culture*. London: Routledge.

Blumberg, Stanley A., and Gwinn Owens. 1976. *Energy and Conflict: The Life and Times of Edward Teller*. New York: F. P. Putnam's Sons.

Bok, Sissela. 1978. *Lying: Moral Choice in Public and Private Life*. New York: Pantheon.

———. 1982. *Secrets: On the Ethics of Concealment and Revelation*. New York: Pantheon.

Boyer, Paul. 1985. *By the Bomb's Early Light: American Thought and Culture at the Dawn of the Atomic Age*. New York: Pantheon.

———. 1998. *Fallout*. Columbus: Ohio State University Press.

Bradley, David. 1948. *No Place to Hide*. Hanover, N. H. and London: University Press of New England.

Brechin, Vernon, and Peter Goin. 1997. A Nuclear Legacy. *Public Culture* 9 (2): 189–196.

Buck, Alice. 1982. *History of the Atomic Energy Commission*. Washington, D. C.: U. S. Department of Energy.

Bunn, Matthew, Jennifer Weeks, Allison Macfarlane, and John P. Holdren. Interim Storage of Spent Nuclear Fuel: A Safe, Flexible, and Cost-Effective Near-Term Approach to Spent Fuel Management. Cambridge, Mass. Managing

the Atom Project, Harvard University and Project of Sociotechnics of
Nuclear Energy, University of Tokyo. [belfercenter.ksg.harvard.edu
/publication/2150/interim-storage-of-spent-fuel] accessed 02 January 2009.

Burdick, Alan. 1992. The Last Cold-War Monument. *Harper's Magazine*, August,
62–66.

Burns, Grant. 1992. *The Nuclear Present*. Metuchen, N. J. and London: The Scarecrow
Press, Inc.

Buys, Christian. 1989. Isaiah's Prophecy: Project Plowshare in Colorado. *Colorado
Heritage*. Spring, 28–39.

Caldicott, Helen. 1986. *Missile Envy.* Toronto: Bantam Books.

Cases: Soldiers' Psychological Stress upon Close Observation of a Nuclear Test Shot.
[www.pmicasebook.com/PMI_Casebook/Case_-_Berkun1.html].

Chilton, Paul, ed. 1985. *Language and the Nuclear Arms Debate: Nukespeak Today*.
London: Frances Pinter.

Chomsky, Noam. 2002. *Understanding Power: The Indispensable Chomsky*. Edited by
Peter R. Mitchell and John Schoeffel. New York: The New Press.

Clark, Thomas L. 1980. The Rhetoric of MX. In *MX in Nevada: A Humanistic
Perspective*, edited by Francis X. Hartigan, 11–18. Reno: Nevada Humanities.

Coates, Paul. 1951. Atomic Umbrella Covers Coates—and Vice Versa. *Los Angeles
Mirror*, 05 February, 31.

Cohn, Carol. 1989. Nuclear Language and How We Learned to Pat the Bomb. In
Exploring Language, edited by Gary Goshgarian, 52–69. Glenview, Ill.: Scott
Foresman and Company.

Conrad, Joseph 1989. Heart of Darkness. In *A Case Study in Contemporary Criticism*,
edited by Ross C. Murfin, 17–94. New York: St. Martin's Press.

Cross, Joe. 2001. Anti-nuke Shundahai Network moves headquarters to Pahrump.
Pahrump Valley Gazette (Pahrump, Nevada), 08 February.

Damele, Peter. 1967. Letter to Senator Alan Bible. 28 January. The Alan Bible Papers,
Special Collections, University of Nevada, Reno.

Darc, Keith. 2000. Mountain of Controversy. *Times Picayune* (New Orleans), 17
December, Money §, 1.

DeGroot, Gerard J. 2004. The Afterlife of a Nuclear Test Site. *History Today* 54: 26–27.

———. 2005. *The Bomb: A Life*. Cambridge, Mass.: Harvard University Press.

DeVoto, Bernard. 1934. The West: A Plundered Province. *Harper's Magazine*, August, 355–364.

Dickson, David. 1984. *The New Politics of Science*. New York: Pantheon Books.

Dunlap, Riley E, Michael E. Kraft, and Eugene A. Rosa, eds. 1993. *Public Reactions to Nuclear Waste: Citizens' Views of Repository Siting*. Durham, N. C. and London: Duke University Press.

Dyson, Freeman. 1984. *Weapons and Hope*. New York: Harper & Row.

Easlea, Brian. 1983. *Fathering the Unthinkable: Masculinity, Scientists and the Arms Race*. London: Pluto Press.

Elliott, Michael. 1988. Out of Pandora's Box. *Time Magazine*, 08 June, 20–21.

Ellul, Jacques. 1964. *The Technological Society*. Translated by John Wilkinson. New York: Vintage Books.

Erikson, Kai. 1994. Out of Sight, Out of Our Minds. *New York Times Magazine*. 06 March, 36.

Ewing, Rodney C. 2006. Performance Assessments: Are They Necessary or Sufficient? In *Uncertainty Underground: Yucca Mountain and the Nation's High-Level Nuclear Waste*, edited by Allison M. Macfarlane and Rodney C. Ewing, 71–83. Cambridge, Mass.: The MIT Press.

Ewing, Rodney C., and Allison Macfarlane. 2002. Yucca Mountain. *Science*, 16 April, 327 (5965): 659.

Eyewitness Atop Peak Tells of Dazzling Flash. 1951. *Los Angeles Times*, 07 February.

Ezrahi, Yaron. 1990. *The Descent of Icarus: Science and the Transformation of Contemporary Democracy*. Cambridge, Mass.: Harvard University Press.

Facts About A-Bomb 'Fall-Out.' 1955. *U. S. News & World Report*, 25 March, 25.

Fairclough, Norman. 1989. *Language and Power*. New York: Longman.

Family Could Survive A-Bombed Home. 1955. *New York Times*, 20 March.

Fehner, Terrence R., and F. G. Gosling. 2000. *Origins of the Nevada Test Site*. Washington, D. C.: U. S. Department of Energy.

Fein, Bruce. 2002. Nuclear waste parochialism. *Washington Times*, 26 February, A21.

Fernlund, Kevin J., ed. 1998. *The Cold War American West: 1945–1989*. Albuquerque: University of New Mexico Press.

FE-S [Fallon Eagle-Standard (Fallon, Nev.)]. 1963. 09 July; 01 October; 06 October; 29 October; 17 December. Churchill County Museum and Archives, Fallon.

Feyerabend, Paul. 1988. *Against Method*. New York: Routledge.

Fields, K. E. 1957. Letter to Senator Alan Bible. 6 June. Alan Bible Papers, Special Collections, University of Nevada, Reno.

Flynn, James, James Chalmers, Doug Easterling, Roger Kasperson, Howard Kunreuther, and others. 1995. *One Hundred Centuries of Solitude: Redirecting America's High-Level Nuclear Waste Policy*. Boulder, Colo.: Westview Press.

Foucault, Michel. 1972. *The Archaeology of Knowledge*. Translated by A. M. Sheridan Smith. New York: Pantheon Books.

———. 1977. *Power/Knowledge: Selected Interviews & Other Writings, 1972–1977*. Edited by Colin Gordon. Translated by Colin Gordon, Leo Marshall, John Mepham, and Kate Soper. New York: Pantheon Books.

Fox, William L. 1999. *Mapping the Empty: Eight Artists and Nevada*. Reno and Las Vegas: University of Nevada Press.

Fradkin, Philip L. 1989. *Fallout: An American Nuclear Tragedy*. Boulder, Colo.: Johnson Books.

Freeman, Leslie J. 1981. *Nuclear Wildernesses*. New York: W. W. Norton.

Fry, Joseph A. 1980. The History of Defense Spending In Nevada: Preview of the MX. In *MX in Nevada: A Humanistic Perspective*, edited by Francis X. Hartigan, 37–43. Reno: The Nevada Humanities Committee.

Fuller, John. 1984. *The Day We Bombed Utah*. New York: New American Library.

Gallagher, Carole. 1993. *American Ground Zero: The Secret Nuclear War*. New York: Random House.

Gardner, Martin, ed. 1994. *Great Essays in Science*. Amherst, Mass. and New York: Prometheus Books.

Germain, Gilbert G. 1993. *A Discourse on Disenchantment: Reflections On Politics and Technology*. Albany: State University of New York Press.

Gilbert, Nigel, and Michael Mulkay. 1984. *Opening Pandora's Box: A Sociological Analysis of Scientists' Discourse*. Cambridge, England: Cambridge University Press.

Glass, Mary Ellen. 1981. *Nevada's Turbulent '50s*. Reno: University of Nevada Press.

Glass, Matthew. 1998. Air Force, Western Shoshone, and Mormon Rhetoric of Place and the MX Conflict. In *The Atomic West*, edited by Bruce Hevly and John M. Findlay, 255–275. Seattle and London: University of Washington Press.

Glasstone, Samuel, ed. 1950. *The Effects of Atomic Weapons*. Washington, D. C.: The U. S. Atomic Energy Commission.

Gleick, James. 1987. *Chaos*. New York: Penguin Books.

Glotfelty, Cheryll, ed. 2008. *Literary Nevada*. Reno: University of Nevada Press.

Goin, Peter. 1991. *Nuclear Landscapes*. Baltimore, Md.: Johns Hopkins University Press.

Goin, Peter, and Paul F. Starrs. 2005. *Black Rock*. Reno: University of Nevada Press.

Grove, Benjamin. 2001. Yucca could be costliest project in history. *Las Vegas Sun*, 09 March.

Gusterson, Hugh. 1996. *Nuclear Rites*. Berkeley: University of California Press.

———. 2007. The Effect of U. S. Nuclear Testing on the Marshallese. *Bulletin of the Atomic Scientists*. [www.thebulletin.org/we-edition/columnists/hugh-gusterson/the-effect-us-nuclear-testing-marshallese] accessed 08 July 2009.

Habermas, Jurgen. 1984. *The Theory of Communicative Action*. Boston: Beacon Press.

Hacker, Barton C. 1987. *The Dragon's Tail*. Berkeley: University of California Press.

———. 1994. *Elements of Controversy*. Berkeley: University of California Press.

———. 1998. Hotter Than a Two $ Pistol. In *The Atomic West*, edited by Bruce Hevly and John M. Findlay, 157–175. Seattle and London: University of Washington Press.

Halberstam, David. 1993. *The Fifties*. New York: Villard Books.

Hales, Corinne Clegg. 2002. Covenant: Atomic Energy Commission, 1950's. In Hales, *Separate Escapes*, p. 16. Ashland, Ore.: Ashland Poetry Press.

Hales, Peter Bacon. 1997. *Atomic Spaces: Living on the Manhattan Project*. Urbana and Chicago: University of Illinois Press.

Hallett, Brien. 1997. Challenging Complicity: A Rectification of Names. *Waging Peace Worldwide: Journal of the Nuclear Age Peace Foundation* 7 (3): 6–7.

Hansen, Chuck. 1998. *U.S. Nuclear Weapons: The Secret History*. Arlington, Tex.: Aerofax.

Henley, Brigadier General David C. 1988. *Battleship USS Nevada*. Western Military History Association.

Henriksen, Margot A. 1997. *Dr. Strangelove's America*. Berkeley: University of California Press.

Hevly, Bruce, and John M. Findlay, eds. 1998. *The Atomic West*. Seattle and London: University of Washington Press.

Herman, Edward S., and Noam Chomsky. 1988. *Manufacturing Consent*. New York: Pantheon Books.

Hewlett, Richard, G., and Francis Duncan. 1969. *Atomic Shield, 1947–1952*. University Park and London: The Pennsylvania State University Press.

Higgins, Gary M. 1963. Memo to Senator Alan Bible. The Alan Bible Papers, Special Collections, University of Nevada, Reno.

Hilgartner, Stephen, Richard C. Bell, and Rory O'Connor. 1983. *Nukespeak: The Selling of Nuclear Technology in America*. New York: Penguin.

Hill, Gladwin. 1951. Third Atom Test Lights Nevada Dawn; Peaks Stand Out in Weird Glare. *New York Times*, 01 February.

———. 1957. Watching the Bombs Go Off: Tourists Can See Blasts in Nevada Test Area This Summer. *New York Times*, 09 June, Travel §, 353.

Hirsh, Michael, and John Barry. 1998. Nuclear Jitters. *Time Magazine*, 08 June, 22–27.

Hora, Stephen C., Detlof von Winterfeldt, and Kathleen M. Trauth. 1991. Expert Judgment on Inadvertent Human intrusion into the Waste Isolation Pilot Plant, December. Sandia Report SAND90–3063.

Hot Dogs. 1990. Nuclear Notebook: Prepared by Robert S. Norris and William M. Arkin, *Bulletin of the Atomic Scientists* 46 (10): 56.

Howard Hughes File. U. S. Department of Energy Archives, Las Vegas, Nevada.

Hulse, James W. 1986. *Forty Years in the Wilderness*. Reno: University of Nevada Press.

Information Materials and Handling First Central Nevada Test. 1967. Memorandum from Division of Public Information. Nevada. U. S. Department of Energy Archives, Las Vegas, Nevada. Collection OGM, Box 5537.

Institutional Reform for Long-Term Nuclear Waste Management. 1999. *Science for Democratic Action*, 07 April.

International Commission to Investigate the Health and Environmental Effects of

Nuclear Weapons Production (IPPNW) and the Institute for Energy and Environ-
mental Research (IEER). 1991. *Radioactive Heaven and Earth: The Health and
Environmental effects of Nuclear Weapons testing in, on, and above the Earth.*
New York: The Apex Press.

Interviews with Bikinian Elders. [www.bikiniatoll.com].

Junetka, James W. 1979. *City of Fire. Los Alamos and the Atomic Age, 1943–1945.*
Rev. ed. Albuquerque: University of New Mexico Press.

Kahn, David. 1996. *The Code-Breakers.* New York: Scribner.

Kennedy, David M. 2000. Only God Was His Senior, review of Weintraub, *MacArthur's
War: Korea and the Undoing of an American Hero. New York Times* Book Review
§, 02 July

Kirsch, David A. 1997. Project Plowshare: The Cold War Search for a Peaceful Nuclear
Explosive. In *Science, Values, and the American West*, edited by Stephen Tchudi,
191–222. Reno: A Halcyon Imprint, The Nevada Humanities Committee.

Kuletz, Valerie L. 1998. *The Tainted Desert: Environmental and Social Ruin in the
American West.* New York: Routledge.

La Barre. Weston 1970. *The Ghost Dance.* New York: Dell Publishing Co., Inc.

Lamont, Lansing. 1965. *Day of Trinity.* New York: Atheneum.

Lang, Daniel. 1959. *From Hiroshima to the Moon.* New York: Simon and Schuster, Inc.

Lapp, Ralph E. 1968. *The Weapons Culture.* New York: W. W. Norton.

Larsen, Soren C., and Timothy J. Brock. 2005. Great Basin Imagery in Newspaper
Coverage of Yucca Mountain. *Geographical Review* 95 (4): 517–536.

League of Women Voters. 1993. *The Nuclear Waste Primer.* Washington, D. C.: The
League of Women Voters Education Fund.

Lewan, Todd. 1999. Nevada Desert Bears Test Scars. *Reno Gazette-Journal*, 15
October, A1.

Lilienthal, David. 1966. *The Journals: The Atomic Energy Years 1945–50.* New York:
Harper and Row.

Lippard, Lucy R. 1999. *On the Beaten Track.* New York: The New Press.

Loomis, David. 1993. *Combat Zoning: Military Land Use Planning in Nevada.* Reno:
University of Nevada Press.

Lowenthal, David. 1985. *The Past is a Foreign Country*. Cambridge, England: Cambridge University Press.

Macfarlane, Allison M. 2006a. Technical Policy Decision Making in Siting a High-Level Nuclear Waste Repository. In *Uncertainty Underground: Yucca Mountain and the Nation's High-Level Nuclear Waste*, edited by Allison M. Macfarlane and Rodney C. Ewing, 85–99. Cambridge, Mass: The MIT Press.

———. 2006b. Uncertainty, Models, and the Way Forward in Nuclear Waste Disposal. In *Uncertainty Underground: Yucca Mountain and the Nation's High-Level Nuclear Waste*, edited by Allison M. Macfarlane and Rodney C. Ewing, 393–410. Cambridge, Mass: The MIT Press.

Macfarlane, Allison M., and Rodney C. Ewing, eds. 2006c. *Uncertainty Underground: Yucca Mountain and the Nation's High-Level Nuclear Waste*. Cambridge, Mass: The MIT Press.

Manning, Mary. 1999. Tritium stirs concern at Test Site. *Las Vegas Sun*, 24 January, D1.

Matthews, Samuel W. 1953. Nevada Learns to Live with the Atom. *National Geographic*, June, 839–850.

McGeary, Johanna. 1998. Nukes … They're Back. *Time Magazine*, 25 May, 34–42.

McPhee, John. 1973. *The Curve of Binding Energy*. New York: Ballantine Books.

———. 1981. *Basin and Range*. New York: Farrar, Straus, Giroux.

Metzger, H. Peter. 1972. *The Atomic Establishment*. New York: Simon and Schuster.

Miller, Richard L. 1986. *Under the Cloud: The Decades of Nuclear Testing*. New York: The Free Press.

———. 1997. *The Atomic Express*. Woodlands, Tex: Two-Sixty Press.

Miller, Walter M. Jr. 1959. *A Canticle for Leibowitz*. Toronto: Bantam Books.

Mills, C. Wright. 1956. *The Power Elite*. Oxford, England: The Oxford University Press.

Mitchell, Don. 2000. *Cultural Geography: A Critical Introduction*. Malden, Mass.: Blackwell Publishers, Inc.

Mitchell, Peter R., and John Schoeffel. 2002. *Understanding Power: The Indispensable Chomsky*. New York: The New Press.

Monmonier, Mark. 1997. *Cartographies of Danger: Mapping Hazards in America*. Chicago: University of Chicago Press.

Montgomergy Scott L. 1996. *The Scientific Voice*. New York: The Guilford Press.

Montoya, Maria E. 1998. Landscapes of the Cold War West. In *The Cold War American West*, edited by Kevin J. Fernlund, 9–27. Albuquerque: University of New Mexico Press.

Mosher, Clint. 1951a. A-Bomb Blast Can't Stop Las Vegas Dice. *San Francisco Examiner*, 01 February, 18.

———. 1951b. A Frightening White Light, Then Silence, Then Blasts. *Houston Chronicle*, 03 February.

Moynihan, Daniel Patrick. 1998. *Secrecy*. New Haven, Conn.: Yale University Press.

Mushkatel, Alvin H., Joanne M. Nigg, and K. David Pijawka. 1993. Nevada Urban Residents' Attitudes Toward A Nuclear Waste Repository. In *Public Reactions to Nuclear Waste: Citizens' Views of Repository Siting*, edited by Riley E. Dunlap, Michael E. Kraft, and Eugene A. Rosa, 239–262. Durham, N. C. and London: Duke University Press.

Nevada Test Site: A Guide to America's Nuclear Proving Ground. 1996. Culver City, Calif.: The Center for Land Use Interpretation.

Nevada Site Selected For Shoal Event. n.d. Alan Bible Papers, Special Collections, University of Nevada, Reno.

Nevada Atom Test Affects Utah Area. 1953. *New York Times*, 20 May.

Nieves, Evelyn. 2002. Amargosa Valley Journal: Barren, desolate and at least arguably heaven. *New York Times*, 15 January. [www.nytimes.com/2002/01/10/national /10NEVA.html]. accessed 04 February 2010.

Norris, Robert S., and William M. Arkin. 1998. NRDC Nuclear Notebook. Known Nuclear Tests Worldwide, 1945–98. *The Bulletin of the Atomic Scientists*, November–December 54 (6). [www.bulatomsci.org/issues/nukenotes /nd98nukenote.html] accessed 12 August 1999.

Nuclear Proving Grounds of the World. 1998. Culver City, Calif.: The Center for Land Use Interpretation.

Oakes, Guy. 1994. *The Imaginary War: Civil Defense and American Cold War Culture*. New York: Oxford University Press.

O'Keefe, Bernard J. 1983. *Nuclear Hostages*. Boston: Houghton Mifflin.

O'Neill, Dan. 1994. *The Firecracker Boys*. New York: St. Martin's Press.

Operation "Doom Town." 1953. *Nevada Highways and Park*. June, 13 (2): 1–17.

Operation Doorstep. 1953. Byron Incorporated & the Federal Civil Defense
Administration: 10 minutes. Videocassette.

Operation Plumbbob: Project 33. Tertiary Effects of Blast-Displacement. 1957. Civil
Effects Test Group, December. AEC doc. ITR 1469.

*Operation Plumbbob: Project 33. 1. Blast Biology—A Study of the Primary and Tertiary
Effects of Blast in Open Underground Protective Shelters*. 1959. Civil Effects Test
Group, 30 June. AEC doc. WT 1467. DEPARTMENT OF ENERGY Archives, Las
Vegas, Nevada.

*Operation Plumbbob: Project 38. 1-I. Effect of Fallout contamination of Processed
Foods, Containers, and Packaging*. 1959. Civil Effects Test Group, 01 May. AEC
doc. WT 1496.

*Operation Plumbbob: Test Group 57, Program 72. Biomedical and Aerosol Studies
Associated With a Field Release of Plutonium*. 1961. Albuquerque, N. Mex.:
Sandia Corporation, 6 February. AEC doc. WT 1511.

Oram, Kent, and Ed Allison. *Nevada Initiative: The Long Term Program An Overview*.
1991. Proposal to the American Nuclear Energy Council, September.

Orrell, David. 2007. *The Future of Everything: The Science of Prediction*. New York:
Basic Books, Thunder's Mouth Press.

Orwell, George. 1989. Politics and the English Language. In *Language Awareness*,
edited by Paul Eschholz, Alfred Rosa, and Virginia Clark, 41–52. New York: St.
Martin's Press.

Painter, Joe. 1995. *Politics, Geography and Political Geography*. New York: Halstead
Press.

Pasqualetti, Martin J. 1997. Landscape Permanence and Nuclear Warnings.
Geographical Review 87 (1): 73–91.

Pendergrass, Gurli, and Lorelle Nelson. 1987. *The Mushroom Cloud and the
Downwinders*. Holstaed, Denmark: Forlaget Futuram.

Peyton, Carrie. 1999. Inside Yucca Mountain: Life or Death Issues Simmering.
Sacramento Bee, 07 February, A1, 20–21.

Pilkey, Orrin H., and Linda Pilkey-Jarvis. 2007. *Useless Arithmetic: Why Environmental
Scientists Can't Predict the Future*. New York: Columbia University Press.

Pool, Peter E., ed. 1999. *The Altered Landscape*. Reno and Las Vegas: Nevada

Museum of Art, in association with University of Nevada Press.

Porter, Theodore M. 1995. *Trust in Numbers*. Princeton, N. J.: Princeton University Press.

Postman, Neil. 1992. *Technopoly: The Surrender of Culture to Technology*. New York: Alfred A. Knopf.

Pringle, Peter, and James Spigelman. 1981. *The Nuclear Barons*. New York: Holt, Rinehart and Winston.

The Problem. 1950. DMA Files, Box 3865, MRA 7 Continental Test Site, 1945–1956. U.S. Department Of Energy Archives, Las Vegas, Nevada.

Project Nutmeg Report. 1949. Deleted version. DNA-82-05796. Department of Energy Archives, Las Vegas, Nevada.

Radiation Exposure Compensation Act. [www.justice.gov/civil/torts/const/reca/about.htm] accessed 22 February 2008.

Rafferty, Kevin, Jane Loader, and Pierce Rafferty, dirs. 1982. *The Atomic Café*. The Archives Project. 88 minutes. DVD.

Reeves, James E. 1961. Uses of Nuclear Explosives. December. Alan Bible Papers, Special Collections, University of Nevada, Reno.

Reines, Frederick. 1950. *Discussion of Radiological Hazards Associated With A Continental Test Site for Atomic Bombs*. LAMS-1173. Los Alamos National Laboratory Archives.

Reith, Charles C., and Bruce M. Thomson, eds. 1992. *Deserts as Dumps? The Disposal of Hazardous Materials in Arid Ecosystems*. Albuquerque: University of New Mexico Press.

Rhodes, Richard. 1986. *The Making of the Atomic Bomb*. New York: Simon and Schuster.

———. 1995. *Dark Sun: The Making of the Hydrogen Bomb*. New York: Simon and Schuster.

Ritter, Ken. 2005. Las Vegas museum traces atomic bomb history. *Reno Gazette-Journal*, 06 March, A8.

The Riverside Shakespeare. 1974. Edited by C. Blakemore Evans. Boston, Mass: Houghton Mifflin Company.

Roberts, James. 1957. Letter to Senator Alan Bible. 06 June. Alan Bible Papers, Special Collections, University of Nevada, Reno.

Rogers, Keith. 1999. Study: Plutonium Seeping. *Las Vegas Review-Journal*, 07 January, B1.

————. 2000. We Were in Awe. *Las Vegas Review-Journal*. 17 December, A34.

Rosenberg, Howard L. 1982. *Atomic Soldiers*. New York: Harper and Row.

Rosenthal, Debra. 1990. *At The Heart of The Bomb: The Dangerous Allure of Weapons Work*. Reading, Mass.: Addison-Wesley.

Ross, Andrew. 1991. *Strange Weather: Culture, Science, and Technology in the Age of Limits*. London: Verso.

Rothman, Hal. 1992. *On Rims and Ridges: The Los Alamos Area Since 1880*. Lincoln: University of Nebraska Press.

Saffer, Thomas. 1982. *Countdown Zero*. New York: Putnam.

Said, Edward W. 1993. *Culture and Imperialism*. New York: Vintage Books.

Sandars, L. J. 1957. Letter to Senator Alan Bible. 03 June. Alan Bible Papers, Special Collections, University of Nevada, Reno.

Scarry, Elaine. 1985. *The Body in Pain*. New York: Oxford University Press.

Schlatter, Colonel. 1950. July. Memorandum for Record. Subject: AFSWP Briefing on Continental Testing. DMA Files, Box 3777, Folder Nevada Test Site.

Schumacher, Geoff. 2002. Commentary: The "There" of Yucca Mountain: How can people back East justify putting a nuclear waste dump in this Nevada desert? *Los Angeles Times*, 28 April. §M,5.

Seabrook, John. 1998. The Gathering of the Tribes. *The New Yorker*, 07 September, 30-31.

Shattuck, Roger. 1996. *Forbidden Knowledge*. New York: Harcourt Brace & Company.

Shelton, Frank. 1996. *Reflections of a Nuclear Weaponeer*. Colorado Springs, Colo.: Shelton Enterprises.

Sherry, James. 1991. *Our Nuclear Heritage*. Los Angeles: Sun and Moon Press.

Shoumatoff, Alex. 1997. *Legends of the American Desert*. New York: Alfred A. Knopf.

Shrader-Frechette, Kristen S. 1993. *Burying Uncertainty: Risk and the Case Against Geological Disposal of Nuclear Waste*. Berkeley: University of California Press.

Snow, C. P. 1988. *The Two Cultures and a Second Look*. New York: Cambridge University Press.

Solnit, Rebecca. 1994. *Savage Dreams*. New York: Vintage Departures.

Spangle, Jerry D., and Donna Kemp Spangle. 2000. Toxic Utah: Goshutes divided over N-storage. *Utah Desert News*, 14 February.

State of Nevada Comments on the U. S. Department of Energy's Draft Environmental Impact Statement For a Geologic Repository for the Disposal of Spent Nuclear Fuel and High Level Radioactive Waste at Yucca Mountain, Nye County, Nevada. 2000. February. Carson City, Nevada.

Sternglass, Ernest J. 1981. *Secret Fallout*. New York: McGraw-Hill.

Stoffle, Richard W., David B. Halmo, John E. Olmsted, and Michael J. Evans. 1990. *Native American Cultural Resource Studies at Yucca Mountain, Nevada*. Ann Arbor: The University of Michigan.

Storey, John. 1993. *Cultural Theory and Popular Culture*. Athens: The University of Georgia Press.

Summary of Project Chariot. n.d. The Alan Bible Papers, Special Collections, University of Nevada, Reno.

Szasz, Ferenc M. 1984. *The Day the Sun Rose Twice*. Albuquerque: University of New Mexico Press.

———. 2004. Atomic Comics. In *Atomic Culture*, edited by Scott C. Zeman and Michael A. Amundson, 11–31. Boulder: The University Press of Colorado.

Taylor, Theodore. 1995. *The Bomb*. New York: Avon Books.

Thomas, Nicholas. 1994. *Colonialism's Culture*. Princeton, N. J.: Princeton University Press.

Tierney, Patrick. 2002. *Darkness in El Dorado: How Scientists and Journalists Devastated the Amazon*. New York: W. W. Norton & Company.

Titus, A. Constandina. 1986. *Bombs in the Backyard: Atomic Testing and American Politics*. Reno and Las Vegas: University of Nevada Press.

———. 2004. The Mushroom Cloud as Kitsch. In *Atomic Culture*, edited by Scott C. Zeman and Michael A. Amundson, 101–123. Boulder: The University Press of Colorado.

Too Late to Say "Extinct" in Ubykh, Eyak, or Ona. 1998. *New York Times*, 15 August, A13.

TPM [Tonopah Public Meeting To Discuss Prospective Central Nevada Test Site]. 1966. U. S. Atomic Energy Commission, Nevada Operations, October. Alan Bible Papers, Special Collections, University of Nevada, Reno.

Treat, John Whittier. 1995. *Writing Ground Zero: Japanese Literature and the Atomic Bomb*. Chicago: The University of Chicago Press.

Tyler, Carroll L. 1953. Documentation of Establishment of Continental Test Site. Committee to Study the Future of Nevada Proving Grounds, December. Los Alamos National Laboratory Records Center, C-2 D-44.

Uhl, Michael, and Tod Ensign. 1980. *GI Guinea Pigs*. New York: Wideview Books.

U. S. DOE's [Department of Energy] Yucca Mountain Studies. 1992. Washington, D. C.: U. S. Department of Energy.

U. S. DOE [Department of Energy]. 1999. Draft Environmental Impact Statement for a Geologic Repository for the Disposal of Spent Nuclear Fuel and High Level Radioactive Waste at Yucca Mountain, Nye County, Nevada, July. DOE/ EIS 025OD.

U. S. DOE [Department of Energy]. 2002. Environmental Impact Statement for a Geologic Repository for the Disposal of Spent Nuclear Fuel and High-Level Nuclear Waste at Yucca Mountain, Nye County, Nevada. Office of Civilian Radioactive Waste Management.

U. S. DOE [Department of Energy]. 1998. Repository Safety Strategy: U. S. Department of Energy's Strategy to Protect Public Health and Safety After Closure of a Yucca Mountain Repository, January. Office of Civilian Radioactive Waste Management, YMP/96-01.

U. S. DOE [Department of Energy]. 1994. United States Nuclear Tests: July 1945 through September 1992. DOE/NV–209. DOE Archives, Las Vegas, Nevada.

Vela Uniform Project Shoal Final Report of Off-Site Surveillance. 1964. Department of Health, Education, and Welfare, Public Health Service, 01 September. DEPARTMENT OF ENERGY Archives, Las Vegas, Nevada, VUF–1009.

Vela Uniform Project Shoal: Geological, Geophysical, Chemical and Hydrological Investigations of the Sand Springs Range, Fairview Valley, and Fourmile Flat, Churchill County Nevada. 1964. Reno, Nevada Bureau of Mines. DeLaMare Library, University of Nevada, VUF–1001.

Vela Uniform Project Shoal, On-Site Health and Safety Report. 1964. Mercury, Nevada, Reynolds Electric and Engineering Company, Inc., June. DEPARTMENT OF ENERGY Archives, Las Vegas, Nevada, VUF–1012.

Vela Uniform Project Shoal, Seismic Safety Net. 1964. August. U. S. Department of Commerce, Coast and Geodetic Survey, August. DEPARTMENT OF ENERGY Archives, Las Vegas, Nevada, VUF–1001.

Vela Uniform Project Shoal, Weather and Surface Radiation Prediction. 1964. June. U.S. Weather Bureau, June. DEPARTMENT OF ENERGY Archives, Las Vegas, Nevada, VUF–1008.

Vermillion, Henry. 1968. Memo to "My Principal Staff." 13 December. DEPARTMENT OF ENERGY Archives, Las Vegas, Nevada, NV0170547.

Virgil. 1981. *The Aeneid.* Translated by Robert Fitzgerald. New York: Vintage Books.

Wald, Matthew L. 2009. Is There a Place for Nuclear Waste? *Scientific American,* August, 301 (2): 47–53.

Walzer, Michael. 1983. *Spheres of Justice: A Defense of Pluralism and Equality.* New York: Basic Books, Inc.

Wasserman, Harvey, and Norman Solomon. 1982. *Killing Our Own.* Garden City, N. Y.: Doubleday.

Waters, Frank. 1988. *The Woman at Otowi Crossing,* Revised Edition. Athens: Swallow Press/Ohio University Press.

Weart, Spencer R. 1987. *Nuclear Fear: A History of Images.* Cambridge, Mass.: Harvard University Press.

Weaver, Mary Anne. 2000. Gandhi's Daughters. *The New Yorker,* 10 January, 50–61.

Wells, H. G. 1994. The New Source of Energy. In *Great Essays in Science,* edited by Martin Gardner. New York: Prometheus Books.

When the Buddha Smiled. 2007. Rediff India Abroad. [www.rediff.com/india60/2007/aug/20fact.htm] accessed 01 January 2010.

Whorf, Benjamin Lee. 1956. *Language, Thought and Reality.* Edited by John B. Carroll. Cambridge, Mass.: The MIT Press.

Williams, Terry Tempest. 1991. *Refuge: An Unnatural History of Family and Place.* New York: Vintage Books.

Winkler, Allan M. 1993. *Life Under a Cloud: American Anxiety About the Atom.* New York: Oxford University Press.

Wolff, Patricia. 1991. Project Gasbuggy. *Rio Grande Sierran,* September/October, 8–9.

Worman, Frederick C. 1965. *Anatomy of the Nevada Test Site.* Los Alamos, N. Mex.: U. S. Atomic Energy Commission.

Yucca Mountain: A very good place for nuclear waste. 2002. *Minneapolis Star-Tribune*, 21 January, Editorial §.

Zeman, Scott C., and Michael Amundson. 2004. *Atomic Culture*. Boulder: University Press of Colorado.

De Baca, named for a county in New Mexico, was a 2.2 kiloton balloon burst detonated at the Nevada Test Site on 26 October 1958. Photograph courtesy of National Nuclear Security Administration/Nevada Site Office.

Page numbers in bold refer to illustrations.

ACKNOWLEDGEMENTS

A project that takes as long to complete as this one has (over ten years) is bound to stumble at times along a dark trail of frustrations, revisions, and abandoned ideas. That trail, nevertheless, has always been brightened by the encouragement, work, and faith of others.

My love and gratitude go to my husband, Michael, and children James, Amy, Leonard, and John, who have always believed in whatever I do. My lovely grandchildren, Maggie, Ellie, Sadie, Fenn, and Hazel have arrived as these pages have multiplied. I hope that they are imprinted with my respect for reading, writing, and independent thought. My brothers, Ernie and Doug, and my twin sister, Michele, are part of my memories of the Fallon "southern sunrises," and remain always firmly and affectionately in mind. I probably should apologize ahead of the fact to Michele, who looks so much like me that she is sure to be angrily confronted by some of those who disagree with my personal interpretations of Nevada's nuclear past and present.

I initially set foot on the trail because in 1996 I was granted a sabbatical leave from my position as professor of English and humanities, at Western Nevada Community College, to pursue the research that led to the writing of this book. I thank the college, now Western Nevada College, and the Nevada System of Higher Education for providing me with the time and support to take that first step. And, I owe many thanks to former Governor Richard Bryan, now Chairman of the Nevada Commission on Nuclear Projects, for selecting me to serve as a commissioner, a job that alternately beckoned, enticed, and forced me to think about the themes in this book. Throughout my years of service on the commission, I had the pleasure of serving with the competent staff of the Nevada Office of Nuclear Projects—scientists, writers, and public servants—who encouraged my interest in Nevada's nuclear story, and who could always answer my technical and political questions. I served alongside fellow commission members—a dedicated and bright group of civic-minded citizens—whose commitment to learning about Yucca Mountain and independent determination to question all aspects of boosterism of the site within Nevada was inspirational. I feel great respect and gratitude to them.

I was fortunate to obtain permission to work with the Alan Bible Papers, held in the Special Collections department of Getchell Library (now the Mathewson-IGT Knowledge Center) at the University of Nevada, Reno, and to gain access to numerous primary documents in the Department of Energy Archives, now housed at the Atomic Testing Museum in Las Vegas. I thank Jane Pieplow, Churchill County Museum Director and Curator; Bunny Corkill, Research Curator; and Andrea Rossman, Photograph Curator.

Many intrepid individuals have read the manuscript at various stages of its development, providing valuable advice, making face-saving corrections, and suggesting further areas to explore. I thank Don Bowman, Vern Brechin, Eric Dieterle, Florence Dugan, Cheryll Glotfelty, Kirk Robertson, Mary Sojourner, Paul F. Starrs, Joe Strolin, Judy Triechel, and academic press reviewers who remain anonymous. Megan Berner and Lara Schott provided much-needed assistance with image production.

And, without Peter Goin, this book would still be a roughly-sketched idea. Peter encouraged the project from its inception, when we worked together with Nevada Humanities to develop ideas for a Nevada nuclear age anthology. That uncompleted project convinced us there was far more to see and say about Nevada in the nuclear age. Peter's gallery of images, under the rubric "Atomic Pop," is a visually exciting contribution to this study of the way that words and images sold atoms to generations of Nevadans.

ABOUT THE
AUTHOR

A native daughter of Nevada, Michon Mackedon was born in Reno and fledged in nearby Fallon. In that sprawling small town—birthplace of the Newlands Reclamation Project, the first federally supported irrigation effort—Michon raised four children (all now grown), in a small agricultural tract with a fulsome summer garden, an orchard of quality, and a vertiginous tree house. A student of Russian, classic black-and-white films, cutthroat gin rummy, classic Ford Mustangs, and science fiction, Michon once appeared on the *Ed Sullivan Show*, and while there touched the hand that shook the hand of Beatle John Lennon. For twenty-seven years, Michon taught English and humanities at Western Nevada College, and at this point knows most of the really interesting people who are long-time Nevadans, since many of them were once her students or colleagues.

Like any steadfast academic and responsible neighbor, Michon has completed enough committee work to stun a Congressional aide, including prolonged service on the Nevada Commission on Nuclear Projects. Thankfully, not all her efforts required life-and-death decisions—in a 2008 episode reminiscent of Larry McMurtry's *Texasville*, she was the Chair of the Fallon Centennial Commission.

Michon is joined by husband Michael in her love of the Nevada sky as observed from their patio, welcoming the sound of water as it leaves the ditch on its way to the garden, and she cherishes cooking, reading, and the experience of lovely or strange corners of the earth, some of them even close to home. While Michon has dozens of articles published on Nevada in various journals, *Bombast* is her first full-length book.

Black Rock Institute

RENO, NEVADA, & BEYOND
A NEVADA NON-PROFIT ORGANIZATION

The Black Rock Institute, based in Reno, Nevada, is a nonprofit tax-exempt 501(c)(3) organization, founded in 2009, that fosters public interest and understanding of landscapes throughout the American West. Projects and research supported by the Black Rock Institute focus on the diverse and complex reality of western landscapes, variously including the region's sense of place, a lyrical interpretation of the nature of mountains and aridity, inquiry into demographic and historical change in the West, or examination of the material reality of physical landscapes.

For more information, contact Peter Goin at pgoin@unr.edu or Paul F. Starrs at starrs@unr.edu or visit the Institute web's site at www.BlackRockInstitute.org.

For the Black Rock Institute

Peter J. Goin	*President*
Paul F. Starrs	*Executive Director*
Candace Wheeler	*Secretary*
Jim Pfrommer	*Treasurer*

About this book

The text for *Bombast* is set in Univers and American Typewriter. The book was designed by Dawn McCusker of Harrisonburg, Virginia. Written materials were copyedited by Margaret Booker, of Santa Fe, New Mexico. The paper is acid-free 150 gsm Yulong Pure Cream woodfree and 157 gsm Gold East matte.